Historical Film

Bloomsbury **Film Genres** Series

Edited by Mark Jancovich and Charles Acland

The *Film Genres* series presents accessible books on popular genres for students, scholars and fans alike. Each volume addresses key films, movements and periods by synthesizing existing literature and proposing new assessments.

Forthcoming:

Film Noir: A Critical Introduction

Published:

Teen Film: A Critical Introduction
Fantasy Film: A Critical Introduction
Science Fiction Film: A Critical Introduction

Historical Film

A Critical Introduction

JONATHAN STUBBS

BLOOMSBURY

NEW YORK • LONDON • NEW DELHI • SYDNEY

Bloomsbury Academic

An imprint of Bloomsbury Publishing Plc

175 Fifth Avenue
New York
NY 10010
USA

50 Bedford Square
London
WC1B 3DP
UK

www.bloomsbury.com

First published 2013

Library of Congress Cataloging-in-Publication Data
Library of Congress Cataloging-in-Publication Data
Stubbs, Jonathan.
Historical film : a critical introduction / by Jonathan Stubbs.
p. cm.
Includes bibliographical references and index.
Includes filmography.
ISBN 978-1-84788-497-8 (pbk. : alk. paper)– ISBN 978-1-84788-498-5 (hardcover : alk. paper) 1. Historical films–United States–History and criticism. 2. Motion pictures and history. I. Title.
PN1995.9.H5S78 2013
791.43′658–dc23
2012033493

ISBN: HB: 9781847884985
PB: 9781847884978

Typeset by Fakenham Prepress Solutions, Fakenham, Norfolk NR21 8NN
Printed in the United States by Thomson-Shore, Inc. Dexter, Michigan

Contents

List of Illustrations

Acknowledgments

This book has been several years in the making and I've accumulated numerous debts of gratitude in the process. I'd like to thank Mark Jancovich and Charles Acland, the editors of this series, for their kind assistance and their faith in me as the project took shape. My research began while I was working at the University of East Anglia and the bulk of the writing took place in warmer climes at Cyprus International University. I consider myself very fortunate to have worked alongside such helpful and thoughtful academics at both of these institutions. During the writing process I benefitted from the enthusiasm of the editorial staff at Berg and Bloomsbury Academic, particularly Tristan Palmer and Katie Gallof. Finally, I would like to thank my mother for her enduring support, and Asliye, whose love and patience continue to be a revelation.

Introduction: Film and the invention of history

[Charlton] Heston then dipped deeply into his historical studies to describe exactly what was known about El Cid. It sounded rather scrappy to a reporter: 'You mean you and the screenwriter had to do a lot of guess-work?' Mr Heston looked rather reproving. 'I hope we didn't do any guessing,' he said, as if it cast aspersions on what he likes to call the 'historicity' of his epics.[1]

(*THE GUARDIAN*, 1961)

The 2009 Hollywood comedy *The Invention of Lying* is set in a parallel universe in which the concept of lying does not exist. There is no dishonesty, no bragging, no tact, no religion, no crime, and no concept of fiction. As a consequence, the dominance of the historical film is uncontested. In the absence of fictional genres, the film industry is based entirely around the production of historical 'lecture films' which are delivered direct to camera by a narrator who sits in an armchair and reads from a teleprompter. Sample titles include 'Napoleon 1812–13,' 'The Industrial Revolution,' and 'The Invention of the Fork.' The film's hero Mark Bellison (played by Ricky Gervais) is employed as a screenplay writer for a 'lecture film' movie studio. Stranded in the '14th Century Department' and apparently powerless to produce screenplays on any topic other than the Black Death, he rapidly falls behind colleagues assigned to apparently more eventful periods. As his personal and professional life disintegrates, Bellison 'invents' lying. He pitches his boss a screenplay based on a 'never before heard event from history' based on a fourteenth-century manuscript which he discovered, personally, in an 'ancient chest.' The story features aliens landing in Babylon, a ninja army, robot dinosaurs, nude Amazonian women, a wedding on Mars, and subsequently the wiping of the memories of all those involved. Still unfamiliar with the concept of fiction, Bellison's colleagues and the viewing public take the

[1] W. J. Weatherby, "The Character of the Epic," *The Guardian*, November 16, 1961, 8.

story at face value and the film proves to be a huge success, even though it too has presumably taken the form of a lecture.

This counterfactual depiction of the historical film points towards some of the most interesting debates which surround the genre. First, even though historical films have never enjoyed quite the monopoly presented in the parallel world of *The Invention of Lying*, cinema of this type has been a mainstay of American film production for over a hundred years and has consistently delivered a large proportion of Hollywood's profits. From *The Birth of a Nation* (1915) to *Titanic* (1997), via *Gone with the Wind* (1939) and *Ben-Hur* (1959), filmmakers in America have repeatedly turned to historical material for their grandest, most expensive creations, and audiences around the world have provided handsome returns on their investments. Secondly, although it would be simplistic to accuse historical films of 'lying' about the past, they are characterized by the interplay of fact and fiction. Historical films are often marketed on the basis of their accuracy and their ability to show the past 'as it really was.' But although some filmmakers have gone to extreme lengths in pursuit of authenticity, historical films inevitably incorporate elements of fiction in order to represent eras in which the visual record is incomplete. As Pierre Sorlin has noted, 'even if they are based on records, [historical films] have to reconstruct in a purely imaginary way the greater part of what they show.'[2] Speaking broadly, historical films might be considered an expedient compromise between fact and fiction.

Thirdly, although real-world audiences are much less likely to take historical films at face value than the fictional audiences in *The Invention of Lying*, the genre is often subject to conflicting expectations regarding their accuracy and authenticity. Fidelity to the past is valued in the promotional and critical discourses that historical films generate, but any historical 'lecture film' would be hopelessly uncompetitive in a marketplace populated by film genres which are not restricted to documented facts. Pre-empting criticism of his directorial choices on the set of *Gladiator* (2000), Ridley Scott said, 'I felt the priority was to stay true to the spirit of the period, but not necessarily to adhere to facts. We were, after all, creating fiction, not practicing archaeology.'[3] On the other hand, comments made by some critics and historians imply a preference for films consisting of unadorned historical facts, prepared by experts, and delivered direct to camera, unmediated by any other form of visual representation. Finally, the very absence of visual artifice in 'lecture films' points to what has often been the major selling point of historical films in the real world: spectacle. From Roman chariot races and the burning of Atlanta to the

[2] Pierre Sorlin, *The Film in History: Restaging the Past* (Totowa: Barnes and Noble, 1980), 21.
[3] Quoted in Diana Landau (ed.), *Gladiator: The Making of the Ridley Scott Epic* (London: Boxtree, 2000), 64.

sinking of the *Titanic* and the beginnings of space travel, historical films have used the past as a grand canvas for the construction of visual excess.

As this book will demonstrate, films based on historical material have been a major mode of production in Hollywood from its earliest period to the present. Historical films also need to be understood as one of the principal ways in which people form relationships with the past. A 1998 study based on interviews with 1,500 Americans found that respondents were significantly more likely to encounter history through films and television than through books or museums.[4] More recently, the cover story from a 2010 issue of *Time* magazine hailed Tom Hanks as 'America's Historian in Chief' due to his involvement in various historical films and TV serials.[5] As Jerome de Groot has suggested, history plays a role in modern culture which greatly exceeds the work of professional, academic historians:

> The 'historical' in popular culture and contemporary society is multiple, multiplying and unstable. The variety of discourses that use history; the complexity of interrogations, uses and responses to that history; and the fracturing of formal, technological and generic systems, all contribute to a dynamic and massively important phenomenon.[6]

The role played by popular historical cinema in this process should be obvious. But for all its presence in popular culture over the past century, the historical film has posed problems for genre theorists. Although precise definitions have not been agreed on, historical cinema tends to cut across existing genre categories and establishes an intimidatingly large group of films. In recent years, a lively body of work has developed around historical cinema, much of it proposing valuable new ways to consider the relationship between cinematic and historical representation.[7] However, only a small proportion of this writing has paid attention to the issue of genre. In order to counter this omission, this book combines a critical analysis of the Hollywood historical film with an examination of its generic dimensions and a history of its development since the silent period. Of course, Hollywood has never held a monopoly on historical cinema, but for the sake of coherence the scope of this book will be limited as such. I argue that the historical film genre needs to be understood not as a set of shared textual characteristics but rather as a discursive practice centered on an unavoidably diverse body of films. For

[4] Roy Rosenzweig and David Thelen, *The Presence of the Past: Popular Uses of History in American Life* (New York: Columbia University Press, 1998), 238.
[5] "How Tom Hanks Became America's Historian in Chief," *Time*, March 15, 2010, 1.
[6] Jerome De Groot, *Consuming History: Historians and Heritage in Contemporary Popular Culture* (London: Taylor & Francis, 2008), 4.
[7] See the "Annotated Guide to Further Reading" appended to this volume for more information.

this reason, this book is concerned not simply with the formal properties of the films at hand, but also the ways in which they have been promoted, interpreted, and discussed in relation to their engagement with the past. My main questions are: How do films engage with the past, both textually and beyond the text? How have these engagements developed over time? What role do they play in the promotion and reception of the films in question? And what is at stake in popular and scholarly debates about the accuracy, authenticity, and cultural value of historical films?

The book is organized into three sections. The first surveys and engages with existing critical approaches of historical cinema, in particular its status as a genre and the various criteria that have been used to assess the value of individual films as works of history. Chapter 1 attempts to reconcile historical cinema produced in Hollywood with theoretical approaches to genre. The term 'historical film' has significant currency in both commercial and academic contexts, and yet it lacks the unified textual features which tend to be associated with other Hollywood genres. Previous writers have nevertheless focused on the textual properties of historical cinemas in their attempts to establish a practical definition for the genre, often working backwards to substantiate a predetermined conception of the genre, but this kind of approach has been unable to unite such a highly disparate body of films. Instead, following contemporary developments in genre studies and drawing on recent writing about historical cinema, I propose a broad, cultural definition of the historical film based around the ways in which specific films have been promoted by the film industry and interpreted by viewers. Historical cinema consists of films which engage with the past and construct a relationship with history, either textually or extra-textually. In order to illustrate this definition I examine examples of textual and extra-textual engagements with the past: first the role played by prologues and epilogues in establishing a film's relationship with history, and secondly promotional discourses which emphasize the research effort supposedly underpinning specific historical films.

Chapter 2 examines the ways in which historical films are able to evoke a sense of the past, their ability to represent history effectively, and the expectations which have been brought to bear on them by historians and critics. First, I consider the extent to which historical films depend on the display of material detail in their evocation of history, and the advantages and limitations of this dependency for the broader process of historical representation. Moving from historical *mise en scène* to historical narrative, I examine the inevitable presence of the present in historical films and the critical tendency to interpret the stories they tell on an analogical basis. These discussions lead into an analysis of critical assessments of historical cinema and the ways these debates have privileged concepts of accuracy and authenticity. Such

writing tends to find historical cinema lacking when directly compared with written histories, but recent developments in the study of history provide the means to assess historical cinema on its own terms. Finally, this chapter considers the work of Robert Rosenstone, perhaps the leading scholarly voice in the study of historical cinema and, to some extent, a proponent of its ability to contribute to popular understandings of the past.

The next three chapters provide a historical overview of historical film production in Hollywood, focusing on production trends and cycles, industrial contexts and the impact of 'breakaway' hits produced within the genre. Beginning with very early examples of historical narratives in American cinema, Chapter 3 traces the emergence and consolidation of historical cinema as Hollywood's business model was established. Many of the most extravagant and most profitable productions of the 1910s and 1920s adopted historical settings, and although budgets decreased in the early sound period, the historical film remained at the center of studio activity. During the 1930s the historical film was associated with prestigious subject matter, often based on the lives of great men, and these films generally favored Old World locations over America's history. Nevertheless, a significant number of historical films also looked to the recent past of the New World and, in particular, the history of American business institutions. Finally, this chapter examines the impact of World War II on historical cinema and the extent to which the genre was able to accommodate the ideological demands of the wartime government.

Chapter 4 focuses on the late 1940s and the late 1960s, a time when historical cinema was particularly prominent in the operations of the Hollywood studios. As the industry adjusted to the fragmentation of the post-war film marketplace, a series of extravagant historical films with escalating budgets suggested that the genre was uniquely positioned to respond to changes in filmgoing habits and the erosion of cinema as a mass medium. The extent to which the historical film was transformed in this era is addressed by examining two major films from the 1930s which were remade for new audiences in 1960s: *Mutiny on the Bounty* (1962) and *Cleopatra* (1963). The chapter proceeds to examine the emergence of the historical epic in more detail, focusing particularly on thematic continuities in its representation of the ancient world and their relationship to the Cold War and Zionist ideology. Discussions of historical cinema in the 1950s and 1960s have tended to marginalize films which fall outside the ancient world epic cycle, so the final section of this chapter examines the other major trends in historical cinema from the era: World War II combat films and historical musicals adapted from Broadway productions.

Concluding the survey section, Chapter 5 examines major themes in the production of the historical film from the 'New Hollywood' period in the late

1960s to the present. Following a series of costly failures during the 1960s, historical cinema no longer played such a prominent role in Hollywood's business activities, but it remained a constant feature in production schedules. The New Hollywood period is frequently seen as a clean break from the past, but I argue that many prominent films from the era can be seen to reconnect with American history. This renewed interest in America's past can also be seen in a cycle of revisionist historical films. In addition, the chapter considers the impact of the American experience in Vietnam on depictions of American military history, first in World War II war films, later in direct representations of the Vietnam War, and later still in a new cycle of World War II combat films from the late 1990s. Finally, this chapter examines the industrial motivations for the apparent re-emergence of the 1950s-style historical epic in the 1990s and the early 2000s.

The three final chapters of the book address some of the specific issues raised by the study of historical cinema: its construction of spectacle, its cultural status, and the involvement of historians in its creation. Chapter 6 considers the role played by spectacle in historical representation and its association with historical eventfulness. Spectacle has often been understood as the means to exhibit the economic and technological prowess of high-budget Hollywood cinema, but it can also be seen as a means to evoke the feeling of being in the past. The chapter proceeds to examine some of the most common tropes which have characterized historical spectacle over time. The role of technology in the creation of spectacle is also considered, particular its relationship with widescreen processes and the promotion of these technologies as a means to immerse the audience in spectacle. Finally, this chapter looks at the impact of digital technologies in shaping the spectacular effects of historical films since the late 1990s.

Chapter 7 considers the cultural value often attributed to historical cinema and examines its apparently privileged status in relation to other Hollywood genres. Historical films have often performed a public relations role for the film industry, particularly during the 1930s as the film industry came under pressure due to concerns over its moral standards, and the cultural achievements of the genre have frequently been acknowledged in Academy Awards ceremonies over the years. Historical cinema is also unusual in its consistent association with educational practice. However, this chapter examines the ways in which the discourses of prestige, moral respectability, and intellectual elevation attached to historical cinema have been disputed, especially in contexts beyond the control of the film industry. In particular, this chapter examines criticisms levelled against historical films by educators and intellectual film critics, and its entanglements with film censorship and patriotic sentiments in foreign countries.

Finally, in my conclusion, I examine the role played by professional historians

in the production and promotion of historical films. It has become relatively common for modern films to foreground the contributions of academic historians in their production, but historians have in fact been involved in the film industry for many decades. In recent years the producers of historical films have also called on historians to provide evaluative commentaries for inclusion in home media packages. Nevertheless, accounts written by historians who have worked as advisors on Hollywood films create an inconclusive picture of their working conditions and the extent of their practical influence. Suspicions have also been raised about the extent to which historians have been used as a means to add legitimacy or to deflect criticism from the films at hand. This conclusion addresses these conflicting accounts in order to arrive at a fuller understanding of the relationship articulated between historical film production, history as an academic practice, and the past in general.

1

What is historical cinema?

Approaches to genre

In the study of film, a genre has conventionally been understood as a group of films unified by a recognizable repertoire of textual practices—plot, setting, character, iconography, music, narrative form, performance style, etc.—around which their production, marketing, and consumption can be efficiently organized.[1] Once this system of conventions has been identified, according to this line of thinking, a critic is better able to understand not only a film's commercial context but also the way it functions within a much larger body of work. For this reason, much writing about cinema has been concerned with placing films in genre categories and with debating the boundaries between these categories. According to Richard Maltby,

> Genre criticism usually identifies up to eight genres in Hollywood feature film production. The western, the comedy, the musical and the war movie are four uncontested categories. Different critics will then argue the relative independent merits of at least one of the thriller and the crime or gangster movie, and list the horror movie and science fiction as either one or two additional genres.[2]

As this suggests, the process of identifying genres is much less precise or unanimous than many writers have been prepared to admit. Moreover, much writing on genre has been based on a kind of reasoning which Andrew Tudor describes as the 'empiricist dilemma':

> To take a genre such as the western, analyze it, and list its principal characteristics is to beg the question that we must first isolate the body

[1] Christine Gledhill, "History of Genre Criticism" in Pam Cook (ed.), *The Cinema Book* (London: BFI, 1999), 137.
[2] Richard Maltby, *Hollywood Cinema* (London: Blackwell, 2nd edn, 2003), 85.

of films that are westerns. But they can only be isolated on the basis of the 'principal characteristics', which can only be discovered from the films once they have been isolated.[3]

In other words, critics tend to select a group of films which they suppose belong to the same genre, and then work backwards to define the genre based on the characteristics that the films share, possibly overlooking information which does not confirm their preconceptions. In doing so, they simply reproduce the initial assumptions that led them to choose these films in the first place.[4]

These problems become even more acute in the case of films whose textual practices are harder to pin down. It may be difficult to arrive at precise definitions for Maltby's four 'uncontested categories,' but telling them apart is usually straightforward. If a couple break off from their date to sing a duet, for example, you can be reasonably certain you are watching a musical. But what about historical films? Do the textual practices of the genre give it the kind of formal unity which critics have identified in the western? Ginette Vincendeau's comments about the genre status of 'heritage' cinema might also apply to the historical film:

> Except for the presence of period costume, they are neither defined by a unified iconography (unlike the thriller and the western), nor a type of narrative (unlike the romance or the musical), nor an affect (unlike horror, melodrama and comedy).[5]

Instead of presenting a broadly cohesive set of textual features, historical films exhibit a massive variance in iconography, narrative style, setting, plot, and character types. Simply being 'in the past' cannot be regarded as a coherent textual characteristic in itself. Moreover, the simple fact that 'the past' refers equally to any point in time between the ancient world and the preceding moment suggests a potential range of iconographies far larger than any other genre. Any common ground occupied by films set in the past is at best tenuous, at least in comparison to more conventional genres.

It is also worth pointing out that the term 'historical film' has barely featured in many of the standard, single-volume surveys of Hollywood genres, including Thomas Schatz's *Hollywood Genres: Formulas, Filmmaking, and the Studio System* (1981), Nick Browne's *Refiguring American Film*

[3] Andrew Tudor, *Theories of Film* (London: Secker & Warburg, 1975), 135–8.
[4] Jason Mittell, "A Cultural Approach to Television Genre Theory," *Cinema Journal*, 40/3 (2001): 22.
[5] Ginette Vincendeau, "Introduction" in Vincendeau (ed.), *Film/Literature/Heritage: A Sight and Sound Reader* (London: BFI, 2001), xviii.

Genres (1998), Rick Altman's *Film/Genre* (1999), Steve Neale's *Genre and Contemporary Hollywood* (2000), and Barry Langford's *Film Genre: Hollywood and Beyond* (2005). And yet the term 'historical film' is strongly represented in film scholarship. Many books have been dedicated to the subject in the past ten years alone, including Robert Burgoyne's *The Hollywood Historical Film* (2008), David Eldridge's *Hollywood's History Films* (2006), J. E. Smyth's *Reconstructing American Historical Cinema* (2006), and James Chapman's *Past and Present: National Identity and the British Historical Film* (2005). There is also plenty of evidence to suggest that term 'historical film' has considerable currency outside the academy. The vast online databases operated by commercial companies provide useful examples. LoveFilm, Europe's largest DVD rental company, allows subscribers to browse films and television shows within 20 broad categories which they identify as 'genres.' In an indication of the overlapping nature of such categorization, most titles are listed in more than one genre, and 'historical' films are listed as a sub-category of three separate genres: 'Action/Adventure,' 'Drama,' and 'Romance'. The practices of online retailer Amazon are similar: 'Historical' is a sub-category of both 'Action & Adventure' and 'Drama.' The Internet Movie Database (IMDb) is owned by Amazon, but it uses a slightly different structure to organize its 1.6 million entries, listing 'History' as one of their 26 'genre' categories. Unlike LoveFilm and Amazon, this category also features a large number of non-fiction titles, mostly television documentaries. The motives and methods used by academic writers and commercial websites are clearly different, but they underline the strong cultural presence of the historical film. Evidently, a gap exists between conventional theoretical approaches to genre on the one hand, and the operation of genre categories in popular and academic practice on the other. It seems, therefore, that conventional ideas about genre are of limited use in understanding the origins and development of historical film.

However, recent work on the function and meaning of film genres has questioned some of the tenets of conventional genre criticism, in particular the notion that genres are characterized by a historically stable and unified system of textual practices. Steve Neale has suggested that genres need to be seen as 'ubiquitous, multifaceted phenomena rather than one-dimensional entities' and that they reside not only in films themselves but also in the expectations which audiences bring with them when they watch films.[6] He also emphasizes the institutional role played by film industries in the creation and perpetuation of these classifications, citing its ability to guide 'the meaning, application, and use of generic terms' in an 'inter-textual relay' of publicity, promotion and reception discourses.[7] In a similar way, Rick Altman

[6] Steve Neale, *Genre and Hollywood* (London: Routledge, 2000), 26.
[7] Ibid., 2.

has suggested that genre should be understood 'not as a quality of texts but as a by-product of discursive activity.'[8] Like Neale, Altman is keen to identify these discourses with the activities of the film industry and its strategy of producing and marketing new films by promoting their likeness to existing, commercially proven properties.[9] In this way, any genre unity that a body of films is perceived to possess at a given time is less the consequence of a filmmaker's adherence to a set of predetermined, transhistorical conventions and more the short-term industry practice of recycling the textual features of popular films in order to emulate their success.

These approaches also lead to a more detailed consideration of the connection between genre and industrial practice. Maltby has argued that it is misleading to think of genre as a principle governing Hollywood's output, arguing that the industry 'categorizes its product by production size and the audience sector to whom it is primarily appealing' and that the resulting production schedules are organized 'around cycles and sequels rather than genres as such.'[10] This notion is developed further in the work of Tino Balio, who dispenses with the term genre entirely in his assessment of Hollywood production in the 1930s.[11] Balio suggests that in order to minimize financial risk, Hollywood production of the period tended to be planned on a seasonal basis and was essentially imitative: a film becomes popular, its textual features are quickly reworked by other films, and these new films are released and promoted in a way that stresses their closeness to the original. The cycle continues until it ceases to be profitable.[12] In some cases the replicated textual features correspond to traditional critical notions of film adhering to genre templates, but the replication can also be less predictable. For example, Neale notes that the success of Grand Hotel (1933) generated a cycle of films that transposed its unusual narrative structure to a variety of completely unrelated settings.[13] Missing from this approach, perhaps, is a means of accounting for the appearance of films which initiate new cycles. Nevertheless, Balio's approach provides a more empirically grounded model for explaining and analyzing textual similarities between films over time than the conventionally defined notion of genre as a critical category, with its insistence on the transcendental unity of certain film types.

Recent work by Jason Mittell on television also enlarges the understanding of genre, particularly the role played by audiences in the creation of categories.

[8] Rick Altman, Film/Genre (London: BFI. 1998), 120.
[9] Ibid., 122.
[10] Maltby, Hollywood Cinema, 130.
[11] Tino Balio, Grand Design: Hollywood as a Modern Business Enterprise, 1930–39 (New York: Scribner's, 1993), 130.
[12] Ibid., 101.
[13] Neale, Genre and Hollywood, 238.

Much more than Neale, Altman, Maltby, and Balio, Mittell has proposed 'looking beyond the text as the centre of genre' and instead focusing on the 'complex interrelations among texts, industries, audiences and historical contexts.'[14] He argues that media texts (including films) do not produce their own categorization, as conventional genre theory has suggested, but rather are categorized as a result of discursive practices.[15] That is, genre is not an intrinsic property of any given film or group of films, no matter how closely it might appear to follow commonly understood genre conventions. Instead, genre categories are applied to films externally as they circulate through culture, generating further texts as they are marketed, reviewed, consumed, and discussed. For this reason, Mittell describes genre as emerging from the 'intertextual relations between multiple texts.'[16] Rather than the source of genre discourse, the film to which the genre category is applied is in fact a constituent part of a broader network of texts which in turn generate additional discourses. It might seem that to describe a film simply as 'a site of discursive practice' is to reduce its complexity, artistic value, and its centrality to the filmgoing experience. But at the same time, Mittell's arguments are significant in the stress they place on cultural factors, particularly audience reception, in the production and circulation of genre categories. It is certainly valuable and necessary to identify the production of film genres as part of an industrial process, but they can also be placed in a broader context as part of the cultural process in which films interact with the viewing public.

Due to the difficulties entailed by establishing its precise textual characteristics, the historical film has often had an awkward, ambiguous relationship to the concept of genre. However, by expanding the study of genre beyond the textual boundaries of individual films to include industrial and cultural practices, the historical film emerges as a viable object of study. The historical film is not a rigid, transhistorical essence possessing textual conventions which have held fast amid cultural and social change. No genre could be, no matter how familiar its conventions might seem at any given time. Instead, and like all other genre categories, the historical film is a series of small-scale, historically specific film cycles which emerge from particular commercial contexts and are shaped by larger cultural forces. In order to make the step between this rather general concept of genre and the specific properties which characterize the historical film, it is useful to examine some of the ways in which different writers have arrived at their own definitions.

[14] Mittell, 7.
[15] Ibid., 8.
[16] Ibid., 6.

Defining the historical film

The most substantial work on the connections between historical film and genre has been written by Robert Brent Toplin, Robert Burgoyne, and Leger Grindon. In *Reel History: In Defense of Hollywood* (2002), Toplin makes an extended effort to define what he calls 'cinematic history' as a genre using a conventional, textual approach. Although he notes cinematic history's 'great diversity in terms of settings, plots and characters' by comparison with other genres, he states that 'there are some familiar practices in the craft.'[17] He describes and discusses nine such practices, noting that not all historical films adhere to every single one:

1 Cinematic history simplifies historical evidence and excludes many details.
2 Cinematic history appears in three acts featuring exposition, complication and resolution.
3 Cinematic history offers partisan views of the past, clearly identifying heroes and villains.
4 Cinematic history portrays morally uplifting stories about struggles between Davids and Goliaths.
5 Cinematic history simplifies plots by featuring only a few representative characters.
6 Cinematic history speaks to the present.
7 Cinematic history frequently injects romance into its stories, even when amorous affairs are not central to these historical events.
8 Cinematic history communicates a feeling for the past through attention to details of an earlier age.
9 Cinematic history often communicates as powerfully in images and sounds as in words.[18]

Several problems in this catalogue of textual features should be clear at once. The idea that cinematic history communicates using images and sounds as well as words seems to be a description of cinema's most fundamental features. In addition, cinematic history may well use the three-act structure, but so do almost all films produced in Hollywood: the practice is ingrained in screenwriting technique. The idea of using films to tell 'morally uplifting' stories in which audiences are encouraged to root for an underdog is also common to a large proportion of Hollywood's output over the past century.

[17] Robert Brent Toplin, *Reel History: In Defense of Hollywood* (Lawrence: University of Kansas Press, 2002), 12, 15.
[18] Ibid., 17–50.

Generalizations such as these do not distinguish historical film from any other genre. Toplin's remaining criteria do relate more directly to historical cinema, most particularly to the narrative shape they give to historical events. However, these criteria are established largely to help him to advance the thesis of his book, namely that the apparent scholarly shortcomings of Hollywood historical films should not be judged too harshly. The streamlining of historical events into familiar narrative shapes is acceptable, he argues, because historical films must adhere to the conventions of mainstream filmmaking in order to meet the expediencies of getting audiences into the cinema. For example, films 'cannot deliver a comprehensive assessment of a subject' because 'fact laden dramas can confuse and tire audiences.'[19] For Toplin, genre is a predetermined formula that films must follow in order to connect with audiences. Rather than a fluid system in which films may participate, it is a rigid template that exists independently of the films under discussion. Toplin also gives no account of how these formulas have developed within the film industry over time, nor does he engage with the ways different audiences have responded to the films in question.

Leger Grindon and Robert Burgoyne also take a largely textual approach to genre in historical cinema, although their approaches offer greater nuance. In *Shadows on the Past: Studies in the Historical Fiction Film*, Grindon suggests that historical films are characterized by two contrasting modes of representation:

> The recurring generic figures of the historical fiction film are the romance and the spectacle – the one emphasizing personal experience; the other, public life. Each film negotiates the relations between the individual and society and expresses the balance between personal and the extrapersonal forces through the treatment of the two generic components. In addressing these issues every film draws on contemporary social conditions and, in portraying history, depicts the historical circumstances from which the film arises.[20]

He goes on to examine both 'generic figures' in turn, arguing that as they work in counterpoint to each other: the relationship between romance and spectacle 'expresses the links between the individual, nature and society, and serves as a vehicle for historical explanation.'[21] It seems reasonable to suppose that historical films of all types do have themes in common, but it

[19] Ibid., 17–18.
[20] Leger Grindon, *Shadows on the Past: Studies in the Historical Fiction Film* (Philadelphia: Temple University Press, 1994), 10.
[21] Ibid., 15.

can also be argued that they are in no way unique to films set in the past. For this reason, Grindon's definition does not serve to distinguish historical filmmaking from other genres. In *The Hollywood Historical Film*, Robert Burgoyne suggests that the historical film consists of five 'subtypes': the war film, the epic film, the biographical film, the metahistorical film, and the topical historical film. Three of these terms are relatively familiar, but the final two are not. The metahistorical film 'offers embedded or explicit critiques of the way history is conventionally represented' while topical films focus on specific incidents or periods rather than on 'grand narratives.'[22] Clearly, there is much overlap between these subtypes. For example, Burgoyne identifies *Lawrence of Arabia* (1962) as a biographical film, but it might easily be labeled an epic or even a war film.[23] Burgoyne suggests that these subcategories find their coherence as historical films through a single strategy:

> What brings these different orders of representation... into the same discursive framework is the concept of reenactment, the act of imaginative re-creation that allows the spectator to imagine that they are 'witnessing again' the events of the past. The principle of re-enactment constitutes the semantic register of the genre. The historical film conveys its messages about the world by re-enacting the past, and it is the idea of reenactment that provides its semantic ground.[24]

This focus on 're-enactment' also enables Burgoyne to describe the relationship between historical cinema and the present: 're-enactment implies that the event being revisited actually did occur, but it also implies that this event still has meaning for us in the present.'[25] But as much as historical films can be seen as a process of re-enactment, this criterion seems rather too abstract to unify and distinguish such a broad range of films. Both Leger and Burgoyne raise valuable ideas in their arguments regarding historical cinema and genre, but their approaches do not pin down specific or unique characteristics which might be used to identify the genre.

Other writers have attempted to define historical cinema by distinguishing it from other types of films set in the past. In particular, it is common to mark a division between 'historical films' and 'costume dramas.' On the face of it, some simple differences between these terms may be observed. According to Sue Harper,

[22] Robert Burgoyne, *The Hollywood Historical Film* (Oxford: Blackwell, 2008), 43–6.
[23] Ibid., 42.
[24] Ibid., 7.
[25] Ibid., 11.

Although they both reinforce the act of social remembering, costume dramas and historical films are different from each other. Historical films deal with real people or events: Henry VIII, the Battle of Waterloo, Lady Hamilton. Costume film uses the mythic and symbolic aspects of the past as a means of providing pleasure, rather than instruction.[26]

A similar distinction has been made in much writing about historical cinema, and the idea can be traced back to Hollywood's infancy.[27] In 1922 C. A. Lejeune declared, "Historical films... fall into two classes – the pure romance, with fictitious figures set in a background of times not our own, and the story woven around events peopled with characters who have lived and been famous in their day."[28]

But although the term 'costume drama' connotes the fanciful narratives of romantic fiction and the term 'historical film' implies a firm connection to historical fact, the black-and-white distinction between these categories is at best problematic. Any film that dramatizes or restages the past from the perspective of the present necessarily strikes a balance between fact and fiction, regardless of whether or not it purports to be depicting events that actually occurred. As Pierre Sorlin puts it, 'there is no "historical film" that is not fiction first: how indeed could the past be filmed live? Nor any that, however serious its documentation, does not fictionalise the most referenced historical argument.'[29] Moreover, as recent historical theorists such as Hayden White has argued, any attempt to translate information about the past into a historical narrative inevitably involves rhetorical conventions that produce a form of fiction. In Alun Munslow's summary: 'Just like written history, film history is a fictive, genre-based, heavily authored, factually selective, ideologically driven, condensed, emplotted, targeted and theorised representation.'[30] In the same way that no historical film can be entirely factual, no costume drama can be entirely fictional. For example, Gone with the Wind (1939) may tell the story of people who never existed, but the film makes frequent and largely accurate reference to the historical period in which its drama unfolds.

[26] Sue Harper, "Bonnie Prince Charlie Revisited: British Costume Film in the 1950s" in Robert Murphy (ed.), The British Cinema Book (London: BFI, 1997), 133.

[27] See, for example, Marcia Landy, British Genres: Cinema and Society, 1930–1960 (Princeton: Princeton University Press, 1991), 55; Robert Rosenstone, Revisioning History: Contemporary Filmmakers and the Construction of a New Past (Princeton: Princeton University Press, 1995), 7; James Chapman, Past and Present: National Identity and the British Historical Film (London: I. B. Tauris, 2005), 2.

[28] C. A. Lejeune, "The Week on Screen: Out of the Past," Manchester Guardian, July 1, 1922, 9.

[29] Sorlin, 42.

[30] Alun Munslow, The Routledge Companion to Historical Studies (London: Routledge, 2005), 111. See also Hayden White, Tropics of Discourse: Essays in Cultural Criticism (Baltimore: Johns Hopkins University Press, 1978).

Even films like *Pirates of the Caribbean* (2003) and *Mary Poppins* (1964), which are far more vague and cavalier about their historical settings and which appear to make no serious bid for period authenticity, depend to a certain degree on historically factual elements: no electric lights are visible, for example, costumes are broadly consistent with the era, the vocabulary eschews recognizably modern expressions, and norms of social conduct differ noticeably from the present. Were historical signifiers such as these omitted, the films might not be recognized as being set in the past at all.

The tendency to define the historical film in relation to costume drama also implies a kind of value judgment. If a historical film is defined primarily as a representation of historical data, does this not also suggest that a *good* historical film is one that represents such data well? Grindon, for example, establishes the ground for his study of historical films by making a distinction between films which 'have a meaningful relationship to historical events' and 'the costume picture that adopts a period setting but fails to engage historical issues.'[31] Marnie Hughes-Warrington has suggested that use of the term 'historical film' may in itself be regarded as 'an act of approval.'[32] In contrast, the term 'costume drama' has often been used in a pejorative sense, denoting a lack of seriousness relative to the historical film, and reflecting anxieties about what Pam Cook calls the 'feminisation of history.'[33]

Some critics have taken the problematic distinction between fact and fiction on board to produce broader, more inclusive definitions of the historical film. Natalie Zemon Davis has suggested that 'history films' are 'those having as their central plot documentable events, such as a person's life or war or revolution, and those with a fictional plot but with a historical setting intrinsic to the action.'[34] Given that a 'historical setting' of some sort is a necessary condition for any representation of the past, regardless of the degree to which this setting is overlaid with fictional elements and the extent to which the film concerns itself with dramatizing processes of historical change, both types may be considered to be 'historical.' Working along similar lines, Philip Rosen has suggested that:

The 'historical film' can be defined here as a certain conjunction of regimes of narrative and profilmic: in its purest form, it consists of a 'true story' (or elements of a 'true story') plus enough profilmic detail to designate a

[31] Grindon, 2.

[32] Marnie Hughes-Warrington, *History Goes to the Movies: Studying History on Film* (Abingdon: Routledge, 2007), 37.

[33] Pam Cook, *Fashioning the Nation: Costume and Identity in British Cinema* (London: BFI, 1997), 77.

[34] Natalie Zemon Davis, "'Any Resemblance to Persons Living or Dead': Film and the Challenge of Authenticity," *Yale Review*, 76 (1987): 459.

period recognizable as significantly 'historical', that is, signifying a generally accepted minimum of referential pastness.[35]

In other words, historical films combine a degree of period *mise en scène* with a narrative that describes the past. In this way, Rosen accommodates films which place a high value on accurate reference to the past, and those which choose to emphasize other elements. Again, both types are historical, regardless of how 'well' they are perceived to represent history. David Eldridge has recently taken a similar approach, stating simply that historical films are 'all films which utilise ideas about the past [and] contain and reflect ideas about "history"'. As evidence, he notes the capacity of fictional western narratives to 'depict and interrogate' the history of the American frontier despite frequently telling fictional stories.[36] Eldridge also seeks to rehabilitate films which appear to be indifferent to historical accuracy, suggesting that 'the very simple fact that the majority of films set in the past *do not* take history seriously' may in fact be significant in itself.[37]

The definitions suggested by Davis, Rosen, and Eldridge allow historical films to be approached not simply in terms of their fidelity or otherwise to historical data, nor as a rigid set of conventions with a textual coherence comparable to (for example) the western or the musical, but rather as part of the longstanding practice of engaging with representations of the past. This remains, however, a primarily textual definition and thus cannot account for the ways in which genre categories are shaped by audience and production practices.

Engaging with the past

Drawing on the work above, as well as the broader approaches to genre which I have outlined, I will define historical cinema as films which engage with history or which in some way construct a relationship to the past. However, in order to account for the impact of production and audience practices on genres, I will argue that these relationships to the past are created not only by the films themselves but also by cultural contexts in which they operate and the discourses that they generate. Following Eldridge, Rosen, and Davis, it also seems both legitimate and appropriate to extend this definition to films regardless of whether or not they purport to

[35] Philip Rosen, *Change Mummified: Cinema, Historicity, Theory* (Minneapolis: University of Minnesota Press, 2001), 178.
[36] David Eldridge, *Hollywood's History Films* (London, I. B. Tauris, 2006), 5.
[37] Ibid., 4.

deal with 'real' people and events. Of course, this throws open the doors to a huge and diverse range of films, including many that might also be identified with other well-established genres such as the western and the war film. But like other film genres, the historical film is not a unified set of textual practices and it frequently overlaps with other genre categories. There is also no reason to insist that films should be identified with just one genre. To use Jacques Derrida's term, films frequently 'participate' in more than one.[38] The multiple categorizations featured in commercial databases such as the IMDb might be seen as practical evidence for this: as Hughes-Warrington has noted, those involved with the selling of films 'have little to gain from tying a work down to a single element.'[39] It also seems illogical to suggest the historical film somehow overrules related genre labels such as the costume film or the biopic, or equally that these are 'subgenres' attached to or descended from an overarching historical film 'master-genre.' Other genre categories may intersect with the historical film, but they also have discursive characteristics of their own.

In the following sections I will examine some of the specific ways in which films construct relationships to the past and may thus be identified with the historical film genre. First, I will examine textual engagements with the past: engagements which are made within films themselves. Secondly I will look at extra-textual engagements to the past: engagements which are made within the film's cultural context. Of course, these processes are not mutually exclusive and any given historical film is likely to engage with the past in both ways, to a greater or lesser degree. It should also be pointed out that these engagements to the past can be weak as well as strong: some historical films are heavily associated with historical discourse—either by their textual referentiality, by their generation of extra-textual discourse, or by both—and some historical films are not. I would suggest that all should be considered to be historical films.

Textual engagements

There are numerous methods available to filmmakers seeking to form relation-ships between films and the past on a textual level. Indeed, any element of a film's *mise en scène* or narrative which serves to locate the drama in a bygone era, from the exhibition of period costume to an allusion to a historical event occurring off screen, can be considered part of a film's textual relationship to the past. However, for the purposes of illustration, I would like to focus on a

[38] Jacques Derrida, "The Law of Genre" trans. Avital Ronell, *Critical Inquiry*, 7/1 (1980): 65.
[39] Hughes-Warrington, 38.

more specific strategy: reference to the past through words printed on the screen or spoken in voiceover as historical films begin and close. Historical films using prologue and epilogue text are probably in the minority overall, but the practice has nevertheless become a significant trope of the genre. Although text of this kind can also be observed in documentaries, it is more or less unique among dramatic films. Only a film set in the past has the need or the ability to form connections with events beyond its own narrative world. Typically, these prologues and epilogues provide simple factual information (dates, places, biographical details) to either contextualize the drama in the case of the former, or to bring the historical narrative to a close in the case of the latter. In their espousal of the unadorned written or spoken word over visual representation, these prologues and epilogues can be interpreted as narrative transitions which attempt to stitch the events depicted in the main body of the film to written accounts of history. In the process, they perhaps indicate some of the ways in which written histories are valued as more trust-worthy and authentic than visual representations of history.

In older historical films, prologue text serves largely to establish a time and a place for the action, and the practice can be traced from the scene-setting 'intertitles' widely used in silent cinema. For example, *The Crusades* (1935) opens with text printed over the image of a minaret: 'The year 1187 AD. The Saracens of Asia swept over Jerusalem and the Holy Land, crushing the Christians to death or slavery.' Similarly, in *The Private Lives of Elizabeth and Essex* (1939), we read, 'London – 1596. After defeating the Spanish forces at Cadiz, Robert Devereux, Earl of Essex marches in Triumph toward Whitehall Palace where Queen Elizabeth awaits him.' More than simply establishing a context for these narratives, these present-tense statements also establish their tone and their attitudes to the past. However, these conventions were flexible, particularly in films depicting recent history. As George F. Custen has shown, biopics of the 1950s were occasionally introduced by written state-ments attributed to the subject or the author of the film. *Somebody Up There Likes Me* (1956) features a title card which reads 'This is the way I remember it, definitely,' signed by the boxer Rocky Graziano, while *I Want to Live!* (1958) is 'signed' at both the beginning and the end by the journalist from whose work the film was adapted.[40] In both cases, the signature serves more as an assurance of authenticity than a statement of authorship. In a similar, although much more unusual vein, *Mission to Moscow* (1943) opens with an introduction by the film's biographical subject, Joseph E. Davies, who speaks in person directly to camera. Following the credits, a second prologue is delivered by the actor playing Davies, also delivered to camera in a remarkably

[40] George F. Custen, *Bio/Pics: How Hollywood Constructed Public History* (New Brunswick: Rutgers University Press, 1992), 55.

similar manner. In this way, *Mission to Moscow* not only establishes its own authenticity, it also bridges the gap between fact and fiction, allowing the audience to measure the performance of the 'real' Davies against his dramatic incarnation.

In many of the ancient world epics popular during the 1950s and 1960s prologues were spoken by an offscreen narrator, always male and typically with a sonorous English accent. In addition to establishing the setting for the action, these spoken prologues frequently established the tone of the drama to follow by adopting mock-archaic vocabulary and phrasing. Thus, in *Knights of the Round Table* (1953), the prologue narrator announces,

> It befell in the old days that Rome, at need, withdrew her legions from England. Then stood the realm in great darkness and danger, for every overlord held rule in his own tower and fought with fire and sword against his fellow.

Similarly, *Cleopatra* (1963) begins with the words, 'And so it fell out that at Pharsalia the great might and manhood of Rome met in bloody civil war, and Caesar's legions destroyed those of the great Pompey.' In addition to these contextual and atmospheric functions, the spoken prologues of epics also state in explicit terms the broader historical lessons to be drawn from the film. In *Quo Vadis* (1951) the prologue asserts that the film will depict the 'immortal conflict' between Christianity and Rome, while the prologue of *Spartacus* (1960) contextualizes the film in terms of the 'new faith called Christianity' which is 'destined to overthrow the pagan tyranny of Rome.' Perhaps most remarkably, the prologue to *The Fall of the Roman Empire* (1964) adopts the rhetorical style of academic historical writing:

> Two of the greatest problems in history are how to account for the rise of Rome and how to account for her fall. We may come nearer to under-standing the truth if we remember that the fall of Rome, like her rise, had not one cause but many and was not an event but a process spread over three hundred years.[41]

In this way, the film does not simply establish the tone of its engagement with the past, it proposes a method for addressing 'problems in history' and thus allows the audience to 'understand the truth'.

[41] The words were in fact based on writing by the film's historical consultant, Will Durrant. Allen M. Ward, "History, Ancient and Modern in *The Fall of the Roman Empire*" in Martin M. Winkler (ed.), *The Fall of the Roman Empire: Film and History* (London: Blackwell, 2009), 57.

In more recent films, prologues have come to serve additional purposes. Text is often used, for example, to assert the truth status of the historical narrative at its very outset. For example, *Dog Day Afternoon* (1975) begins with the words, 'What you are about to see is true – it happened in Brooklyn, New York on August 22, 1972.' The statement is informal but emphatic, and apparently supported by its specific reference to time and place. A similar insistence is made as *Missing* (1982) begins: 'This film is based on a true story. The incidents and facts are documented.' Not only is the story true, but its truth can be proven, although the nature of the supporting documentation is unspecified. As Custen notes, statements such as these also function as a reminder that most films made in Hollywood are *not* meant to be taken at face value as true.[42] However, these formulaic truth claims have rapidly become clichés, and the trope soon came to be used ironically. The phrase 'this is a true story,' printed in block red capitals, is used in the prologue to *Walker* (1987) as a sardonic counterpoint to the spaghetti western pastiche which it interrupts. In this way, the film establishes an ironic contrast between conventional approaches to the past and its own, more inventive strategies. Similarly, *Fargo* (1996) is introduced as 'a true story... told exactly as it occurred' despite, as the directors later admitted, being nothing of the sort.[43] Through its overuse in historical films, particularly biopics and films based on the recent past, the 'true story' avowal became an easily subverted convention rather than a credible guarantee of historical status.

It is perhaps for this reason that more recent historical films have used prologue text to assert their truth status in alternate ways. In particular, modern films have attempted to establish a direct relationship to the process of historical research, rather than simply to 'truth.' For example, in *Glory* (1989) a long title card introduces Robert Gould Shaw, the hero of the film, and states that the regular letters he wrote home 'are collected in the Houghton library of Harvard University.' The film thus signals its own authenticity by invoking the documents from which it was apparently adapted. The reference to Harvard University also invokes academic prestige and gives the claim a plausible specificity. A similar reference to historical research is made in the prologue of *King Arthur* (2004):

> Historians agree that the classical 15th century tale of King Arthur and his Knights rose from a real hero who lived a thousand years earlier in a period often called the Dark Ages. Recently discovered archaeological evidence sheds light on his true identity.

[42] Custen, 51.
[43] David Sterritt, "*Fargo* in Context: The Middle of Nowhere?" in William Luhr (ed.), *The Cohen Brothers Fargo* (Cambridge: Cambridge University Press, 2004), 18–19.

This apparent consensus of historians, plus unspecified 'archaeological evidence', substantiates the drama which follows, situating it as revisionist history rather than genre-bound fiction.[44] Other films have been more circumspect about their relationship to historical processes. *Nixon* (1995) is introduced with a prologue that reads almost as a disclaimer: 'This film is a dramatic interpretation of events and characters based on public sources and an incomplete historical record. Some scenes and events are presented as composites or have been hypothesized or condensed.' This uncharacteristic transparency is perhaps disingenuous, however; acknowledging shortcomings might be interpreted as a means to emphasize its diligent historical practice. In *Braveheart* (1995) the purpose of the disclaimer (delivered as a voiceover rather than in print) seems to be political: 'I will tell you of William Wallace. Historians from England will say I'm a liar, but history is written by those who've hanged heroes.' The historical context is emphasized once again, but the anti-English rhetoric of the unseen narrator pre-emptively evades any criticism of the film's historical content.

Prologue text has a long history, but epilogue text in historical films was not widely seen until the 1970s. The epilogue of *Serpico* (1973) is printed over an image of the film's hero and states that he 'resigned from the police department on June 1972' and is 'now living somewhere in Switzerland.' In *Dog Day Afternoon* (1975) the text following the film's violent climax tersely reveals the present whereabouts of the principal characters. By the 1980s, the use of epilogue text was familiar enough to be parodied. Woody Allen's *Zelig* (1983) concludes with mock biographical updates for the film's fictional characters, including a gag concerning Zelig's annoyance about dying before he had finished *Moby Dick*. Since the 1990s its use in American historical films has become widespread. Indeed, its very absence can make a point of its own: the George Bush biopic *W* (2008) ends not with a text account of Bush's final years in office (perhaps this would have been rather too familiar for a 2008 audience) but with a card that states, pointedly, 'The End.' Recent epilogue text has frequently been more elaborate, however. For example, in *Quiz Show* (1994) the prologue text runs over five separate cards and reports on five of the main characters from the film. In what may be a record, the epilogue for *American Gangster* (2007) requires nine cards and takes up more than a minute of screen time. Some epilogues present information which seems to be of marginal interest and relevance to the preceding drama. The first of two epilogue cards used in *Frost/Nixon* (2008) states that Frost's 'annual summer party

[44] The *King Arthur* prologue has in fact caused some consternation among medieval historians. According to Alan Lupack, 'few historians agree on anything about Arthur, certainly not his identity.' "Review," *Arthuriana*, 14/3 (2004): 123.

is a firm fixture on the British social calendar,' even though no such event is referred to in the film.

But despite this abundance of narrative detail, the visual style of epilogue text and the tone of the language they use have remained austere. The text is typically printed in a small white font, usually against a plain black background but sometimes over moving images, and the cards typically transition at a measured pace. The solemn effect created by this remarkably uniform aesthetic is matched by a tendency for uncomplicated, formal, declarative language. For example, the epilogue of *Hotel Rwanda* (2004) includes a characteristically straightforward resolution to the events presented in the film's narrative, stating, 'the genocide ended in late June 1994, when the Tutsi rebels drove the Hutu army and the Interhamwe militia across the border into the Congo.' This composed, factual tone adds emotional impact to the final card, which reads, 'They left behind almost one million corpses.' As sombre music plays, the card is held on the screen for longer than would typically be required to read it. The solemnity of much epilogue text is also well suited to the process of memorialization, an act which many historical films are concerned with. The epilogue text of the Vietnam film *We Were Soldiers* (2002) ends with a lengthy roll-call of American servicemen killed in the battle represented in the film, while *World Trade Center* (2006) concludes with a scrolling register of Port Authority Police who were lost in the terrorist attack. This memorialization process can be selective, however: *Black Hawk Down* (2001) concludes with an epilogue stating that over 1000 Somalis and 19 American soldiers were killed in the raid presented in the film, but chooses to list only the names of the American dead.

In historical films dealing with less weighty material, the solemnity of epilogue text can also serve to pass judgment on historical characters represented in the drama and to suggest that unsettled scores have been resolved in posterity. For example, the epilogue of *The People vs. Larry Flynt* (1996) reveals that Charles Keating, one of the drama's villains, was subsequently disgraced in a savings and loans scandal which 'cost American taxpayers over 2 billion dollars.' The event is not directly related to Keating's role in the preceding narrative, but it is called on to vindicate the film's portrayal of him. Rather more blatantly, the epilogue of *The Damned United* (2009) is used to resolve matters left unfinished at the end of the film's main narrative: the nominal antagonist 'failed as England manager' and was left in 'soccer wilderness,' while the film's hero 'remains the greatest manager the England team never had.' An element of judgment-passing might also be detected in the epilogue to *The Social Network* (2010). As the protagonist sits alone, waiting to be 'friended' by the woman who jilted him at the beginning of the film, the Beatles' caustic 'Baby You're a Rich Man' plays on the soundtrack and the text reads, 'Mark Zuckerberg is the youngest billionaire in the world.'

The future achievement celebrated in the text is thus undercut by the personal isolation Zuckerberg is shown to experience in the film's narrative present.

The majority of epilogues and prologues work in a separate register to the main body of the films they belong to, emphasizing words over images, and thus standing outside the principal narrative even as they extend its temporal scope. At the same time, the epilogues of some historical films do incorporate significant visual elements into their narratives. For example, *The Last King of Scotland* (2006) concludes with fairly conventional text narrating the downfall of Idi Amin, the film's subject. However, the epilogue illustrates the text not with dramatized images but with archival newsreel. The final two cards, which describe Amin's death, are printed over footage of the 'real,' historical Amin rather than the film's dramatic representation of him. This newsreel footage of Amin becomes the film's closing image. In this way, the epilogue of *The Last King of Scotland* works to close the gap between the film's representation of historical events and the historical events themselves, underlining the authenticity of the drama by bringing it into line with visual documents of the past. A similar strategy can be seen in *Milk* (2008), which illustrates its epilogue text with photographs and footage of seven figures represented in the drama. However, these documents are intercut with images of the actors playing the characters, allowing the audience to compare 'real' people with their dramatic representations in a manner similar to *Mission to Moscow* (1943). In many cases the transition from actors to historical figures in *Milk* is seamless: the physical resemblance of the actors (heightened by matching wardrobe and hair) is often striking, and the editing attempts to graphically match the dramatized images with the documentary footage. Like *The Last King of Scotland*, this epilogue makes a transition from dramatic representation to historical 'reality' which underlines the film's apparent authenticity. But by integrating these two sets of images in a way which emphasizes their superficial similarities rather than their differences, the epilogue of *Milk* can be seen as an attempt to bridge the gap between reality and the act of representing it.

The epilogues of *Malcolm X* (1992) and *Schindler's List* (1993) depart even further from the text-based conventions established in other historical films. The epilogue of *Malcolm X* occurs after the assassination of the film's hero and begins with a montage of newsreel footage from the civil rights movement, including images of the real Malcolm X and comments from Martin Luther King, Jr. about Malcolm's death. The montage is accompanied by the voice of Ossie Davis, an associate of Malcolm's and a character in the film, reading the eulogy he originally gave at the funeral in 1965. As Davis speaks, the images in the montage transition from 1960s newsreel to modern images of school-children in Harlem and Soweto, who hold pictures of Malcolm and chant his

name. The epilogue continues in the classroom of a Harlem school, where a teacher tells her students that 'Malcolm X is you.' Echoing the climactic scene in *Spartacus*, four children stand up at their desks in turn and declare, direct to camera, 'I'm Malcolm X!' The film cuts to a Soweto classroom where four South African children repeat the same words. In the final scene of the epilogue, the same Soweto classroom is addressed by Nelson Mandela, only recently released from prison at the time of production, who quotes from one of Malcolm's speeches. The epilogue cuts away from Mandela to newsreel footage of Malcolm in time for him to deliver the final line of his speech, and of the film itself: 'by any means necessary.' This remarkably dense epilogue is characterized by a series of rapid substitutions: of dramatic representation for documentary footage, of the mid-1960s for the early 1990s, of Harlem for Soweto, and of *Malcolm X* for Nelson Mandela. In each case, the epilogue attempts first to align the events represented in the film with historical records of the real Malcolm X, and secondly to connect them to a broader history of popular struggle against racial discrimination.

The epilogue of *Schindler's List* is marked by similar shifts in time and space. It begins with conventional text narrating subsequent lives and deaths of the film's two major characters. But a reference to a tree planted in Jerusalem in Oskar Schindler's memory allows the epilogue to transition to Israel, where Schindler was buried. A black-and-white image of Jewish characters exiting a concentration camp in Poland dissolves into a graphically matched color image of modern Jews approaching a cemetery in Israel, and a caption reads 'The Schindler Jews today.' In a sequence lasting almost four minutes, the surviving Schindler Jews (or in some cases their family members) line up with the actors who played them in the film and together they place stones on Schindler's grave. As they approach, their names are printed on the screen, an act of memorialization which also echoes the Nazi census of Jewish refugees which takes place in the very first scene of the film. The final caption reads, 'in memory of the more than six million Jews murdered.' Like *Malcolm X*, this epilogue serves to expand the historical context of the preceding drama—the film is a testament to the victims of the Holocaust as well as the small number of survivors present at Schindler's grave—while also connecting these events to the present. Just as Malcolm X's legacy is shown to be at work in apartheid-era South Africa, the effects of Schindler's actions are shown to resonate in modern Israel. By featuring actors and historical figures side by side, *Schindler's List* also attempts to integrate its dramatic representation with the historical record, demonstrating the film's basis in historical fact and foregrounding the consent and collaboration of holocaust survivors in its representation of them.

Epilogues and prologues are one of many methods available to filmmakers who wish to form a textual relationship with the past. But as I have shown,

the practice is reasonably widespread and it frequently serves to elaborate the terms on which historical films engage with ideas about history. In particular, prologues and epilogues establish the nature of a historical film's relationship to the past: they lay claim to authenticity, assert the truth status of the film, establish its position in relation to historical research, show how scores have been settled in posterity, and memorialize the figures from the past from the point of view of the present. When historical films depart from the text-based format typical of epilogues and prologues, they may also attempt to integrate the drama's visualization of the past with the historical record, blurring the line between representation and reality. Prologues and epilogues in historical films may thus be read as moments of narrative transition, connecting the film to larger historical narratives beyond its diegesis and pointing to a broader sweep of events that extend before and beyond the immediate world of the film. This narrative function is perhaps unique among fictional film genres, and it perhaps points to the intermediary space which the historical film occupies between fiction and non-fiction forms.

Extra-textual engagements

In contrast to the textual engagements illustrated above, the extra-textual engagements which historical films make with the past are not restricted or even necessarily determined by the content of the films in question. Extra-textual engagements are a function of the discourses generated by historical films, and can thus take a huge range of forms. For example, a film's relationship to the past can be established though the descriptive language and imagery used in its promotion and marketing, through its evaluation by professional critics working in the media, or through its discussion among the wider public in public forums such as social networking websites and the 'comments' sections of online news media and blogs. As before, and for the purposes of illustration, I will focus in this section on just one of the ways in which an extra-textual relationship with the past may be constructed: the foregrounding of historical research as a promotional feature in the marketing of historical films.

In his work on the biopic, George Custen observes that the publicity campaigns of many historical films in the 1930s frequently highlighted the research process that supposedly occurred behind the scenes. 'Extravagant research efforts became,' he suggests, 'a way of reassuring consumers that every effort had been expended to bring them true history in the guise of spectacle.'[45] Promotional material often attempted to express this

[45] Custen, 34–5.

extravagance in quantifiable terms, reeling off escalating figures much in the way that film advertising also boasts about the vast sums of money invested in the creation of spectacle. For example, the campaign booklet for *Marie Antoinette* (1938) claimed that production researchers amassed 'a bibliography of 1,538 volumes, gathering 10,615 photographs, paintings and sketches, and mimeographing 5,000 pages of manuscript containing more than 3,000,000 words.'[46] The filmmaker perhaps most closely associated with historical research in the 1930s was Cecil B. DeMille, who produced a string of historical films during the period. According to a *New York Times* review of his western *Union Pacific* (1939), 'Mr. DeMille insists he has history on his side – demonstrating it by the complete documentation of every spike, shovel, costume, engine number, and war-bonnet in the film.'[47] Good historical practice was thus associated with the accumulation and quantification of material detail. DeMille's interviews and promotional materials frequently acknowledged the research effort that was put into his historical films, and the director himself was closely associated with the process. In a 1939 interview he summarized his approach to his pirate film *The Buccaneer* (1938) in typically unrestrained terms:

> I spent $90,000 on research. With six men, I devoted almost two years to searching every available bit of data on the pirate Jean Lafitte. We explored archives and papers in New Orleans which had not been touched for a hundred years. I found out more about Lafitte than anyone had ever known before.[48]

Eighteen years later, he discussed his final historical film in a similar way: "In our research for *The Ten Commandments*, we have consulted some 1,900 books, collected nearly 3,000 photographs, and used the facilities of 30 libraries and museums in North America, Europe and Asia."[49] This self-consciously fastidious approach was also foregrounded by a 1956 cinema trailer for *The Ten Commandments*, which featured DeMille discussing the development of the film in an office stuffed with heavy, leather-bound books, replica art work, maps, photographs, and movie props.[50] Moving rapidly between Renaissance sculpture, passages from Hebrew scripture, and extracts from the film itself, DeMille showcases the abundant resources at

[46] Quoted in Custen, 38.

[47] Frank S. Nugent, "The Screen in Review," *New York Times*, May 11, 1939.

[48] Quoted in Bosley Crowther, "DeMille Checks the Facts," *New York Times*, May 7, 1939.

[49] Cecil B. DeMille, "Introduction" in Henry S., Noerdlinger, *Moses and Egypt: The Documentation to the Motion Picture* The Ten Commandments (Los Angeles: University of Southern California Press, 1956), 2.

[50] The trailer is available on the "50th Anniversary Collection" DVD of *The Ten Commandments*.

the production's disposal. The methodology used to guide this conflation of vastly different research materials, however, is unexplained.

The research enterprise which laid the groundwork for *The Ten Commandments* (1956) was further emphasized by the publication of a book summarizing the research project. Entitled *Moses and Egypt: The Documentation to the Motion Picture* The Ten Commandments, it was written by Henry Noerdlinger, who had acted as DeMille's personal research consultant since 1945. In his introduction, DeMille disingenuously empha- sizes the extent of his research effort:

> Motion picture producers have sometimes been criticized for spending so much money on research – in the case of *The Ten Commandments* more than ever before... Research does not sell tickets, I may be told. But research does help to bring out the majesty of the Lawgiver and the eternal verity of the law.[51]

As David Eldridge observes, *Moses and Egypt* seems to reverse the conven- tional research process: rather than showing how the film grew out of historical enquiry, it works backwards from the completed film to retrospec- tively authenticate its spectacle.[52] For example, in the chapter on 'Camels, Horses and Transportation,' Noerdlinger acknowledges that it is unlikely that camels were domesticated in the time of Moses, but defends their inclusion nonetheless.[53] More generally, Alan Nadel has suggested that the book 'gathers together every possible source without any attempt to authenticate one over the other, to discover points of corroboration, or to reconcile points of contradiction.'[54] Despite these shortcomings, *Moses and Egypt* was lent academic prestige by the University of Southern California Press imprint, and DeMille claimed that it was published at the behest of 'numerous scholars and clergymen.'[55] In private, however, Noerdlinger acknowledged that the volume was a paid-for publication intended to be distributed among Sunday school teachers, newspaper editors, and other American opinion-formers as part of the film's marketing campaign.[56] Although it took the guise of an academic work, *Moses and Egypt* was evidently part of a wider promotional

[51] DeMille in Noerdlinger, 3.
[52] Eldridge, *Hollywood's History Films*, 148.
[53] Noerdlinger, *Moses and Egypt*, 95.
[54] Alan Nadel, *Containment Culture: American Narrative, Postmodernism and the Atomic Age* (Durham: Duke University Press, 1995), 95.
[55] DeMille in Noerdlinger, *Moses and Egypt*, 2. In Alan Nadel's estimation, *Moses and Egypt* is 'the most singularly bogus work ever published by a reputable university press'. Nadel, *Containment Culture,* 95.
[56] Eldridge, *Hollywood's History Films,* 148.

discourse which sold *The Ten Commandments* to specific audiences by foregrounding its authentic relationship to the past.

In the decades which followed, few historical films have been complimented by promotional volumes comparable to *Moses and Egypt*. The Oliver Stone film *JFK* (1991) is probably the most notable exception. The considerable media controversy generated by the film prompted Oliver Stone and his collaborators to write *JFK: The Book of the Film*, which was published several months after the film first appeared in cinemas. In 600 densely printed pages, the book presented the 'documented screenplay,' a selection of 97 'reactions and commentaries' from the American press, many of which are highly negative in their appraisal of the film, plus several 'historical documents,' mostly National Security Action memos pertinent to the events depicted in *JFK*. Of these, the 'documented screenplay' is the most significant. Like many commercially published screenplays, it is a reformatted, revised version of the film's shooting script and is illustrated with numerous stills from the film. But unlike anything published before, the text is interspersed with some 340 'research notes' which are apparently taken from Stone's own files and which serve to authenticate and corroborate the historical content of the film. For example, a scene depicting Lee Harvey Oswald's arrest is supported by a numbered reference to a police report and to an exhibit from the Warren Commission Hearings.[57] A scene where the character David Ferrie is shown to be aggressive to a woman is supported by a quotation from a FBI memo noting his 'sadism and masochism.'[58] A small number of notes even document minute deviations from the historical record. In an early scene we read that 'the real Jim Garrison' watched the news of JFK's assassination at a bar called 'Tortoich's, not Napoleon's.'[59]

The amount of evidence cited is almost overwhelming and it is clearly motivated by the stinging criticisms which the film received in the press. In a sense, the 'documented screenplay' in part one of the book is a rebuttal to the media response conveniently compiled in the pages which follow it. Although the various criticisms of the film are reprinted verbatim and are not commented on directly, the new context they are given in the book might be seen as an attempt to discredit them. *JFK: The Book of the Film* is an indignant response to a negative media debate rather than premeditated attempt to promote a positive reception for the film, and in this sense it differs from *Moses and Egypt*. However, the techniques used in the two books are similar. Both books imitate norms of academic history writing in order to showcase a far-reaching research effort. As Marita Sturken suggests, the *JFK* book

[57] Oliver Stone and Zachary Sklar, *JFK: The Book of the Film* (New York: Applause Books, 1992), 35.
[58] Ibid., 81.
[59] Ibid., 11.

'attempt[s] to shore up [Stone's] work though the academic mechanisms of footnotes and a critical approach to evidence.'[60] But unlike more conventional academic writing, there is little attempt to distinguish the various works cited: each one serves principally to bulk up the case for the film's authenticity. It is also difficult to establish which came first, the screenplay or the research. Should we accept that the extensive annotations constitute the foundation of the film, or have they been added after the fact in order to authenticate a predominantly dramatic construction? Oliver Stone has complained that *JFK: The Book of the Film* received little attention on its publication, and it was perhaps for this reason that the documented screenplay for his next major historical production was released in advance of the film itself.[61] Much like the preceding volume, *Nixon: An Oliver Stone Film* annotated the screenplay with 168 footnotes directing readers to sources for the film's content. In place of the press reaction, the *Nixon* book offered a 240-page dossier of documents and transcripts pertinent to the Watergate scandal, although unfortunately they are not cross-referenced with the screenplay footnotes.[62] It is possible that this pre-emptive strategy was successful. Although *Nixon* received some negative press, the criticisms of its historical accuracy were significantly less widespread.

The *JFK* and *Nixon* books are perhaps unique in their format and their attention to historical detail, but many other historical films have been accompanied by books which assert the significance of the research effort. For example, the promotional tie-ins for *Gladiator* (2000) include an illustrated book entitled *Gladiator: The Making of the Ridley Scott Epic*, which contains a great deal of information about the research underpinning the project, particularly its production design. As with *The Ten Commandments*, a combination of archaeological material and more recent visual art are established as *Gladiator's* primary inspirations. The film's costume designer states, 'we must have looked through thousands of books and visited dozens of museums and galleries.'[63] Although the figures are less concrete than those provided by DeMille and others in older Hollywood publicity material, the quantitative approach to the presentation of historical research is the same. To a large extent, however, research discourses for recent historical films have shifted from print to the short documentaries conventionally featured as 'bonus material' or 'extras' on the DVD and Blu-Ray editions of films. In historical films, this bonus material often functions to foreground and

[60] Marita Sturken, "Reenactment, Fantasy and the Paranoia of History: Oliver Stone's Docudramas," *History and Theory: Studies in the Philosophy of History,* 3/4 (1997): 67.
[61] Gary Crowdus, "History, Dramatic License, and Larger Historical Truths: An Interview with Oliver Stone," *Cineaste,* 22/4 (1997): 38.
[62] Eric Hamburg (ed.), *Nixon: An Oliver Stone Film* (London: Bloomsbury, 1996).
[63] Diana Landau (ed.), *Gladiator: The Making of the Ridley Scott Epic* (London: Boxtree, 2000), 95.

celebrate the accuracy of the films and to emphasize the labour that went into making this possible, particularly in terms of production design, writing, and performance. For example, in *Thirteen Days* (2001), which depicts the Cuban missile crisis, a documentary entitled *Bringing History to the Silver Screen* explains how the screenwriters based the film's dialogue on transcripts and recordings of actual White House meetings. It is also claimed that actors cast in the film prepared for scenes by listening to tapes of the historical figures they were playing. A similar commitment to verisimilitude is expressed in interviews with the production design team, who discuss their use of photographs of the Kennedy White House as the basis for the film's main set. Perhaps the strongest assertion of research-based authenticity, however, is made for a scene which takes place in the United Nations building. Behind-the-scenes footage taken on the set shows the director playing back documentary footage of the real meeting from 1962 on one video monitor, while directing the actors on another monitor directly underneath it.

A more elaborate example of this celebratory process can be seen in the *Apollo 13* (1995) documentary *Lost Moon: The Triumph of Apollo 13*. As with the *Thirteen Days* documentary, the fidelity of the film's dialogue and production design is emphasized by reference to documentary material, in this case audio recordings and photographs taken at NASA's mission control in the period prior to the Apollo 13 launch. Further testimony to the film's authenticity is added by members of the real Apollo 13 team, who are filmed on set acting as technical advisors. One such advisor claims that the Mission Control set constructed for the film was so accurate he momentarily forgot that he was in a studio. Other Apollo 13 witnesses, including the wives of the astronauts, praise the performances of the actors hired to portray them. Echoing the grandiose claims made by DeMille, astronaut David Scott claims that the film will 'go into the records as a source of accurate data.' But the strongest celebration of the film's accuracy and fidelity comes in the scenes in the documentary where television news footage of real events from 1970 is intercut with reconstructions from the film. This technique is used several times, but the most extended sequence comes in the presentation of the Apollo 13 sea rescue which forms the climax of the film. The documentary cuts back and forth between historical video footage and dramatic reconstruction, imitating the editing pattern of the film, as the astronauts are lifted from the sea by helicopter, disembark on a ship, and are applauded first by Mission Control in Houston, and then by the officers on the ship. This short sequence makes it clear how closely individual images from the film were based directly on documentary footage of the historical event. The intention seems to be to demonstrate the extent of the research effort made by the film's production team and by extension to assert the historical authenticity

FIGURE 1.1 *Comparison of documentary (left) and dramatized (right) images in* Apollo 13 *(1995)*

of the film itself, but the sequence also has the effect of blurring the line between the reality and the film's representation of it.

As I have shown, historical films are frequently augmented and annotated in order to emphasize the level of research which has been undertaken in their production. Various motivations for this process may be deduced. The showcasing of the pre-production research project might be understood as a means to negate potential criticism about historical inconsistencies and oversights in the film itself by overwhelming the viewer with supplementary information. Similarly, the process might be seen as a way to assert legitimacy and seriousness of the film in order for it to be marketed on the basis of its prestige or educational value. As I have indicated, achievement in the historical film genre is often judged according to the perception of historical accuracy rather than by aesthetic criteria. In many cases, press material, tie-in books, and supplementary documentaries serve to argue in favor of the authenticity and thus for the overall quality of the films in question. The extratextual practices which I have identified serve to highlight, moderate, and even extend the relationship between films and the historical periods they purport to represent. Recalling Mittell's suggestion that genre emerges from the 'intertextual relations between texts,' these discourses thus emphasize the participation of films in the historical film genre.

In many ways, historical cinema and genre are not a comfortable fit. Although the term 'historical film' has been widely used in critical and commercial contexts, many writers have struggled to find textual coherence in its vast array of narrative and iconographic features. However, as I have argued, contemporary approaches to genre studies are able to resolve this disjuncture by looking beyond the textual properties of individual films in order to examine the discourses which films generate as they are produced, promoted, and consumed. Building on the work of other writers, I have suggested that historical cinema can best be understood as a body of films

which attempts to engage with and construct a relationship to the past. As the examples I describe indicate, the process of engaging with the past and participating in the historical film genre has been undertaken by a huge range of Hollywood films. Crucially, these engagements can be made both within the films themselves, as with use of historical prologues and epilogues, or on an extra-textual basis, as in the promotional emphasis sometimes placed on the research process. This definition allows a wide range of films to be considered as historical, including those which have strong and detailed relationships to the past, and those which are less concerned with the authenticity of their engagement. No matter how well or how badly a film is perceived to represent the past, it can still be considered as historical cinema. Instead of asking how authentic or accurate a film is in its engagement with the past, I would suggest that it is more useful and interesting to ask first why so many Hollywood films over such a long period have attempted to build relationships with the past, and secondly why so many of these historical films have been popular with audiences. These are broad questions, but in the chapters which follow I will attempt to shed light on them.

2

Detail, authenticity, and the uses of the past

The role of detail

In 1936, as Warner Bros. finalized the screenplay for *The Charge of the Light Brigade,* Head of Production Hal Wallis went on record to express concern about the studio's decision to conflate historical events from the Crimean War with a more fashionable Colonial Indian setting several thousand miles away:

> I realise that we have a very highly fictionalised story and that it bears no relation to the historical facts but, at the same time, if we are to save ourselves from a lot of grief and criticism in England, we must make our picture as historically accurate as possible, or at least surround our Battle of Balaclava and *The Charge of the Light Brigade* with historically correct incidents and detail.[1]

According to this reasoning, a story which 'bears no relation to historical facts' could nonetheless be 'historically accurate' so long as the 'surrounding' surface detail brought the mid-nineteenth century period to mind in a convincing manner. To this end, for example, publicity material claimed that actual postage stamps of the period were used, even though they were not visible on screen.[2] Almost 80 years later, Mark Zuckerberg reflected on a similar phenomenon after scenes representing his private life and career were dramatized as *The Social Network* (2010):

> It's interesting what stuff they focused on getting right; like, every single shirt and fleece that I had in that movie is actually a shirt or fleece that I

[1] Quoted in Maltby, *Hollywood Cinema,* 444.

[2] "*The Charge of the Light Brigade,*" *AFI Film Catalog,* CD-ROM edition (Chadwyck Healey Inc., 1999).

own. So there's all this stuff that they got wrong and a bunch of random details that they got right.[3]

This dislocation between the accuracy of *mise en scène* and the inaccuracy of dramatized events might be explained by the fact that Hollywood screenwriters and production design teams tend to work separately and possibly with different creative imperatives. However, these comments also emphasize the ways in which Hollywood historical films—in the 1930s as much as the 2010s—have represented the past by accumulating visual evidence which evoke a sense of historical period and overwhelm potential laxities in the narrative. The 'bunch of random details' Zuckerberg observes are, in fact, pivotal to the way historical films represent and engage with the past.

Numerous anecdotes highlight the ways in which filmmakers have created and promoted excessive detail in historical films. During the production of *Mutiny on the Bounty* (1935), for example, it was reported that the actor Charles Laughton discovered 150-year-old receipts and measurements belonging to Captain Bligh, the character he was playing, at a Savile Row tailor and had the company cut his costume to the same specifications.[4] Similarly, the studio newsroom set built for *All the President's Men* (1976) supposedly featured waste-paper baskets filled with genuine rubbish taken from the *Washington Post's* actual offices.[5] In both cases, material details are foregrounded as a way to establish an authentic connection with real events. More recently, the 1997 film *Titanic* emphasized material detail within the film itself as a means to transport the viewer from the present into the past. The film begins in the present day, but a historical narrative is introduced by the elderly Rose, who recalls her journey on *Titanic* as a teenager. As she speaks, the camera tracks over her shoulder to an image of the submerged, wrecked ship on a TV monitor behind her head. Filling the screen, the tiny shipwreck rotates and dissolves into a spectacular wide-shot of *Titanic* as it appeared on the morning of its maiden voyage. In an instant, the empty shell at the bottom of the ocean is transformed into an enormous yet highly detailed spectacle. The initial shot emphasizes the ship itself, but its depth of field also reveals hundreds of passengers crowding the deck and the dock. Closer shots pick out the costumes of the crowd, particularly the luxurious clothes and elaborate headwear worn by (the younger) Rose. Attention is also directed to a series of pristine, antique cars, their brass headlamps gleaming in the bright

[3] Quoted in Kyle Buchanan, "Mark Zuckerberg Praises The Social Network's T-Shirt Accuracy," *Vulture*, last modified October 19, 2010, www.vulture.com/2010/10/mark_zuckerberg_praises_the_so.html.
[4] "*Mutiny on the Bounty*," *AFI Film Catalog*.
[5] Mark C. Carnes, "Shooting Down the Past: Historians vs. Hollywood," *Cineaste*, 29/2 (2004): 47.

sunlight. This density of immaculate, luxurious material detail creates what Julian Stringer has called a 'fusion of nostalgia and consumerism.' [6] Combined with the spectacular scale and hyper-realism of the computer-generated ship, the effect of this rapid burst of period imagery is to transport the viewer from the dismal present and immerse him/her in the narrative past.

Roland Barthes sheds some light on these excessive practices in his discussion of the 'narrative luxury' in Flaubert's *Madame Bovary*, which he suggests is created by the foregrounding of 'useless detail' apparently unrelated to the plot. This described information, Barthes suggests, 'say[s] nothing but this: we are the real; it is the category of "the real"... which is then signified.' [7] The excess of detail is, in a sense, the hallmark of realism. It is important to note, however, that detail plays a very different role in the novel than in cinema. As the novelist George MacDonald Fraser notes,

> The novelist... can state simply that Sir Francis Drake rolled in and bowed to the Queen, or that Marie Antoinette flung herself, sobbing wildly, on the bed, and that's it; the reader visualises the scene. The filmmaker has to create it entire, from the coat of arms above the throne to the last diamond in the Queen's ruff. [8]

Perhaps this simplifies matters too much, but the distinction between cinema and writing is nonetheless valid, and as a consequence historical films almost always contain large amounts of period detail, regardless of how serious they are about representing the past authentically. To put it another way, the majority of historical films carry a high information load in terms of the material detail they put on display, even if they chose to avoid other types of information about the past. In this sense, any film set in the past is to a certain degree realistic by virtue of the basic level of detail required in order to establish its representation of the period in the mind of the viewer. At the same time, no matter how closely the written word of a screenplay adheres to available historical data, once these words are dramatized, the incorporation of material details (actors, costumes, sets) inevitably leads to a departure from any factual basis. It is impossible for any historical film to be entirely accurate in all of its physical details, no matter how many or how few it uses. As Pam Cook has suggested,

[6] Julian Stringer, "'The China Had Never Been Used!' On the Patina of Perfect Images in *Titanic*" in Kevin S. Sandler and Gaylyn Studlar (eds), *Titanic: Anatomy of a Blockbuster* (New Brunswick: Rutgers University Press, 1999), 205.

[7] Roland Barthes, "The Reality Effect" in *The Rustle of Language*, trans. Richard Howard (Berkeley: University of California Press, 1989), 148.

[8] George MacDonald Fraser, *The Hollywood History of the World: From* One Million Years B.C. *to* Apocalypse Now (New York: William Morrow, 1988), xiv.

The obsession with period authenticity reveals a contradiction at the heart of the historical film: the symbolic carriers of period detail – costume, hair, décor – are notoriously slippery and anachronistic. They are intertextual sign systems with their own logic which constantly threaten to disrupt the concerns of narrative and dialogue.[9]

The concentration on detail as a means to evoke the past thus makes historical films simultaneously more realistic than written history, due to the volume of visual information presented on screen, and less authentic, because it is impossible, in practical terms, for this information to be entirely correct. The high level of visual information typical in historical cinema thus signifies realism as a convention while also necessitating a departure from past events as they actually occurred.

For the most influential analysis of the role played by detail in historical film we must return to Roland Barthes. In his essay 'The Romans in Films' he describes the short fringes worn by male actors in the Hollywood adaptation of *Julius Caesar* (1953) as 'the label of Roman-ness':

We therefore see here the mainspring of the Spectacle – the sign – operating in the open. The frontal lock overwhelms one with evidence, no one can doubt that he is in ancient Rome. And this certainty is permanent: the actors speak, act, torment themselves, debate 'questions of universal import', without losing, thanks to this little flag displayed on their forehead, any of their historical plausibility.[10]

In other words, this hairstyle is so strongly and unambiguously associated with its historical period that it fixes any drama that uses it in ancient Rome, superseding evidence to the contrary and authenticating the 'Roman-ness' of the film in question. Other costume and hair-based historical shorthand, established by repetition over centuries of visual representation, also comes to mind: the ruffled collar of the Elizabethan period, the bonnet of Regency England, the unkempt facial hair of medieval peasantry. In each case, it is the familiarity of these images and their accessibility to audiences, rather than their intrinsic relationship to the past, which creates the sense of 'historical plausibility.' As Vivian Sobchack suggests, 'concrete images' of this type have the power to 'condense' historical events, historical narratives, and historio-graphical accounts into 'something more general, more "mythological."'[11]

[9] Pam Cook, *Fashioning the Nation: Costume and Identity in British Cinema* (London: BFI, 1997), 67.
[10] Roland Barthes, "The Romans in Films" in *Mythologies*, trans. Annette Lavers (London: Vintage, 1993), 26.
[11] Vivian Sobchack, "The Insistent Fringe: Moving Images and Historical Consciousness," *History and Theory: Studies in the Philosophy of History*, 36/4 (1997): 9.

But as potent and effective as these images are, most historical films tend to present an array of visual evidence rather than concentrating on a single, evocative detail. The frontal lock does not 'overwhelm one with evidence' on its own, but rather as an element in a larger system which immerses the audience in visual signs associated with the past. As Sobchack noted in an earlier discussion the historical epic, the immersive approach to representation is prevalent in much historical cinema:

> History emerges in popular consciousness not so much from any *particular accuracy* or even *specificity* of detail and event as it does from a *transcendence of accuracy and specificity* enabled by a general and excessive parade and accumulation of detail and event (author's italics).[12]

The effect of historical representation is achieved not through the repetition of any particular detail, then, but rather through the accretion and display of many details which collectively provide evidence not only of 'being in' the past, but also a sense of realism which potentially overwhelms and negates areas of dispute. The fixation on surface detail in historical cinema also implies that history is primarily a question of that which is material, visible, and thus concretely representable. As Janet Staiger has written of *The Return of Martin Guerre* (1982), the film's impression of 'history' is shown to reside in 'the *mise en scène*, the props, the costumes, and the people' and not in the ideas, beliefs, and relationships presented on screen.[13] In many historical films, the past is embodied in their abundance of realistic, visible details rather than by social relations, ideology, or other essentially invisible forces. The foregrounding of historical detail is thus central to representation of the past in Hollywood films, even though it does not necessarily correlate with historical authenticity in a broader sense. It should also be noted that not all historical films are serious about representing the past authentically. As Ellen Draper has noted, the detailed *mise en scène* featured in many historical melodramas reflects a desire to 'locate its fiction in a world apart from the reality that awaits its audience outside the theatre' rather than a desire for historical accuracy.[14] Visual detail may thus be used to transcend reality as well as to simply evoke it.

[12] Vivian Sobchack, "Surge and Splendor: A Phenomenology of the Hollywood Historical Epic" in Barry Keith Grant (ed.), *Film Genre Reader II* (Austin: University of Texas Press, 1995), 285.
[13] Janet Staiger, "Securing the Fictional Narrative of a Tale of the Historical Real: *The Return of Martin Guerre*" in Jane Gaines (ed.), *Classical Narrative Cinema: The Paradigm Wars* (Durham: Duke University Press, 1992), 118.
[14] Ellen Draper, "Untrammelled by Historical Fact: *That Hamilton Woman* and Melodrama's Aversion to History," *Wide Angle*, 14/1 (1991): 58.

History as analogy

Although historical cinema tends to be dominated by evidence of the past at the level of visual representation, at the narrative level it has often sought to build connections with other eras, particularly the present. A good example of this occurs in Cecil B. DeMille's spoken prologue to *The Ten Commandments* (1956). Echoing his trailer for the same film which was discussed in the previous chapter, DeMille describes some of the textual sources used to research and design his film. In closing, however, he declares:

> The theme of this picture is whether man ought to be ruled by God's law, or whether they ought to be ruled by a dictator like Rameses. Are men the property of the State, or are they free souls under God? This same battle continues throughout the world today.

The reference to America's Cold War stand-off with the USSR would surely have been clear for much of his audience. For the purported historical accuracy of the *mise en scène*, in other words, *The Ten Commandments* is not really (or at least not only) a film about ancient Egypt. Similarly, in 1939 Warner Bros. released *Juarez*, a prestigious dramatization of the nineteenth-century independence movement in Mexico. One of its writers, commenting on an early treatment, suggested that 'the dialog, as far as it is political and ideological, must consist of phrases from today's newspapers.' Identifying the story with the Spanish Civil War, he added, 'every child must be able to realize that Napoleon and his Mexican intervention is none other than Mussolini plus Hitler in their Spanish adventure.'[15] In both these examples, the past becomes an allegory for the present—a figure of speech in which one subject is intentionally addressed under the guise of another. Drawing on Paul Ricoeur, William Guynn proposes that the textual relay between past and present is an inevitable part of any historical film because historical representation is 'analogical in character: historiography is a mimetic activity that constructs a discourse that does not resurrect but stands for historical events.'[16] Ismail Xavier has suggested that this process of analogy forms the basis of historical allegory, a mode in which 'the underlined analogies between past and present are taken as a piece of rhetoric, a form of raising a question about the present using the past, given that the episode in question had similar issues at its center.'[17] A historical film, in other words, may inten-

[15] Wolfgang Reinhardt, quoted in Maltby, *Hollywood Cinema*, 448.
[16] William Guynn, *Writing History in Film* (London: Routledge, 2006), 21.
[17] Ismail Xavier, "Historical Allegory" in Toby Miller and Robert Stam (eds), *A Companion to Film Theory* (Oxford: Blackwell, 1999), 354.

tionally build the past in the image of the present, and in this way it becomes a means to comment indirectly on it.

Due to this element of narrative disguise, historical allegory has frequently been associated with the attempt to bypass forms of institutional censorship. The insertion of contemporary resonances in *Juarez* is a case in point, given that the film was developed at a time when America was officially maintaining a neutral stance on events in Europe. In American cinema, the best-known use of historical allegory to this end occurred during the House Un-American Activities Committee (HUAC) 'red scare' of the early 1950s. As Jeff Smith has shown, the 1953 Biblical epic *The Robe* has frequently been discussed as an 'implicit critique of both the blacklist and of dominant American Cold War ideology.'[18] Smith quotes John Belton to this effect: the film 'casts Caligula as a witch-hunting, McCarthyesque figure and the Christians as persecuted victims of his demonic attempts to purge the Roman empire of potential subversives.'[19] Similar patterns can be observed in the medieval adventure *Ivanhoe* (1952). Like Arthur Miller's *The Crucible* (first performed in 1953), *Ivanhoe* features a literal trial for witchcraft in which an innocent character is condemned on evidence which is shown to be false and for reasons which are shown to be politically motivated.[20] Crucially, both *The Robe* and *Ivanhoe* were worked on by screenwriters who had been forced to appear before the HUAC and who were later blacklisted. As individuals in the American film industry were interrogated and in many cases prevented from working, historical allegory provided covert means for some to reply to those harassing them. Nevertheless, film critics have also been quick to identify contemporary resonances in historical films in the absence of such political pressures, even when the messages they apparently contain are entirely in harmony with the prevailing ideologies of the day. For example, Gregory A. Burris argues that *300* (2006) uses the ancient world to stage a right-wing, hawkish portrait of modern American involvement in the Middle East which 'bolster[s] the simplistic black-and-white worldview advanced by our political leaders, pundits, and mainstream media.'[21] If this analysis is correct, the relationship between *300* and contemporary American society would seem to be the exact opposite to those established by the HUAC allegories of the 1950s.

[18] Jeff Smith, "Are You Now Or Have You Ever Been a Christian? The Strange History of *The Robe* as Political Allegory" in Frank Krutnik, Steve Neale, Brian Neve, and Peter Stanfield (eds), *'Un-American' Hollywood: Politics and Film in the Blacklist Era* (New Brunswick: Rutgers University Press, 2007), 21.

[19] Belton, quoted in ibid.

[20] Jonathan Stubbs, "Hollywood's Middle Ages: The Script Development of *Knights of the Round Table* and *Ivanhoe*, 1935–53," *Exemplaria: A Journal of Theory in Medieval and Renaissance Studies*, 21/4 (2009): 408.

[21] Gregory A. Burris, "Barbarians at the Box Office: *300* and *Signs* as Huntingtonian Narratives," *Quarterly Review of Film and Video*, 28/2 (2011): 112.

In addition, it has been commonplace to suggest that analogies to other time periods in historical cinema might be considered a matter of routine rather than the consequence of exceptional political circumstances. Gilles Deleuze has suggested that 'American cinema constantly shoots and reshoots a single fundamental film, which is the birth of a nation-civilisation.'[22] Deleuze's interpretation is echoed by Brian Taves, who proposes that an entire genre category—what he calls the 'historical adventure' film—can be interpreted as 'metaphorical depiction[s] of the American Revolution' in which the 'timeless need for liberty and freedom' in the face of tyranny is asserted across a range of diverse times and places.[23] Taves' analysis is unusual in that it identifies historical films with an alternate historical period rather than with the present, but it nevertheless underlines the critical tendency to see historical films as belonging to an age other than the one they attempt to represent. In similarly broad strokes, Arthur Lindley has suggested that 'so often with films of the Middle Ages, for twelfth century we must read twenty-first.'[24] Reference to the present, in other words, is a predisposition for films of this type. Amelia Arenas frames her discussion of Hollywood films set in the ancient Rome in similar terms:

> These antiquarian extravaganzas are ultimately not about Abraham or Ben Hur, Spartacus or Maximus, or about anonymous Christian martyrs and converted centurions, but about ourselves, or, more precisely, about our ideals, conveniently presented in the flattering but distancing guise of armor and toga and confirmed by the authority of the past.[25]

The implication seems to be that historical films can never really be 'about' the past: their actual, 'ultimate' subjects lie elsewhere, in the present. Robert Burgoyne has even proposed that historical films might somehow reflect the near future as well as being tied to the present, suggesting that *Gladiator* (2000) 'seems to foreshadow the crisis of national identity and national social structures catalyzed by the events of 9/11.'[26] Haunted by analogy, the past of historical cinema always seems to point in a different direction.

[22] Gilles Deleuze, *Cinema 1: The Movement Image,* trans. Hugh Tomlinson and Barbara Habberjam (Minneapolis: University of Minnesota Press, 1986), 148.

[23] Brian Taves, *The Romance of Adventure: The Genre of Historical Adventure Movies* (Jackson: University Press of Mississippi, 1993), 14.

[24] Arthur Lindley, "Once, Present, and Future Kings: *Kingdom of Heaven* and the Multitemporality of Medieval Film" in Lynn T. Ramey and Tison Pugh (eds), *Race, Class, and Gender in 'Medieval' Cinema* (New York: Palgrave Macmillan, 2007), 16.

[25] Arenas, Amelia, "Popcorn and Circus: *Gladiator* and the Spectacle of Virtue," *Arion: A Journal of Humanities and the Classics,* 9/1 (2001): 8.

[26] Burgoyne, *Hollywood Historical Film,* 82.

But should historical films always be considered primarily as representations of the present in which they were produced? Is historical allegory less an intentional narrative disguise and more an inevitable consequence of any attempt to represent the past? An extreme position on this matter has been taken by Pierre Sorlin in his writing on historical cinema. He proposes that 'in the films we have discussed history is a mere framework, serving as a basis or a counterpoint for a political thesis. History is no more than a useful device to speak of the present time.'[27] But this seems to be rather reductive. The fact that it is *possible* to interpret a historical film as a reflection of the present does not prevent the film from having any other meaning. A historical film can surely contain elements which relate to both the present *and* the past. Moreover, many critics over time have argued that any film is symptomatic of the culture in which it was produced, whether its subject matter is directly historical or not. As Richard Maltby has put it, 'the concept of film as "objectified mass dream", consensual myth or "barometer of social and cultural life" has retained considerable seductive power.'[28] Other writers have argued that the connections between past and present in historical film are more subtle. Burgoyne suggests that historical films engage in the 'revisionary enterprise of the late twentieth-century; they reenact the narrative of nation.'[29] This focus on re-enactment and revision indicates that while historical films represent the past, they also embody a worldview that derives from the present in which they were produced. Like any form of history, the past events represented by historical films are not static; rather, they are molded by the shape of the present. Burgoyne also describes the historical film as 'a privileged discursive site in which anxiety, ambivalence and expectation about the nation, its history, and the future are played out in narrative form.'[30] Again, historical films are written from the perspective of the present even as they narrate the past. It should be noted that the connection between past and present is rarely straightforward, however, and it is possible for it to be interpreted in different ways at different points in time.

Historical films represent the past, but they also represent the present in which they were produced, either intentionally in order to use the past as a means to comment on the present, or unintentionally because filmmakers approach the past with present-day beliefs. Indeed, it is hard to imagine how any film could not be shaped by the social forces at work as it was created. As Walter Benjamin has suggested, history is 'filled by the presence of

[27] Pierre Sorlin, *The Film in History: Restaging the Past* (Totowa: Barnes and Noble, 1980), 208.
[28] Richard Maltby, "Mapping New Cinema Histories," in Maltby, Daniel Biltereyst, and Philippe Meers (eds), *Explorations in New Cinema History: Approaches and Case Studies* (Oxford: Wiley-Blackwell, 2011), 6.
[29] Robert Burgoyne, *Film Nation: Hollywood Looks at US History* (Minneapolis: University of Minnesota Press, 1997), 6.
[30] Ibid., 11.

now.'[31] It might also be argued that rather than compromising a film's status as a work of history, the inevitable connection between any given historical film and the present should be seen positively. As Maria Wyke puts it, the historical film 'can be viewed as a central component of the historical text that a society writes about itself.'[32] Warren I. Susman has elaborated on this idea to suggest that historical films operate not simply as reflections but as 'interpreter[s] of history, the provider[s] of an explanation of historical development and an analysis of the process of history itself.'[33] Historical films, then, are interpretations of history made at a historically specific moment. They are concerned with the past, but their perspective is that of the present and as such they represent not simply the past, but the past as it is understood from a particular point in time. Analogies to the present are a key element in historical films, but they do not necessarily handicap their ability to represent the past. Moreover, interpretations of historical films which overemphasize their relationship to the present also diminish their status as valuable interpretations of history. As Hayden White puts it, history is 'a process of social change that includes not only the past but the present as well.'[34]

Concepts of authenticity

Historical cinema, then, is led by visual evidence in its representation to the past, although these details tend to correspond to popular conceptions about what the past looked like and not necessarily to historical records. But despite the attention to the detail of the past, historical films are also filled with evidence of the present which they cannot entirely escape. This tension provides one explanation as to why journalistic and academic writers, particularly historians, have so often been suspicious of historical cinema's ability to represent the past and to function as history. In these debates, historical films are often measured against the elusive qualities of historical 'accuracy' and 'authenticity.' For example, the American website Yahoo! Movies recently published a list of the '10 Most Historically Inaccurate Movies,' claiming that each one treat[s] the truth like silly putty – pulling and twisting it until it's

[31] Walter Benjamin, "Theses on the Philosophy of History," in Benjamin, *Illuminations*, trans. Harry Zohn (New York: Schocken Books, 1968), 261.
[32] Maria Wyke, *Projecting the Past: Ancient Rome, Cinema and History* (London: Routledge, 1997), 24.
[33] Warren I. Susman, "Film and History: Artifact and Experience," *Film and History*, 15/2 (1985): 30.
[34] Hayden White, "Film and History: Questions to Filmmakers and Historians," *Cineaste*, 29/2 (2004): 66.

unrecognizable.'[35] The article proceeds to identify ostensive factual errors in contemporary Hollywood films: in *Gladiator* (2000), for example, Commodus was murdered in his bathtub rather than in the area; in *Braveheart* (1995) kilts were not worn at the time the film is set; in *300* (2006) the warriors of Sparta wore bronze armour rather than 'leather Speedos.' A similar process is under-taken in the *Guardian*'s continuing 'Reel History' series, in which, according to the blurb, 'the historian Alex von Tunzelmann watches classics of big screen history and prises fact from fiction.' As before, historical films (principally American) are held to account, assessed in terms of their relationship to historical 'fact,' and given separate grades for 'entertainment' and 'history.' In *Kingdom of Heaven* (2005), von Tunzelmann points out that 'the real Balian of Ibelin only ended up in Jerusalem by mistake.' In *Troy* (2004), she asserts that 'it is impossible that there would have been any llamas in Europe or Asia for at least another 2,800 years.' And in *Robin Hood: Prince of Thieves* (1991), 'words such as "bollocks" and "tosspot"... were not in recorded use until the 18th- and 16th century respectively.'[36] Although the tone is often ironic, this type of criticism implies first that a 'correct' version of past events exists and is available to professional historians, enabling them to determine precisely where screen representations depart from historical truth. Secondly, it suggests that 'fact' and 'fiction' (or to use the other dichotomies implied, 'history' and 'entertainment' or 'reel' and 'real') are distinct, irreconcilable elements which are unnaturally yoked together on screen, but which the informed historian is able to 'prise' apart.

Similar attitudes are evident in several books purporting to document the accuracy or otherwise of prominent historical films. Some are simply dismissive: for example, Frank Sanello's *Reel v. Real: How Hollywood Turns Fact into Fiction* states on page one that 'Hollywood treats history like an ugly stepchild that needs to be tarted up with fictional additions' and proceeds to name-and-shame what it considers to be the worst offenders.[37] The combat metaphor in the book's title is also symptomatic of the relationship the author assumes between film and 'reality.' Vankin and Whalen's *Based on a True Story: Fact and Fantasy in 100 Favorite Movies* and Joseph Roquemore's *History Goes to the Movies: A Viewers Guide to the Best (and Some of the Worst) Historical Films Ever Made* are similar in attitude and format. The latter takes time to itemize the historical inaccuracies of *The Sound of Music* (1965), while the latter is more political in tone, dismissing *Land and Freedom* (1995),

[35] "10 Most Historically Inaccurate Movies," *Yahoo! Movies,* last modified March 1, 2008, http://movies.yahoo.com/feature/10mosthistoricallyinaccurate.html.

[36] Alex von Tunzelmann, "Reel History", *Guardian*, last modified March 30, 2012, www.guardian.co.uk/film/series/reelhistory.

[37] Frank Sanello, *Reel v. Real: How Hollywood Turns Fact into Fiction* (Lanham: Taylor Trade, 2003), i.

In the Name of the Father (1993), and *Gandhi* (1982) as 'propaganda.'[38] A more considered approach is taken in books edited by Mark C. Carnes and Peter C. Rollins. In *Past Imperfect: History According to the Movies*, Carnes—a prominent professor of American history—assembles a range of specialists to discuss various historical films. Notwithstanding the implications of the title, Carnes asserts at the outset that 'the purpose of this book is not to censure.'[39] Furthermore, in a prefacing interview, the historian Eric Foner states,

> The hardest thing for people who don't think much about history to realize is that there may be more than one accurate version of history. In other words, there may not be just one 'correct' view of something, with all other views incorrect. There are often many legitimate interpretations of the same historical event or the same historical process, so none of us can claim that we are writing history as objective fact.[40]

However, the individual essays in the book often make a rather different impression. As part of each entry, a page is divided into a section entitled 'History' and below it a section entitled 'Hollywood.' They are accompanied, respectively, by documentary images or photos of artworks, and stills from the films under discussion. The format suggests not only that the Hollywood version of events is subordinate to 'history,' but also that Hollywood historical narratives are incompatible with and necessarily estranged from written accounts of the past. The primacy of the written word is asserted again by the brief bibliographies printed at the end of each entry. Moreover, some of the entries are openly hostile to the films they discus. Stanley Karnow's essay on *JFK* (1991) focuses on the psychology of director Oliver Stone, suggesting that he 'desperately yearns to be respected,' describing the film as his 'cinematic crusade,' and suggesting that he twists key events 'out of all recognition' in order to 'buttress his proposition.'[41] In contrast to Foner's remarks, Karnow suggests that the representation of the past is not a matter of interpretation at all, and that the distinction between 'correct' and 'incorrect' versions of the past is black and white.

Peter C. Rollins' *The Columbia Companion to American History on Film: How the Movies Have Portrayed the American Past* differs from the

[38] Jonathan Vankin and John Whalen, *Based on a True Story: Fact and Fantasy in 100 Favorite Movies* (Chicago: Chicago Review Press, 2005); Joseph Roquemore, *History Goes to the Movies: A Viewers Guide to the Best (and Some of the Worst) Historical Films Ever Made* (New York: Random House, 1999).

[39] Mark C. Carnes (ed.), *Past Imperfect: History According to the Movies* (New York: Henry Holt, 1995), 9.

[40] Eric Foner in Carnes, *Past Imperfect*, 25.

[41] Stanley Karnow in Carnes, *Past Imperfect*, 271–2.

other books mentioned here, first because it is restricted to films about the American past and secondly because, in its attempt at encyclopaedic breadth, the book is structured not around individual films but around specific historical periods, events, figures, and institutions. The discussion of *JFK*, for example, occurs in a chapter dedicated to 'the Kennedys,' which also looks at several documentary and television representations of the Kennedy family. Rollins' book is also more rigorous and wide-ranging in its efforts to contextualize historical films and to understand them on their own terms as films and not simply as historical narratives. The contributors are asked to assess how much the historical films 'deviate' from their sources, but also to examine what type of historical sources were available to the filmmakers at the time of production. Like any work of history, a historical film is a product and a reflection of the knowledge in circulation in its own time. As such, contributors also consider the extent to which production histories and contemporary social issues shaped the films in question.[42] But despite this sensitivity to historical films as objects shaped by history, the book nevertheless places historical films in a subsidiary position to written history. In his introduction, Rollins contrasts historical films with what he calls 'the authentic insights of real history,' noting that 'the best history is written to investigate the truth about the past without the intrusion of melodramatic, entertainment or ideological concerns.'[43] No indication is made that written history might equally be subject to these intrusions. Finally, Rollins asserts,

> Those who rely on historical films for their understanding of the past are often in danger of learning the wrong lessons – and, as a result, using the wrong models for interpreting the present. The essays in this collection should help teachers, students, and general readers to avoid such pitfalls.[44]

The book, then, is intended not as a 'companion' to American historical films as such but as a corrective for lay readers which draws on the expertise of professional historians to counteract the 'danger' posed by historical films with a correct, written version of the past.

There is nothing new or unusual in this intellectual anxiety about the false allure of historical cinema. As early as 1937, a report published by the British Film Institute criticized film producers who 'pervert history for the sake of box office returns.'[45] In recent years, competent historians have frequently been

[42] Peter C. Rollins, (ed.), *The Columbia Companion to American History on Film: How the Movies Have Portrayed the American Past* (New York: Columbia University Press, 2003), xiv–xvi.
[43] Ibid xiii.
[44] Ibid., xiv.
[45] "Travesties of Cinema," *Manchester Guardian*, May 8, 1937.

articulate on the topic of historical cinema. According to David Herlihy, writing in 1988,

> [Films] cannot serve as independent statements regarding the past. They are illusions and must be recognized as such. Somehow, somewhere, they must be accompanied by a historical commentary... they must answer for their messages in the high court of historical criticism. [46]

As in the Rollins book, historical films are seen to be unable to function as history without the extra-textual input of academic historians, who (implicitly) should also act as legal prosecutors. In a discussion of the dangers posed by historical films, historian Arthur M. Schlesinger Jr. described cinema as 'the most lifelike of arts, playing upon – preying upon? – vulnerable audiences herded in darkened halls.'[47] The imagery evokes the patrician moral panics generated by cinema-going in the early twentieth century, but the words come from an article about Oliver Stone from 2000. Indeed, Stone, memorably described by George Will as an 'intellectual sociopath,' was something of a lightning rod for the anxieties of academic historians during the 1990s.[48] In a ferocious review of *Nixon* (1995) for the *American Historical Review*, Joan Hoff drew on an even more extreme form of imagery to make her point: 'Stone has "raped" Nixon and seduced and silenced his audience. He has once again imposed his paranoid, conspiracy-driven mentality on us.'[49] Audiences are passive victims and silent onlookers; historical films are like violent criminals who must face the force of the law. To call the relationship between some historians and historical films 'troubled' would seem to be an understatement.

However, recent theoretical developments in history writing have led some historians to adopt a different attitude to the historical film. These developments are neatly summarized by Maria Wyke:

> Since the 1970s, a new self-consciousness about traditional conceptions of history and the rhetorical conventions for its presentation have collapsed the formerly clear boundaries between history and fiction. *All* historical discourses, according to this mode of analysis, are a form of fiction. All history involves storytelling and a plot, troping and figurality.[50]

[46] David Herlihy, "Am I a Camera? Other Reflections on Films and History," *American Historical Review,* 93/5 (1988): 1192.

[47] Arthur M Schlesinger Jr. "On JFK and Nixon" in Robert Brent Toplin (ed.), *Oliver Stone's USA* (Lawrence: University of Kansas Press, 2000), 216.

[48] George Will, "Oliver Stone Gives Paranoia a Bad Name," *New Orleans Times-Picayune,* September 23, 1991.

[49] Joan Hoff, "Nixon," *American Historical Review,* 111/4 (1996): 1173.

[50] Wyke, 12.

The past is not available to historians as a fixed, discrete narrative ready to be passed on to readers; rather, this narrative must be fashioned out of the available data in what is an inevitably creative process. Most notably, Hayden White has argued that much historical writing is not the objective, scientific, transparent record of the past it is frequently held to be, but is shaped by acts of interpretation and an unintentional adherence to a formal model derived from the nineteenth-century novel. Moreover,

> Many historians continue to treat their 'facts' as though they were 'given' and refuse to recognize, unlike most scientists, that they are not so much found as constructed by the kinds of questions which the investigator asks of the phenomena before him.[51]

In the attempt to transform dry data about the past into written histories, then, historians have tended to streamline complex events into digestible narratives, they have omitted details that do not fit in, and they have allowed ideologies to shape their interpretations—criticisms that have also been made of historical films. In a later essay which addresses historical film directly, White argues:

> Every written history is a product of processes of condensation, displacement, symbolization, and qualification exactly like those used in the production of a filmed representation. It is only the medium that differs, not the way in which messages are produced.[52]

It might be argued, however, that the 'medium' has a substantial influence over the message. Written histories and historical films may be similar in theory, but in practice they tend to be produced in vastly different ways, distributed to different audiences and readers, and are subject to very different commercial imperatives and expectations. It is perhaps necessary to make a distinction between that which it is *possible* for film to achieve in theory, and the more limited forms typically practiced by the mainstream film industry. Nevertheless, books and films can both be regarded as history in as much as both narrate past events. They draw on similar conventions for representing these events, and they share limitations on the perspective they are able to provide. Written histories may, in practice, adhere to a higher level of scholarship than films, but this is due to the external factors rather than the innate superiority of one medium over the other. Natalie Zemon Davis usefully

[51] White, *Tropics of Discourse*, 43.
[52] Hayden White, "Historiography and Historiophoty," *American Historical Review*, 93/5 (1988): 1194.

suggests that films tend to fall short of written histories in two key areas: 'suggesting the possibility that there may be a very different way of reporting what happened' and 'giving some indication of their own truth status, an indication of where knowledge of the past comes from and our relation to it.'[53] But the problem is not that historical films are incapable of doing these things—a sufficiently creative filmmaker could surely find the means to fulfil these criteria, and someone less creative might simply print footnotes at the bottom of the screen. The problem is that, for a variety of reasons, the majority of filmmakers choose not to.

For these reasons, any dichotomies proposed between 'correct,' 'factual' written history, and 'incorrect,' 'entertainment' historical films, seem at best to be misleading. Journalists, critics, and historians who protest at the errors, elisions, and biases of historical cinema are in some ways doing valuable work; like any form of history, a film is bound to generate (and potentially be enhanced by) additional discourses. However, this attention to authenticity in relation to written sources may obscure a more important point. As Maria Wyke proposes, 'Historians should try to understand not whether a particular cinematic account of history is true or disinterested, but what the logic of that account may be, asking why it emphasizes this question, that event, rather than others.'[54] Alun Munslow has made a similar point: 'Rather than spend our time and much angst on how and why films invariably get the facts wrong and the story crooked, we would be better employed trying to understand history's constructed nature.'[55] In other words, questions about *why* historical films represent the past in particular ways are much more productive and revealing than questions about whether or not they can or should be considered to be authentic. It is also worth noting that while the idea that historical films and books operate on a level playing field might appear to be a postmodern intervention, the idea is in fact not new. In 1936 a House of Lords debate on historical cinema was reported thus:

Lord Moyne returned the only possible answer when he asked how historical truth is to be determined. Hardly by the historians[...] film must have at least as much licence as the historians themselves take. And that is considerable.[56]

[53] Davis, 476.
[54] Wyke, 13.
[55] Munslow, 112.
[56] "Truth and the Film," *Manchester Guardian*, December 10, 1936.

Robert Rosenstone

The most sustained attempt to examine historical films from a historian's perspective has been made by Robert Rosenstone. In a series of essays collected in his books *Visions of the Past: The Challenge of Film to Our Idea of History* (1995) and *History on Film/Film on History* (2006), Rosenstone has outlined a framework in which historical films can be considered a form of history and film directors can be regarded as historians. He identifies his approach to history with the theoretical innovations made by Hayden White, setting out his stall as follows:

> All history, including written history, is a construction, not a reflection. That history (as we practice it) is an ideological and cultural product of the Western World at a particular time in its development. That history is a series of conventions for thinking about the past. That the claims of history to universality are no more than the grandiose claims of any knowledge system. That language itself is only a convention for doing history – one that privileges certain elements ... history need not be done on the page. It can be a mode of thinking that utilizes elements other than the written word: sound, vision, feeling, montage.[57]

Conventional, written histories thus have no monopoly on historical truth, and their centrality in professional scholarship comes at the expense of other forms and techniques which may in fact be well suited to the representation of modern historical events. Rosenstone argues that visual culture, notably films, have the potential to 'change the nature of our relationship to the past,' much as written history once challenged the oral tradition of narrating past events.[58] In this way, historical films have the potential to reveal that 'there may be more than one sort of historical truth, or that the truths conveyed in the visual media may be different from, but not necessarily in conflict with, truths conveyed in words.'[59] As the subtitle of his first book suggests, Rosenstone sees the historical film as a means to challenge and question the pre-eminence of written histories in his professional field and to open it up to alternate forms of representation. Observing the anxiety and mistrust of historical cinema among his peers, he suggests that

> Film is out of the control of historians. Film shows we do not own the past. Film creates a historical world with which books cannot compete, at least

[57] Robert A. Rosenstone, *Visions of the Past: The Challenge of Film to Our Idea of History* (Cambridge: Harvard University Press, 1995), 11.
[58] Ibid., 43
[59] Ibid., 43.

for popularity. Film is a disturbing symbol of an increasingly postliterate world.[60]

In these terms, the ability of historical films to destabilize received wisdom about the way history is written may be a liberating and even constructive force. Rosenstone amplifies this point in a later essay, contending that film 'helps return us to a kind of ground zero, a sense that we can never really know the past, but can only continually play with, reconfigure, and try to make meaning out of the traces it has left behind.'[61] These quotations suggest a willingness to embrace historical cinema, in all its varied forms and practices, as works of history, and to take them seriously on these terms. However, as I will argue, Rosenstone's tolerance for historical cinema's challenge to written history is in fact set within very narrow limits.

Rosenstone has been eager to assert that independent criteria are required to assess the value of historical film, arguing that 'it is impossible to judge history on film solely by the standards of written history.'[62] In a later essay he further emphasizes the distinction between the two forms:

> It is time... to stop expecting films to do what (we imagine) books to do. Stop expecting them to get all the facts right, or to present several sides of an issue, or to give a fair hearing to all the evidence on a topic, or to all the characters or groups represented in a particular situation or to provide a broad and detailed historical context for events.[63]

Rosenstone thus sees historical films as functioning very differently to written histories, and once again his comments also serve to dispute the status of the book as the pre-eminent medium for historical representation. But what, then, should we expect historical films to do? How should they be judged, if not by the same standards as books? According to Rosenstone, critics should not ask whether films 'convey facts or make arguments' as well as written sources. Instead,

> The appropriate questions are: What sort of historical world does each film construct and how does it construct that world? How can we make judgments about that construction? How and what does that construction

[60] Ibid., 46.

[61] Robert A. Rosenstone, *History on Film/Film on History* (Harlow: Pearson Educational, 2006), 164.

[62] Rosenstone, *Visions*, 36.

[63] Rosenstone, *History on Film,* 37.

mean to us? After these questions are answered, we may wish to ask a fourth: How does the historical world on screen relate to written history?[64]

These questions echo comments from Wyke quoted above and they suggest that insights into the constructed nature of historical representation and the specific historical context in which a film is produced are more significant than attempts to reconcile history on film with history produced in alternate media. However, Rosenstone elsewhere appears to hold historical films to much more stringent standards:

> To be taken seriously, the historical film must not violate the overall data and meanings that we already know of the past. All changes and inventions must be apposite to the truths of that discourse, and judgment must emerge from the accumulated knowledge of the world of historical texts into which the film enters.[65]

In contrast to his comments about history being 'a series of conventions for thinking about the past,' Rosenstone appears to suggest here that historical 'truths' are something that historical films may be measured against. And despite his claims that film should not be held to the same standards as written histories, his suggestion that they should be judged according to the 'world of historical texts' seems to propose exactly this. We might also ask, taken seriously by whom? Which group or faction has the responsibility to decide whether or not historical films deserve to be taken seriously? It is hard not to conclude that Rosenstone is in fact reasserting the traditional role given to professional historians as gatekeepers in the production of historical representation.

From these criteria, a distinct taxonomy of historical films emerges. Rosenstone separates films into three 'broad categories': 'history as drama,' 'history as document,' and 'history as experiment.'[66] In later work, these categories are refined and renamed 'mainstream drama,' 'documentary,' and 'innovative drama.'[67] 'History as drama' falls short of Rosenstone's criteria for history on film due to its insistence on visual realism, its use of morally uplifting narratives, its focus on emotionally engaging individuals as agents of historical change, and its presentation of the past as a closed, completed system.[68] In this way, he likens historical dramas with 'more popular, uncritical

[64] Rosenstone, *Visions*, 50.
[65] Ibid., 79.
[66] Ibid., 50.
[67] Rosenstone, *History on Film*, 14.
[68] Rosenstone, *Visions*, 55–59.

forms of written history, the kind history "buffs" like.'[69] Rosenstone identifies 'history as drama' with Hollywood cinema, whose popularity he evidently finds disquieting:

> When historians think of history on film, what probably comes to mind is what we might call the Hollywood historical drama... Like all genres, this one locks both filmmaker and audience into a series of conventions whose demands – for a love interest, physical action, personal confrontation, movement towards a climax and denouement – are almost guaranteed to leave the historian of the period crying foul.[70]

This statement is problematic, first because it is not supported anywhere in Rosenstone's work by a survey of such 'Hollywood historical dramas' and their conventions for historical representation. Secondly, even if we assume that mainstream historical films across all periods of Hollywood history are bound to a flawed and restrictive model of historical narration, it is surely worthwhile asking why this might be the case. Why have Hollywood films represented the past in these narrow terms? To recall Rosenstone's earlier question, rather than dismissing such a broad range of Hollywood historical films, is it not more valuable to attempt to understand them by asking 'what sort of historical world... each film construct[s] and how does it construct that world?'

Rosenstone's main focus is 'history as experiment' or 'innovative drama,' a category he describes as being in 'conscious opposition to Hollywood codes.'[71] As before, the category is presented in terms of the tastes of professional historians:

> All historians who feel a need to resist the empathic story told in Hollywood films, with its "romantic" approach and its satisfying sense of emotional closure, will find themselves at one with many Western radical and Third World filmmakers who have had to struggle against Hollywood codes of representation in order to depict their own social and historical realities.[72]

History as experiment includes films which are 'analytic, unemotional, distanced, multicausal; historical worlds that are expressionist, surrealist, disjunctive, postmodern; histories that do not just show the past but also talk about how and what it means to the filmmaker (or to us) today.'[73] Presented

[69] Ibid., 53–54.
[70] Ibid., 29–30.
[71] Rosenstone, *History on Film*, 50.
[72] Rosenstone, *Visions*, 39.
[73] Ibid., 61.

in this category are Sergei Eisenstein's Soviet histories *Battleship Potemkin* (1925) and *October* (1928), Roberto Rossellini's TV drama *The Rise to Power of Louis XIV,* Chris Marker's personal documentary *Sans Soleil* (1982), Ousmane Sembene's Senegalese drama *Ceddo* (1977), and Brazilian director Carlos Diegue's *Quilombo* (1986). Rather than purporting to 'open a window directly onto the past,' as in the realistic style of Hollywood dramas, these films 'open a window into a different way of thinking about the past.'[74] Evidently, Rosenstone identifies these films with terms of Hayden White's earlier call for a 'surrealistic, expressionistic, or existentialist historiography' which might counter the antiquated, pseudo-realistic literary techniques used in conventional history writing.[75] 'Such works,' Rosenstone suggests, 'provide the possibility of what might be called a "serious" historical film, a historical film that parallels – but is very different from – the "serious" scholarly or written history.'[76] Once again, the hallmark of a good historical film is its seriousness, or perhaps the ability for professional historians to take it seriously. It also seems that while Rosenstone has stated that historical films should be judged independently of history books, 'serious' written history remains his overriding reference point when evaluating the properties of films.

Rosenstone's work has done a great deal to advance the study of historical cinema and to promote the acceptance of films as works of history within academia. However, his notion of what should constitute a 'serious' historical film produces a selection of films which on the one hand is remarkably small and exclusive, and on the other is incredibly disparate in terms of the production context and place in which they were made, and the periods which they represent. This preference for esoteric, experimental, anti-illusionist filmmaking comes at the expense of the long tradition of more popular historical films produced in Hollywood since the 1910s. Only a small number of recent Hollywood films meet his criteria: *JFK* (1991), which he describes as being 'among the most important works of American history ever to appear on the screen,' *Walker* (1987), and, with reservations, *Glory* (1989).[77] For better or worse, Hollywood representations of history have had a huge impact on popular understandings of the past, and for all the shortcomings of individual films, they remain invaluable as documents from their own time and as works of history. It is also problematic that Rosenstone plays very little attention to the individual production histories of the films he examines. By neglecting the cultural forces that shaped them as they were produced and examining them only in relation to the historical events

[74] Ibid., 63.

[75] White, *Tropics of Discourse*, 43.

[76] Rosenstone, *Visions*, 53.

[77] Robert A. Rosenstone, "*JFK*: Historical Fact/Historical Film," *American Historical Review*, 97/2 (1992): 511.

they represent, he reduces their complexity as historical artifacts of their own time. James Chapman has suggested some of the ways in which this inattention to 'production determinants and political restraints' limits his case study analysis of *October*.[78] Rosenstone might also be said to be more interested in the reception of historical films among fellow historians than among the filmgoing public in general. Broader histories of reception, which would suggest ways in which the films he examines relate to public opinion at their time of release, are not mentioned. Indeed, it should be noted that Rosenstone pays very little attention to the work of academic film studies in general, despite its overlapping areas of interest. Ultimately, Rosenstone's conception of the historical film is too narrow, too specialized, and too much of an exacting standard to account for the genre in all its complex forms.

Historical films tend to be built from the details up—working backwards from the surface, perhaps—and often seek to overwhelm viewers with material evidence evoking the past. But a surfeit of realistic visual detail does not in itself recreate the past, and the ability of certain iconographies to evoke given periods may be a function of their familiarity to contemporary audiences rather than their authenticity. On the narrative level, conversely, many historical films frequently gesture towards the present in which they were produced. Even when direct analogies are not apparent, critics have often interpreted historical films as reflections of the present first and representations of the past second. These contradictory impulses—towards the materiality of the past on the one hand and towards the cultural contexts of the present on the other—partly explain why many writers and historians have been suspicious and dismissive of historical cinema. Time and time again, historical films have been compared to written histories and have been found wanting. Even Robert Rosenstone, who has based his approach to historical cinema around the contention that historians should be open to non-written forms of historical representation, ultimately finds that very few historical films are suited to the task. However, the practice of transforming data about the past into a communicable form inevitably involves compromises, elisions, and the potential for distortion, and it seems to be that the written word is no more innately suited to this process than any other medium. I would suggest that historical films should be regarded as works of history in as much as they are narrative interpretations of past events. Like books, some of them undertake this process well and some of them do it badly. It is possible to argue that many historical films are inadequate as works of history, but it is quite different to suggest that there is something innate to film as a medium which makes it unsuited to the task of historical

[78] James Chapman, review of *History on Film/Film on History*, last modified December 1, 2009, www.history.ac.uk/reviews/review/629.

representation. Moreover, as I have already suggested, it is more interesting and important to ask *why* films represent the past than to ask how well they have done it. The preoccupation with accuracy and authenticity which has been part of so many discussions of historical cinema is understandable and to some extent valuable, but these debates reveal more about the anxieties which historical films have generated among critics and historians than they do about the specific ways in which historical films have engaged with the past over time.

3

Hollywood historical cinema up to World War II

The following three chapters provide a history of the historical film in Hollywood up to the present day. Chapter 3 examines the emergence of historical filmmaking in the 1890s up to the end of World War II, including the 'classical era' of Hollywood filmmaking in the 1920s and 1930s. Chapter 4 addresses the ways in which Hollywood production and exhibition shifted in the late 1940s and early 1950s and examines the rise and fall of the large-scale historical epic, concluding in the late 1960s. Chapter 6 looks at developments in historical filmmaking from the New Hollywood era in the late 1960s and 1970s up to the re-emergence of the historical epic in the late 1990s and 2000s. Following the definition of the historical film established in Chapter 1, this historical survey casts a wide net and attempts to broaden the corpus of films which can be identified as 'historical.' As Kristin Thompson and David Bordwell have argued, working on such a 'wide canvas' has advantages: 'new patterns of information may leap to the eye, and fresh causal and functional connections may become more visible.'[1] At the same time, giving an account of every significant historical film produced during this hundred years-plus period would be exhausting and possibly unproductive. Instead, this section focuses on the key films, production cycles, and industrial trends which characterize the development of historical cinema in the American film industry, and which in the broadest sense can be considered representative of the genre in its entirety.

[1] Kristin Thompson and David Bordwell, *Film History: An Introduction* (New York: McGraw Hill, 1994), xlii.

Silent histories

The roots of the historical film in America can be traced back to the late nineteenth century, many years before the term 'Hollywood' was publicly associated with filmed entertainment. Material produced during the emergence of cinema tended to be orientated around sensation and spectacle rather than the presentation of sustained narratives. Nevertheless, the existence and indeed the popularity of films depicting the past usefully contextualize the historical engagements made subsequently as the American film industry matured. In 1895 the Edison Manufacturing Company produced a number of very short films based on historical iconography for its Kinetoscope device, including *Joan of Arc*, *Rescue of Capt. John Smith by Pocahontas*, and *The Execution of Mary Queen of Scots* (all 1895).[2] Only the latter survives; lasting less than a minute, it is essentially a 'trick shot' dramatization of the beheading using a hidden cut to allow the actor playing Mary to be substituted for a dummy. Despite the relatively detailed Elizabethan costumes worn by 12 visible performers, it seems most likely that the film's main attraction was its gruesome content rather than its evocation of the past. In 1901 the Edison Company returned to the execution theme in a film depicting the electrocution of Leon Czolgosz, who was convicted of assassinating President McKinley the same year. *Execution of Czolgosz with Panorama of Auburn Prison* (1901) consists of two sections: in the first, a camera pans slowly around the exterior of the prison where Czolgosz was held; in the second, the prisoner is led from his cell to an electric chair where he is wired up and proclaimed dead. The first section was filmed at the real location on the morning of the actual execution, while the second was a reconstruction based on 'the description of an eye-witness.'[3] In terms of its coherent evocation of historical time and place, *Execution of Czolgosz* is notably more sophisticated than *The Execution of Mary Queen of Scots* and in this way it reflects the rapid development of filmmaking grammar in the early years of the medium. Moreover, its amalgamation of documentary footage and reconstruction might be said to muddy the distinction between representation and reality in a way that prefigures the subsequent development of the historical film in America.

As the American film industry expanded and audiences poured into nickelodeon theaters, producers began to develop films with longer and more complicated narratives. Commonly known as 'features,' these extended productions redefined industry conventions by using multiple reels of film,

[2]Charles Musser, *Before the Nickelodeon: Edwin S. Porter and the Edison Manufacturing Company* (Berkeley: University of California Press, 1991), 56.
[3]Quoted in Ibid., 186–9.

although at first the reels were not always shown together.[4] The Vitagraph Company was at the forefront of these developments, producing a cycle of relatively lavish and expensive feature films which were often based on historical material. Examples include historical literary adaptations such as *Antony and Cleopatra* (1908) and *Les Misérables* (1909), the historical biopics *The Life of Napoleon* (1909) and *The Life of George Washington* (1909), and the biblical narrative *The Life of Moses* (1909). These extended films proved popular with audiences, but as William Uricchio and Roberta Pearson have argued, they also served to mollify patrician anxieties about the malign influence of cinema on audiences and to improve the cultural status of America's burgeoning film industry.[5] In the words of the vice-president of the recently formed Motion Picture Patents Company, speaking in 1910:

> When the works of Dickens and Victor Hugo, the poems of Browning, the plays of Shakespeare and the stories of the Bible are used as a basis for moving pictures, no fair-minded man can deny that the art is being developed along the right lines.[6]

The early 1910s also saw the first multi-reel European films imported to the American market.[7] In particular, Italian-made epics set in the ancient world made an enormous impact on American audiences and filmmakers, intensifying the connection between spectacular historical narratives and cultural prestige. *The Last Days of Pompeii* (1913), released in eight reels, was followed by *Quo Vadis?* (1913), also eight reels, and the twelve-reel *Cabiria* (1914). As Hall and Neale have shown, the American distributors of these Italian imports pioneered innovative exhibition practices to emphasize prestige and maximize profit, booking them initially into 'legitimate' Manhattan theaters (rather than nickelodeons) at inflated ticket prices, and subsequently touring the films around the country in a process known as 'roadshowing.'[8] In addition, *Cabiria* was admired for the spectacular scale and detail of its sets, which were skilfully emphasized by editing within scenes, panning movements, and brief tracking shots which moved the camera forward into the depth of the image. The latter technique was considered so novel in America that it became known as the 'Cabiria movement.'[9]

[4] Sheldon Hall and Steve Neale, *Epics, Spectacles, and Blockbusters: A Hollywood History* (Detroit: Wayne State University Press, 2010), 19.
[5] William Uricchio and Roberta E. Pearson, *Reframing Culture: The Case of the Vitagraph Quality Films* (Princeton: Princeton University Press, 1993), 5.
[6] Quoted in Ibid., 48.
[7] Eileen Bowser, *The Transformation of Cinema, 1907–1915* (New York: Charles Scribner's Sons, 1990), 197.
[8] Hall and Neale, 28–9; Bowser, 192.
[9] Bowser, 251.

These spectacular ancient world films made a lasting impact with some of the more ambitious film directors working in America at the time. A screening of *Quo Vadis?* motivated D. W. Griffith to attempt an epic of his own: *Judith of Bethulia* (1914), adapted from the Old Testament book of Judith.[10] At four reels, it was the first feature film of Griffith's career, but disagreements with his production company delayed and muted its release. Griffith turned to American history for his follow-up feature, *The Birth of a Nation* (1915), which depicted the Civil War and its aftermath in the American South. Released in twelve reels with an estimated production cost of $110,000, the film emulated the scale and ambition of the Italian epics and was distributed in a similar way, opening at a legitimate New York theater and later roadshowing throughout America.[11] Contemporary critics noted its similarity to imported historical films: in what might be considered a back-handed complement, the New York *Morning Telegraph* claimed that 'nothing so stupendous, so elaborate and so thrilling has ever before been attempted by an American director.'[12] *The Birth of a Nation* generated controversy due to its highly partisan depiction of American history, which emphasized the wickedness of African Americans during the Reconstruction period and painted the Ku Klux Klan as heroes. Its account of the Civil War was endorsed by President Woodrow Wilson, who supposedly described the film as 'writing history with lightning,' but it met with protests from the National Association for the Advancement of Colored People, among others, in many cities where it was shown.[13] In fact, as Robert Rosenstone has suggested, the film 'was neither a bizarre personal nor purely commercial interpretation of the Civil War, but in fact a fairly decent reflection of the best academic history of its own time.'[14] Although it predates reliable box office records, *The Birth of a Nation* is assumed to have been the greatest commercial success of the silent era.[15] According to Robert Burgoyne, it also stands as the first serious historical film in America due to its attempt 'to offer an explanation and interpretation of history.'[16]

Griffith may have attempted to address critical responses to *The Birth of a Nation* with his next historical epic, *Intolerance*, released in 1916. The twelve-reel film was organized around the theme of man's intolerance through history and consisted of four parallel historical episodes: the fall

[10] Hall and Neale, 34.

[11] Richard Koszarski, *An Evening's Entertainment: The Age of the Silent Feature Picture, 1915–1928* (New York: Charles Scribner's Sons, 1990), 2.

[12] Quoted in Alex Ben Block (ed.), *George Lucas's Blockbusting* (New York: George Lucas Books, 2010), 42.

[13] Melvyn Stokes, *D. W. Griffith's* The Birth of a Nation: *A History of 'The Most Controversial Motion Picture of All Time'* (Oxford: Oxford University Press, 2007), 227.

[14] Rosenstone, *History on Film/Film on History*, 23.

[15] Koszarski, 31.

[16] Burgoyne, *Hollywood Historical Film*, 26.

of ancient Babylon, the crucifixion of Christ, the St. Bartholomew's Day Massacre in sixteenth-century France, and events in contemporary America. Historical and biblical eras such as these had been depicted in other films of the period, but Griffith's presentation of them was unique. The film edits between its historical settings, back and forth across time, creating what the subtitle of the film described as a 'drama of comparisons.' As Burgoyne suggests, this unusual narrative structure argues for 'a universal historical patterning.'[17] *Intolerance* was acclaimed as the 'apex of the motion picture art,' but unlike *The Birth of a Nation*, it was only a moderate success with audiences.[18] Nevertheless, Griffith's inventiveness and commercial appeal helped establish an identity for American historical films which emphasized extended length, expensive spectacle, cultural prestige, commercial value, and artistic aspiration. Appraising *The Birth of the Nation*'s impact on its twentieth anniversary, the critic Seymour Stern wrote: 'the cinema became at one stroke a self-respecting art... film was delivered from the gaudy dominion of the vaudeville show.'[19]

Between 1916 and the end of the decade, the American film industry was transformed. Now primarily located in Los Angeles, film production was streamlined into a factory process undertaken by large, vertically integrated companies which, from 1919, cooperated to dominate the domestic market in an increasingly oligopolistic manner. As profits rose, so did capital investment, and while Europe went to war between 1914 and 1918 Hollywood was able to consolidate its presence in film markets across the globe. As Thomas Schatz has suggested, a delicate balance of social, industrial, and aesthetic forces generated a 'consistent system of production and consumption, a set of formalized creative practices and constraints, and thus a body of work with a uniform style.'[20] Amid this stability, the historical film continued to develop. The second major American director to produce a multi-reel epic was Cecil B. DeMille, whose *Joan the Woman* was released in 1916 by the Famous Players–Lasky company. A spectacular biography of Joan of Arc presented as the vision of a World War I soldier, *Joan the Woman* was a popular success but its box office takings were eclipsed by its mammoth production and distribution costs.[21] As with Griffith's historical films, the marketing of *Joan the Woman* emphasized prestige, but other film producers sought to exploit more sensational aspects of the past. In particular, the Fox company produced

[17] Ibid., 27.

[18] Quoted in Simon Louvish, *Cecil B. DeMille and the Golden Calf* (London: Faber and Faber, 2007), 119.

[19] Seymour Stern, "Birthday of a Classic," *New York Times*, March 25, 1935.

[20] Thomas Schatz, *The Genius of the System: Hollywood Filmmaking in the Studio Era* (London: Faber and Faber, 1998), 8.

[21] Louvish, 129.

a series of historical films based on the highly sexualized persona of star actress Theda Bara: *Cleopatra* and *Madame Du Barry* (both 1917), *Salome* (1918). In the advertising for the first, Cleopatra was identified as 'the most famous vamp in history' and Bara as her modern 'reincarnation.'[22] According to Hall and Neale, the popularity of Bara's films helped broaden the social status of historical and literary productions by appealing to a new kind of audience.[23] Popular historical spectacle was also provided in the adventure films of Douglas Fairbanks, one of the biggest stars of the silent era. His early films cast him as a kind of American Everyman, but as he assumed greater creative control in the 1920s he transferred his romantic, humorous, acrobatic persona into a series of swashbuckling period epics in a variety of spectacular settings: chivalric medieval pageantry in *Robin Hood* (1922), Orientalist fairytale in *The Thief of Baghdad* (1924), and an experimental Technicolor seascape in *The Black Pirate* (1926). As Gaylyn Studlar has suggested, Fairbanks' decision to locate these films in the real or legendary past allowed him to repeat the same comic, romantic pleasures he had established in his earlier films 'within an epic, prestige picture format' that broadened his popular appeal.[24]

During the 1920s, many of Hollywood's biggest commercial successes were made in the epic historical mold. Based on the period leading to World War I and set in Argentina and Europe, *The Four Horsemen of the Apocalypse* (1921) became one of the most popular films of the decade with gross earnings estimated between $4 million and $5 million.[25] The film's success was due in large part to the massive appeal of Rudolph Valentino, who appeared in his first major role, but the film was also rapturously received by American critics. The *New York Times* remarked that 'the humbly popular art has reached outward toward the infinite and upward to the pinnacle of great deeds,' while in *Life* magazine Robert Sherwood described it as a 'living, breathing answer to those who still refuse to take motion pictures seriously.'[26] The wartime theme of *The Four Horsemen of the Apocalypse* was revisited in *The Big Parade* (1925), which presents the experiences of three American servicemen on the Western Front. Exhibited in roadshow fashion, the film ran for a record-breaking 96 weeks in New York on its way to a worldwide gross of over $6 million.[27] American experience was also at the center of a cycle of prestigious, epic westerns, the most notable of which were *The Covered Wagon* (1923) and *The Iron Horse*, directed by John Ford in 1924. The former

[22] Quoted in Wyke, 89.
[23] Hall and Neale, 45.
[24] Gaylyn Studlar, *This Mad Masquerade: Stardom and Masculinity in the Jazz Age* (New York, Columbia University Press, 1996), 80.
[25] Hall and Neale, 53.
[26] John Corbin, "An Epic of the Movies," *New York Times*, March 27, 1921; Quoted in Block, 82.
[27] Hall and Neale, 58–9.

reframed the already familiar iconography of the western genre by shifting emphasis from stars to visual authenticity and spectacle, which were evoked through extensive location photography in Nevada and Utah.[28] As Richard Slotkin has suggested, the use of conventions associated with historical epic cinema in these films had a lasting impact on the western genre: 'these epics expanded the repertoire of the genre beyond the allegorical simplicities of the moral melodrama. It was now possible to set a dignified and 'historical' fable in western dress.[29] But although the late 1910s and 1920s saw the expansion of American historical cinema into new areas, traditional epics based in Biblical and ancient world settings remained popular. In particular, MGM's *Ben-Hur: A Tale of the Christ* (1925), adapted from Lew Wallace's bestselling 1880 novel, combined the spectacle of Roman imperialism with the piety and moral uplift of the Christ story. A commercial failure on initial release due to production costs of $4 million, the film nevertheless cemented the relationship between historical subjects, spectacle, and prestige in American cinema prior to the arrival of the talking film.[30]

The 1930s: Biopics, prestige films, and internationalism

The unexpected popularity of synchronized sound in the late 1920s, combined with the wider impact of the Great Depression, led to considerable adjustments in Hollywood's production and exhibition practices. The aesthetic and technological effects of the former are well documented, but the industry-wide retrenchment necessitated by the latter proved to be a sterner challenge for filmmakers. Compared to the excesses of the silent era, many of the most notable historical films of the 1930s were relatively modest in terms of their spectacle, duration, and cost. According to Hall and Neale, only 'around a dozen' films produced in Hollywood between 1931 and 1934 cost more than $1 million to produce.[31] The historical film nevertheless remained a key production category in Hollywood, counting for many of its greatest commercial and critical successes. Indeed, Hollywood mogul Daryl F. Zanuck was reputed to be so fond of historical material that some referred to his

[28] Koszarski, 248.

[29] Richard Slotkin, *Gunfighter Nation: The Myth of the Frontier in Twentieth-Century America* (Norman: University of Oklahoma Press, 1992), 253.

[30] Eddie Mannix Ledger, Margaret Herrick Library, Center for Motion Picture Study, Los Angeles. See also Mark H. Glancy (ed.), "The Eddie Mannix Ledger," *Historical Journal of Film, Radio and Television*, 12/2 (1992), microfiche supplement.

[31] Hall and Neale, 89.

studio as '19th Century Fox.'[32] For much of the decade, historical cinema was associated with three related trends: biographical films depicting the deeds of great men, films which looked to the past in order to add prestige to the movie industry, and an international outlook which valued European history over that of America.

These trends were combined in one of the first major historical films of the 'talking picture' era: *Disraeli,* produced by Warner Bros. in 1929. Adapted from a 1911 stage play, the film cast British actor George Arliss as the Victorian Prime Minister Benjamin Disraeli, a role he originated on stage and had previously performed for the camera in a 1921 adaptation. The marketing of the film lent heavily on Arliss' fame as a thespian and the ability of the talking film to compete with the 'legitimate' theater. According to its advertising copy, the film 'dwarfs the stage with its perfect presentation of one of the theatre's great masterpieces.'[33] From the outset, *Disraeli* emphasizes the act of speaking as a spectacle in its own right: its opening scene is a public speech in Hyde Park in which the Prime Minister is denounced as a foreigner, and Arliss makes his first appearance in the House of Commons where he delivers a rousing defence of his expansionist foreign policy. The bulk of the drama concerns Disraeli's efforts to purchase the Suez Canal, which he sees as a means to protect Britain's imperial possessions in Asia, in the face of attempted sabotage from genteel Russian spies and the personal antipathy of the Governor of the Bank of England. Disraeli's sly intelligence and skill at 'play acting' (an internal reference to Arliss' own acting prowess) allow him to outwit these antagonists while barely leaving the drawing rooms of his own house, and in the final scene his rather presumptuous purchase of the canal is validated by Queen Victoria in person. *Disraeli*'s use of a relatively obscure episode in British diplomatic history and its emphasis on theatrical modes of performance might have made it a hard sell, but the film played in Los Angeles and New York for longer than any other Warner Bros. film during the 1930s and earned rentals of almost $1.5 million internationally.[34] Perhaps more importantly, *Disraeli*'s links to Old World history and middlebrow culture was good for public relations. The Warner Bros. press department declared that *Disraeli* was made in order to 'increase the prestige of talking pictures,'

[32] Guy Barefoot, *Gaslight Melodrama: From Victorian London to 1940s Hollywood* (London: Continuum, 2001), 53.

[33] Quoted in Altman, 39.

[34] Hall and Neale, 91; Mark Glancy (ed.), "William Schaefer Ledger," Historical Journal of Film, Radio and Television, 15/1 (1995), microfiche supplement, 8. Between the 1920s and the 1980s the box office performance of films was typically measured in rental income. A film's rental revenue is the amount of money paid to its distributor after the exhibitors have deducted their costs and profits.

but it seems more likely that the prestige was intended to reflect primarily on Warner Bros. themselves.[35]

Disraeli was an early example of the biopic, a genre which George F. Custen liberally defines as being 'minimally composed of the life, or part of a life, of a real person whose real name is used.'[36] Custen calculates that between 1927 and 1960 the eight principal Hollywood studios produced almost 300 films of this type.[37] Biopics tend to narrate a particular version of history: a top-down approach where social change is attributed to the charisma, heroism, and/or wisdom of great men (and occasionally women). At the same time, the Hollywood biopic tends to personalize history, foregrounding the psychological motivation of the hero and presenting his/her life as a series of individualized, easily understandable conflicts. This form of narration, combined with the casting of star actors, encourages the audience to identify with the historical figures on display, presenting them as simultaneously normal and extraordinary.[38] The tendency to associate major stars with major historical figures can be seen in the career of George Arliss. Following *Disraeli* he was cast as the lead in a further series of biopics, mostly based on European history, including *Alexander Hamilton* (1931), *Voltaire* (1933), and *Cardinal Richelieu* (1935). In the same period, the popularity of the British import *The Private Life of Henry VIII* (1933) led Hollywood producers to develop biopics that focused on European royalty, principally the relationship between their personal lives and their public personae. This approach became more common in the treatment of female historical figures. *The Scarlet Empress* (1934), starring Marlene Dietrich, presented the rise of Catherine the Great as a sequence of seductions and sexual betrayals, while *Marie Antoinette*, MGM's major release of 1938, depicted its protagonist's role in history as a coming-of-age story. In both cases, intrigues and collusions staged behind closed doors are prioritized over public activities.

Perhaps the most celebrated biopics of the 1930s were produced by Warner Bros. starring Paul Muni and directed by William Dieterle. Most famously, *The Story of Louis Pasteur* (1936) deals with the scientist's battle for medical acceptance of his theories about germs, and *The Life of Emile Zola* (1937) concerns Zola's decisive involvement in the Dreyfus case. Both were highly successful, reporting international rentals of $1.1 and $2 million respectively, and both demonstrated the moral seriousness of the cinema in the face of increased censorship.[39] By this time, the conventions of the

[35] Quoted in J. E. Smyth, *Reconstructing American Historical Cinema: From Cimarron to Citizen Kane* (Lexington: University Press of Kentucky, 2006), 57.
[36] Custen, 6.
[37] Ibid., 3.
[38] Ibid., 19.
[39] Glancy (ed.), "William Schaefer Ledger," 16, 18.

biopic were relatively settled. Both Pasteur and Zola were lone voices of conscience and reason, supported by their families but obstructed by more powerful establishment figures. From the privileged perspective of the present, the audience can be in no doubt about who is in the right. Reflecting on the success of these films while planning the biopic *Young Mr. Lincoln* (1939), screenwriter Lamar Trotti defined the formula accordingly:

> In my opinion, the basic need of this story is a major theme, or purpose. In every great character story on the screen... the principal character, or characters, have battled against something great for something great.[40]

As Thomas Elsaesser suggests, biopics generate much of their moral intensity by engineering situations where the virtuous hero presents his case through a theatrical, impassioned speech before a public audience which stands in for the film viewer.[41] In *The Life of Emile Zola* this moment occurs as Zola addresses a jury and makes a six-minute appeal not simply for Dreyfus' innocence for the honor of 'a great nation.' A closing oration at Zola's funeral connects Zola's life to the contemporary situation in Europe, warning the audience not to 'applaud the lies of fanatical intolerance' and praising Zola's decision to intervene in a battle that he might easily have ignored. In this way, the moral challenges faced in the past of the Old World were made relevant at a moment when Europe (and America) stood on the edge of war.

Cecil B. DeMille was as much a key figure in the historical cinema of the 1930s as he had been in the silent era, and his ancient world films provide a bridge between historical cinema in the 1930s and the even grander epics of the 1950s. Despite the relatively frugal $600,000 budget set by Paramount, *The Sign of the Cross* (1932) was advertised as 'the first talking picture spectacle.'[42] The drama was based on the persecution of early Christians by the mad, depraved Emperor Nero, played by Charles Laughton (perhaps initiating the trend for casting British actors as Roman dignitaries). In addition to spectacle, *The Sign of the Cross* was marketed on the basis of its sexual content, most notoriously a scene where Claudette Colbert bathes naked in asses' milk and brazenly invites a female companion to join her. According to press material, the film pitted 'the faith of the Christians against the sex-mad pagan lust.'[43] A *Motion Picture Herald* review suggested that audiences would appreciate the film 'provided their sensibilities survive the odors of

[40] Quoted in Custen, 136.
[41] Thomas Elsaesser, "Film History as Social History: The Dieterle/Warner Brothers Bio-Pic," *Wide Angle* 8/2 (1986): 25.
[42] Hall and Neale, 98.
[43] Quoted in Louvish, 313.

Lesbos and de Sade.'[44] This prurience was quite at odds with the respectability of other 1930s historical films, notably Warner Bros.' biopics, but DeMille carefully avoided censure by presenting the overt sexuality as a Roman vice and ultimately showing the triumph of Christianity over paganism.

DeMille's next major film was *Cleopatra* (1934). As an account of the intersecting personal and political adventures of a major historical figure, it might easily be regarded as a biopic, but due to its exotic, excessive historical spectacle it has usually been identified as an epic. Indeed, the creation of spectacle is closely associated with Cleopatra herself. In order to seduce Mark Antony for her political advantage she arranges a series of dazzling, erotic events, including a fishing-net filled with semi-nude women bearing jewels inside clamshells, and more women dressed in tiger skins who are whipped by leather-clad soldiers and jump through rings of fire. As Maria Wyke has suggested, for all its historical otherness, *Cleopatra* can also be seen as 'a comedy of manners in modern dress' and 'a vehicle for the exploration... of contemporary concerns about gender, sexuality and ethnicity in 1930s America.' [45] For all the power she exercises over men in the early part of the film, Cleopatra ultimately submits to Mark Antony's political ambitions, declaring 'I'm no longer a queen, I'm a woman.' According to Wyke, the film 'displays a minatory vision of the New Woman only to contain her eventually within the safe bounds of conventional romance.'[46] *Cleopatra* was followed by *The Crusades* (1935), which DeMille described as 'an epic of the early days of the church.'[47] However, the film was a financial failure and, according to Hall and Neale, 'the ancient world epic was effectively put on hold until the 1950s.'[48]

The creative possibilities of the sound film also led to a new cycle of literary adaptations. The first major success was *Little Women* (1933), produced by David O. Selznick for RKO and based on Louisa May Alcott's Civil War-era family drama. Selznick joined MGM on the heels of *Little Women*'s box office success and produced an all-star adaptation of Charles Dickens' *David Copperfield* (1935). The film took rentals of almost $3 million, including a very strong overseas performance, confirming Selznick's belief that 'the public has finally decided to accept the classics as motion picture fare.'[49] Warner Bros. also invested heavily in bringing classical literature to the screen in their lavish production of *A Midsummer Night's Dream* in 1935. The material derived from a spectacular stage production mounted by Austrian director

[44] Quoted in "*The Sign of the Cross*," *AFI Catalog*.
[45] Wyke, 91, 94.
[46] Ibid., 97.
[47] Quoted in "The Crusades," *AFI Catalog*.
[48] Hall and Neale, 99–100.
[49] Quoted in Schatz, *Genius of the System*, 168.

Max Reinhardt which toured internationally, including an acclaimed run at the Hollywood Bowl in 1934. Warner's film aimed to recreate Reinhardt's theatrical staging for the screen, importing Reinhardt as director (in collaboration with William Dieterle) and several of his creative personnel. In this way, the film packaged European high art with an existing production whose commercial pedigree has been proven. Press material urged exhibitors to emphasize this combination of prestige and marketability, proposing that the collaboration of Shakespeare and Reinhardt united 'the greatest money-names of the theatre.'[50] *A Midsummer Night's Dream* was well received by critics and met approval from cultural groups eager to promote higher standards in the cinema, but its international rentals of $1.2 million were a relatively disappointing return on its mammoth $1 million budget.[51] When MGM's *Romeo and Juliet* proved to be an outright commercial failure in 1936, *Variety* ran a headline declaring 'the Bard a B.O. Washout.'[52]

Despite these mixed results, Hollywood's investment in Dickens and Shakespeare suggests that American producers in the 1930s were frequently drawn to the British past. In a 1936 film review *Variety* noted that 'Hollywood… seems of late to have gone into the serious business of perpetuating British history.'[53] The film in question was *Lloyds of London* (1936), a 20th Century Fox production detailing the fortunes of a young employee with the famous London insurance company during the Napoleonic Wars. In its opening credits, the film thanked 'the official historian of Lloyds of London in the preparation of the historical background for this production.' More often, however, Britain's past was presented as a site of adventure—a spectacular backdrop for masculine heroism where good inevitably overthrows tyranny. In MGM's *Mutiny on the Bounty* (1935), for example, the crew of an eighteenth-century naval ship revolt against their barbaric, overbearing captain and establish a new life on an idyllic Pacific island, in the process cutting their ties to their homeland. As Brian Taves suggests, the narrative is 'a small-scale allegory of revolution… espousing the right of a people to free themselves from oppression.'[54] Budgeted at almost $2 million, *Mutiny on the Bounty* was a major gamble for MGM, but with international rentals of $4.5 million it emerged as their biggest success in ten years.[55] Similar anti-authoritarian themes can be seen in the cycle of lavish historical swashbucklers produced by Warner Bros. starring Errol Flynn. Dubbed by Nick Roddick the 'Merrie

[50] Quoted in Russell Jackson, *Shakespeare's Films in the Making: Vision, Production and Reception* (Cambridge: Cambridge University Press, 2007), 60.
[51] Glancy (ed.), "William Schaeffer Ledger," 16.
[52] Quoted in Hall and Neale, 103.
[53] "Lloyds of London," *Variety*, December 2, 1936.
[54] Taves, 169.
[55] Eddie Mannix ledger.

England' cycle, they include *Captain Blood* (1935), *The Adventures of Robin Hood* (1938), and *The Sea Hawk* (1940). 'In all of the films,' Roddick suggests, 'Flynn becomes the more or less persecuted and isolated defender of a legitimate, benevolent authority which is threatened with usurpation or subversion.'[56] In *Robin Hood*, for example, Robin is set against the despotic Prince John who has taken the throne in the absence of the good King Richard. Perhaps reflecting the tough economic climate in which the film was produced, England's working poor are the principal victims of Prince John's tyranny, leading Robin to make an oath 'to despoil the rich only to give to the poor, to shelter the old and hopeless, and to protect all women, rich and poor, Norman and Saxon.' Produced for just over $2 million, Warner's highest budget up to that point, *Robin Hood* was immensely profitable with international rentals of almost $4 million.[57]

The association of British history with masculine adventure was also expressed in a cycle of Hollywood films set in Britain's nineteenth-century Empire, predominantly India. However, in contrast to other Hollywood-British adventure films, the political content of the Empire cycle tended to be less egalitarian and more hostile to anti-authoritarian activity. *Lives of a Bengal Lancer* (1935), produced by Paramount, is often credited with initiating the Empire cycle.[58] In many ways a variation on the conventions of the Hollywood western, *Lancer* examined life on the frontier (in this case the Northwest Frontier) and the conflicts between white soldiers and the indigenous people they attempt to displace. The film climaxes as the British military put down an attempted mutiny and restore order to the Raj. Mutinous Indians returned again in films including RKO's *Gunga Din* (1939), loosely based on Rudyard Kipling's poem, and Warner Bros.' *The Charge of the Light Brigade* (1936), even more loosely based on an episode from the Crimean War. Jeffery Richards has suggested that the Empire films of the 1930s reflected nineteenth-century attitudes to imperialism rather than contemporary ideas.[59] Conversely, Prem Chowdhry has argued that films depicting Imperial India were very much a response to colonial nationalist activity and aimed to 'demolish nationalist rhetoric' by emphasizing divisions within the Indian population and depicting a 'vast reservoir of loyalty for the British.'[60] For some in America, Hollywood's interest in the empire building of a rival political

[56] Nick Roddick, *A New Deal in Entertainment: Warner Bros. in the 1930s* (London: BFI, 1983), 236.

[57] Glancy (ed.), "William Schaeffer Ledger," 18; Balio, *Grand Design*, 205.

[58] James Chapman and Nicholas Cull, *Projecting Empire: Imperialism and Popular Cinema* (London, I. B. Tauris, 2009), 36.

[59] Jeffrey Richards, *Visions of Yesterday* (London: Routledge & Kegan Paul, 1973), 7.

[60] Prem Chowdhry, *Colonial India and the Making of Empire Cinema: Image Ideology and Identity* (Manchester: Manchester University Press, 2000), 6, 240.

power struck an odd note. In a review of *The Charge of the Light Brigade*, the *New York Times* declared,

> England need have no fear of its empire so long as Hollywood insists on being the Kipling of the Pacific. The film city's pious regard for the sacrosanct bearers of the white man's burden continues to be one of the most amusing manifestations of Hollywood's Anglophilia.[61]

However, such concern did little to curb the appeal of Empire films among audiences. *Gunga Din* was particularly popular, earning $2.8 million internationally on initial release and an additional $1.4 million through re-releases during the 1940s.[62]

American history films

The highest profile historical film of the 1930s was *Gone with the Wind*, produced by David O. Selznick and released with MGM in 1939. In financial terms, the film stands alone: adapted from Margaret Mitchell's 1936 novel, which had sales of more than two million copies before the film was released, *Gone with the Wind* was produced for a record-setting cost of $4 million.[63] MGMs internal records put the film's international rentals at $49 million, a figure which utterly overwhelms every other release of the era (although it probably included takings from numerous re-releases in the decades which followed).[64] In its epic scale, its emphasis on spectacle, and the prestige value associated with it, *Gone with the Wind* may be seen as a culmination of conventions associated with the historical film in the 1930s. In contrast to the films mentioned above, however, this was a New World story, albeit one populated by an Old World social order. Like *Birth of a Nation*, perhaps its closest antecedent in terms of mass appeal, *Gone with the Wind* was set in America's antebellum South and the subsequent Reconstruction period following the Civil War. But Selznick sought to play down the more controversial elements in Mitchell's novel and carefully omitted a scene featuring a Ku Klux Klan vengeance raid.[65] According to J. E. Smyth, 'rather than

[61] Frank S. Nugent, "Kiplings of the Pacific," *New York Times*, November 8, 1936, X5.
[62] Richard Jewell (ed.), "The C. J. Tevlin Ledger," *Historical Journal of Film, Radio and Television*, 14/1 (1994), microfiche supplement.
[63] Hall and Neale, 113.
[64] Eddie Mannix ledger.
[65] Charles Manland, "Movies and American Culture in the *Annus Mirabilis*" in Ina Rae Hark (ed.) *American Cinema of the 1930s: Themes and Variations* (New Brunswick: Rutgers University Press, 2007), 250.

emphasizing time and place… Selznick retreated from the historical period'
and thus evaded many of the historical complexities presented by the source
material.[66] Instead, the film's prologue text asserts that what follows will be a
nostalgic fantasy of Old South mores rather than a reconstruction:

> There was a land of Cavaliers and Cotton Fields called the Old South…
> Here in this pretty world Gallantry took its last bow… Look for it only in
> books, for it is no more than a dream remembered. A Civilization gone
> with the wind.

History is kept at arm's length again in the first scene of the film, as heroine
Scarlett O'Hara derails a conversation about the looming Civil War ('this war
talk's spoiling all the fun in every party this week') in order to address local
gossip. However, as Scarlett comes to appreciate the seriousness of the
events occurring in her midst and her own role in them, *Gone with the Wind*
coalesces into an account of the South's victimization and regeneration in the
face of external aggression.

As the tremendous popularity of *Gone with the Wind* demonstrated,
Hollywood historical cinema was by no means averse to America's past.
Indeed, despite the high profile of European subjects, it can be argued that
American history played a larger role in Hollywood cinema of the 1930s
and 1940s than has generally been acknowledged. Smyth has argued that
gangster films such as *The Public Enemy* (1931) and *Scarface* (1932) should
be regarded as works of popular American history rather than simply as
genre pieces.[67] In particular, the latter was a lightly disguised account of
Al Capone's rise (and fictional death) during the 1920s leading up to the St.
Valentine's Day Massacre. The content was sufficiently familiar that some
national reviewers referred to it as 'the Capone film.'[68] More explicitly, *San
Francisco* (1936) and *In Old Chicago* (1938) dramatized major disasters in
America's recent history: respectively, the 1906 earthquake and the 1871 fire.
The late 1930s also saw a cycle of films based on American industrial history.
According to a 1938 *Variety* article, this new cycle was inspired partly by the
success of *Lloyds of London* and *Wells Fargo* (1937), the latter narrating the
growth of the American Wells Fargo freight company during the Civil War,
and partly as a public relations exercise which promoted films in terms of
the educational value.[69] Subsequent releases included, among many others,
Men with Wings (1938), concerning the history of aviation, *Spawn of the*

[66] Smyth, 164.
[67] Ibid., 59.
[68] Ibid., 81.
[69] "Historical Pix to Up B.O.," *Variety,* April 20, 1938, 7.

North (1938), set in Alaskan salmon fisheries, *Yellow Jack* (1938), on the treatment of yellow fever during the Spanish-American War, *Union Pacific* (1939), about the construction of the Central Pacific Railroad, and *Western Union* (1941), based on the founding of the telegraph company.

Several biopics from the era also reflected the vogue for industrial history. For example, *The Story of Alexander Graham Bell* (1939) presents not only Bell's invention of the telephone, motivated and supported by his deaf mute wife, but his attempt to establish the Bell Company in the face of competition from a rival backed by Western Union. Similarly, *A Dispatch from Reuters* (1940) combines a biography of Paul Julius Reuters with an account of his struggle to transmit news across the Atlantic by telegraph at a greater speed than his rivals, culminating in his reporting of Lincoln's assassination. *Citizen Kane* (1941) might also be considered in this vein. Much like *Scarface* it was ostensibly a work of fiction, but the film was widely recognized on release as a lightly veiled and largely unflattering biography of newspaper magnate William Randolph Hearst. Not all of these films were successful, and not all of them placed historical content in the forefront of their narratives, but their production points to the confidence of studios in their ability to sell serious historical topics to general audiences.

American history was also well represented during the 1930s and early 1940s in depictions of America's westward expansion. For much of the 1930s the western survived as a low-budget, B-Picture category. But towards the end of the decade a new cycle of A-Picture westerns featuring bigger budgets and bigger stars appeared, and studios sought to heighten their prestige value by emphasizing their relationship to history. Richard Slotkin has suggested that this appeal to history was also motivated by a political need to restore the 'sense of progressive and patriotic optimism' which had been punctured by the Depression.[70] The term 'epic' was frequently identified with this new generation of westerns. A 1941 *New York Times* article, entitled 'When is an "Epic"?', commented ironically on this association:

> For a time, it appeared as though any 'Western' which boasted a covered wagon train and at least one historical character was worthy of the name [epic]. Then it became essential that a railroad or some public works project had to be put in construction against the usual anti-expansionist odds in order to warrant the tag.[71]

The filmmaker most closely associated with the new westerns was Cecil B. DeMille, a director known for his creation of lavish spectacle but also for his

[70] Slotkin, 279.
[71] Bosley Crowther, "When is an 'Epic'?," *New York Times*, February 9, 1941.

careful marketing of historical research as a production value. DeMille's *The Plainsman* (1936), produced for Paramount, featured Wild Bill Hickok, Buffalo Bill, and General Custer facing off against Cheyenne Indians and an American businessman who sells rifles to them. DeMille described the film as the 'first in a series of pictures based on the magnificent pageant of American history.'[72] Phil Wagner has suggested that the film attempted to connect ordeals faced in America's past to those of the modern era, presenting a message of 'spiritual continuity between history's great men and present day laypeople' which resonated with the politics of the New Deal.[73]

In *Union Pacific* DeMille connected the epic western with America's industrial history, basing his drama around the momentous unification of America by rail in the face of industrial sabotage organized by a banker speculating against its completion. The bulk of the film is devoted to a love-triangle between the principal characters, but historical events play a significant background role. Opening scenes in Washington establish that railroad will not only create profit, but will 'bind us together... as one people.' The proposal is subsequently signed into existence by Lincoln. At the end of the film, as the final, golden spike is hammered in to the railroad, a politician declares that this 'great nation is united with a wedding ring of iron.' In addition, *Union Pacific* represents the Western expansion and unification of America as an act of imperialism: the prologue text states that 'the West is America's Empire' which the railroad has 'conquered.' The modern implications of this process are underlined in the final image of the film, in which an 1880s steam engine is graphically 'wiped' from the screen by a contemporary diesel locomotive, emphasizing its optimistic narrative of technological progress.

Finally, American history flourished in Hollywood cinema of the 1930s and 1940s in the form of the biopic. The most successful of these concerned popular American entertainers. In 1936 MGM released *The Great Ziegfeld* (1936), a three-hour musical biography of theatrical impresario Florenz Ziegfeld, charting his rise from carnival barker to Broadway producer. Budgeted $2.2 million, *The Great Ziegfeld* was MGM's most expensive film since *Ben-Hur*, but with international rentals of $4.6 million it was one of the most successful releases of the 1930s.[74] Several high-budget musical biopics followed. *Alexander's Ragtime Band* (1938), produced by 20th Century Fox, drew lightly on the life and career of songwriter Irving Berlin while incorporating generous selections from his popular songbook. *Yankee Doodle Dandy* (1942) applied the same formula to the career and songbook of George M.

[72] Quoted in Phil Wagner, "Passing through Nightmares: Cecil B. DeMille's *The Plainsman* and Epic Discourse in New Deal America" in Robert Burgoyne (ed.), *The Epic Film in World Culture* (London: Routledge, 2011), 210.
[73] Ibid., 211.
[74] Eddie Mannix ledger.

Cohan, the Broadway singer, dancer, and composer whose career flourished in 1910s. Released in 1942, shortly after America's entry into World War II, the film emphasized the patriotic, flag-waving populism of Cohan's oeuvre in order to promote the war effort. Due in part to its reflection of triumphalist wartime mood, Yankee Doodle Dandy recorded international rentals of $6.5 million.[75]

A different kind of American biography was represented in Young Mr. Lincoln (1939), released by 20th Century Fox and directed by John Ford. The film opens in Salem Illinois in 1832 as a youthful Lincoln begins to make his way in local politics. But rather than using this as a jumping-off point for his major political successes in later decades—a route taken by many biopics of the era—the film focuses on formative events which foreshadow Lincoln's later achievements. Throughout, Lincoln is shown to be a man of the people, but also a man apart, often depicted in solitude. He is shown engaging in physical activity and defending the weak, but he is also cerebral, preternaturally wise, and highly principled, enabling him to rise above the town drunks, quick-tempered tradesmen, and corrupt politicians who surround him. As Geoffrey O'Brien suggests, Lincoln is presented 'in a state of pure potentiality': possessing the talent for greatness, but waiting for the historical moment to arrive.[76] This moment is prefigured in the final scene of the film, as Lincoln walks alone to the top of a hill amid a gathering storm. The Civil War anthem 'Battle Hymn of the Republic' builds on the soundtrack, linking the violence of the weather to the impending conflict. At the summit, he walks out of frame and the image dissolves to a shot of the Lincoln Memorial statue. The empty frame Lincoln leaves behind might be seen to portend his death, but the statue embodies the legacy ahead of him.

History and World War II

As hostilities escalated in Europe towards the end of the 1930s, some filmmakers in Hollywood sought to pass comment on the conflict and America's potential involvement in it. However, the wealth of isolationist feeling among the American public, coupled with sensitivities in some of Hollywood's export markets, meant that political sentiments had to be handled carefully. The first openly interventionist reaction in Hollywood came from Warner Bros., whose owners had a close relationship with the

[75] Glancy (ed.), "William Schaefer Ledger," 23.
[76] Geoffrey O'Brien, "Young Mr. Lincoln: Hero in Waiting," Criterion Collection, last modified February 13, 2006, http://www.criterion.com/current/posts/413-young-mr-lincoln-hero-in-waiting.

Roosevelt White House.[77] In *The Sea Hawk* (1940), a maritime adventure associated with the 'Merrie England' cycle, the studio used history as a means to comment safely on the present. The film was set at the time of the Spanish Armada and casts the warlike King Phillip II of Spain as its villain, proposing parallels between him and Hitler. In one scene the Spanish King stands before a map of the world, casting a large shadow over the Atlantic, and declares that only England stands between him and a Spanish conquest of both continental Europe and the New World. The past was also used for propagandist purposes in *That Hamilton Woman* (1941), an Anglo-American production which adapted the story of Lord Nelson and his lover Emma Hamilton in order to warn against the present-day dangers of appeasement and isolationism. In an angry speech to British politicians who are contemplating negotiations with Napoleon, Nelson declares: 'Napoleon can never be master of the world until he has smashed us up, and believe me gentlemen, he means to be master of the world. You cannot make peace with dictators, you have to destroy them.'

The term 'dictator' is anachronistic in this context, but the parallels between Hitler and Napoleon and the warning against appeasement are clear. As a reviewer for *Time* put it, 'with the subtlety of a sock on the jaw, it is more concerned with informing US cinema audiences of the parallel between Britain's struggle against Napoleonic tyranny and her current tangle with Hitler.'[78] In these films, the conventions of historical adventure were used to give credence to the threat posed by Nazi Germany: if Napoleon and Phillip II could be accepted as dangerous tyrants, so too could Hitler. The past thus functioned as a disguise, albeit a half-hearted one, for what might otherwise have been controversial political comment.

Other Hollywood historical films took a more direct approach to promoting involvement in World War II by depicting American figures of the recent past. Warner Bros.'s *Sergeant York* (1941) was based on the biography of Alvin York, a simple Tennessee farmer who is shown to overcome both his hell-raising youth and his religious pacifism to become a hero of World War I. History intrudes on York's insular life in the form of the draft, and after his attempts to register as a conscientious objector fail he is ordered to a training camp in Georgia. He proves to be a crack marksman, but struggles with the idea of killing until a kindly officer presents him with a copy of 'the history of the United States' and he learns to reconcile his duty to his country with his Christian values. Arriving on the front line in France, a cockney soldier tells him, 'you Yanks got here in the nick of time... we

[77] Todd Bennett, "The Celluloid War: State and Studio in Anglo-American Propaganda Film-Making, 1939–1941," *The International History Review*, 24/1 (2002): 76.
[78] "The New Pictures," *Time*, March 31, 1941.

could do with some help.' His help bears immediate fruit: almost single handedly, York captures the best part of a German division, killing many enemy soldiers in the process, and is awarded the Congressional Medal of Honor. York embodies the qualities America needs for victory in Europe: he is principled yet obedient and selfless, a skilled warrior who takes no pleasure in killing. His personal struggle with the morality of war and the need to intervene overseas also resonated with the interventionist struggle occurring in America at the time. To clarify the historical analogy further, the film's New York premiere was heralded by a parade of Great War veterans led by the real Alvin York.[79] Isolationist politicians were understandably unimpressed and their objections led to the film being temporarily removed from release, but *Sergeant York* nevertheless was Warner's most successful film of 1941. [80]

Patriotic, pro-military propaganda was also present in *Yankee Doodle Dandy*, which began shooting a few days before the attack on Pearl Harbor. A turning point in the film occurs at the outbreak of World War I, which leads Cohan to comment,

> It seems it always happens. Whenever we get too high-hat and too sophis-ticated for flag-waving, some thug nation decides we're a push over all ready to be blackjacked, and it isn't long before we're all looking up mighty anxiously to be sure flag's still waving over us.

After attempting to enlist in person, Cohan composes the song 'Over There,' a jingoistic anthem to American overseas intervention which accompanies a montage depicting the departure and victorious return of American troops. At the end of the film, Cohan (like York) is given a Congressional Medal of Honor by present-day President Roosevelt, who praises his 'contribution to American spirit' and notes that 'a man may give his life to his county in many different ways.' In the process, the film implicitly endorses Hollywood's own 'contribution to American spirit' and its capacity to shape public opinion for patriotic ends.

Once America joined the war, dramatic reconstructions of actual military events emerged with remarkable speed. *Guadalcanal Diary* (1943) depicted the 1942 Battle of Guadalcanal, *Thirty Seconds over Tokyo* (1944) was based on the 1942 Doolittle Raids in Japan, and *Objective Burma!* (1945) dramatized events from the Allied Burma Campaign. Among others, these films helped to establish long-standing conventions for the representation of World War II

[79] Clayton R. Koppes and Gregory D. Black, *Hollywood Goes to War: How Politics, Profits and Propaganda Shaped World War II Movies* (London: Collier Macmillan, 1987), 39.
[80] Smyth, 234.

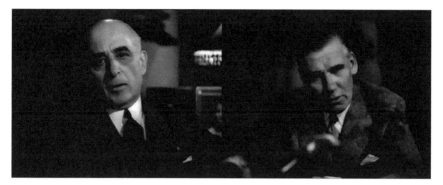

FIGURE 3.1 *The real (left) and fictional (right) Joseph Davies in* Mission to Moscow *(1943)*

combat.[81] The war effort was also served by a 1944 re-release of *The Sign of the Cross*, expanded by a newly filmed prologue and epilogue which asserted continuities between pagan Rome and Fascist Italy. As a contemporary American bomber drops propaganda leaflets over Rome, a voiceover establishes an analogy which could not have been intended when the film was actually made: 'Nero thought he was the master of the world. He cares no more for the lives of others than Hitler does.' Following the final scene of the original film, Allied bombers are shown flying in the shape of the cross, thus associating the struggles of the early Christians in the film with America's good fight against European tyrants of the present.[82]

The depiction of America's new allies in Hollywood films also became a sensitive issue. The Roosevelt Government's new Office of War Information (OWI) began to exert influence in this area, reviewing Hollywood scripts and completed films from June 1942 and lobbying for alterations as it saw fit.[83] The depiction of the Soviet Union as a suitable ally for America proved to be particularly challenging. Nevertheless, Warner Bros. accepted a request from Roosevelt to adapt the memoirs of Joseph E. Davies, America's ambassador to the Soviet Union between 1936 and 1938 and an unlikely supporter of Stalin's leadership.[84] Released in 1943, *Mission to Moscow* remains one of the most unusual historical films produced in Hollywood. As I mentioned in the

[81] Jeanine Basinger, *The World War II Combat Film: Anatomy of a Genre* (Middletown: Wesleyan University Press, Updated Edition, 2003), 56.

[82] Bruce Babington and Peter William Evans, *Biblical Epics: Scared Narrative in the Hollywood Cinema* (Manchester: Manchester University Press, 1993), 184; Wyke, 134.

[83] Mark Glancy, *When Hollywood Loved Britain: The Hollywood 'British' Film (1939–45)* (Manchester: University of Manchester Press, 1999), 183.

[84] Clayton R. Koppes, 'Regulating the Screen: The Office of War Information and the Production Code Administration' in Thomas Schatz, *Boom and Bust: The American Cinema in the 1940s* (New York: Scribner's, 1999), 276.

first chapter of this book, the film opens with a spoken introduction by Davies himself, who explains that while he is a Christian and a supporter of free enterprise, he admires the Soviet leaders. He also thanks 'the fine patriotic citizens of Warner Brothers' for making the film. The second introduction, delivered by the fictionalized Davies (played by Walter Huston), states that the leaders of the Soviet Union have been 'misrepresented and misunderstood' and praises their 'gallant struggle to preserve peace.' The dramatic part of the film concerns Davies' experiences in the USSR from 1936, where he finds Russians to be industrious, hospitable, prosperous, and sympathetic to Americans. On a fact-finding mission he is impressed by the Red Army, the impact of Stalin's Five Year Plans, and the integration of Russian women into the workforce. In addition, *Mission to Moscow* reconstructs Stalin's notorious Purges and the subsequent 1938 show trials, in which witnesses freely admit to participating in a plot hatched by Trotsky in association with Nazi Germany. Some of the foreign observers are skeptical, but Davies comments, 'based on twenty years of trial practice, I'd be inclined to believe these men.' As he prepares to leave Russia, Davies meets Stalin, a statesmanlike figure who claims that 'we feel more friendly to the United States than to any other government.' Back in America, the film traces events up to the present day as Davies leads a campaign to counter the isolationist movement and to promote an alliance with the USSR. In the process he defends the Nazi-Soviet Non-Aggression Pact, despite its inconsistency with the message of the film, while nevertheless criticizing Britain's appeasement of Hitler. One credulous spectator is moved to ask, 'I wonder why these things have been kept from us?' A product of a very particular historical moment, *Mission to Moscow* demonstrates the extent to which the American Government was able to assert its influence on Hollywood during World War II, and the extent to which Hollywood was prepared bend with the wind in its presentation of history.

The history of American cinema between the 1890s and the 1940s was marked by intense growth and innovation, and historical films were closely related to many of the transformations which took place. Despite the pace of these changes, certain patterns in historical cinema can be observed. Most noticeably, the major historical productions of the era concentrated on a relatively small range of historical eras: most commonly the Old Testament Holy Land, the Roman Empire, medieval Europe, industrial age Europe and America, the British Empire, and World War I. Although the range of topics available to historical filmmakers was vast, in practice it was organized around a limited and familiar array of narratives and iconographies. These favored eras also indicate the extent to which Hollywood historical films can also be divided into representations of Europe and representations of America. Although prominent exceptions exist, this Old World/New World dichotomy underlines Hollywood's limited perspective on the past. Gilles Deleuze has

likened this tendency in Hollywood historical film to Nietzsche's conception of 'monumental' history:

> Such an aspect of history favours the analogies or parallels between one civilisation and another: the great moments of humanity, however distant they are, are supposed to communicate via the peaks, and form a 'collection of effects in themselves' which can more easily be compared and act all the more strongly on the mind of the modern spectator.[85]

History films across this period were also frequently characterized by their use of spectacle as a means to evoke a sense of the past. From *The Birth of a Nation* onward, the past was represented as gigantic, encompassing, and overwhelming. Historical cinema was also associated with prestige, and this exalted social status allowed them to be marketed to broader and sometimes more affluent audiences than the standard Hollywood product. In addition, prestigious films elevated the public profile of the film industry in the face of criticism and the threat of censorship. Finally, as the outbreak of World War II indicated, historical cinema could be moulded to fit the political conditions of the present time. Above all, historical films counted for some of the biggest films of the era, both in terms of the money invested in them and their financial performance at the global box office. Almost from the moment the production of cinema coalesced into a stable industry, historical cinema was central to its business practices. In the period that followed, as the American film industry was forced to reorganize to suit the shifting economic and cultural environment, the relationship between historical cinema and the film industry became even more significant.

[85] Deleuze, 149.

4

The age of epics

Hollywood under fire

The American economy surged in the years following World War II, and so did the affluence of American people. Between 1950 and 1960 the nation's combined disposable income grew from $207.1 billion to $350 billion.[1] Amid this climate of industrial growth and consumerism, many American families moved away from urban centers and leisure habits began to change. Most significantly, at least as far as Hollywood was concerned, televisions quickly established a place in the home: by the end of the 1950s they had been installed in 90 percent of American households.[2] With their audience transplanted from the cities, where the majority of cinemas were still located, and with entertainment needs increasingly met by television, Hollywood began to struggle. While the American economy expanded as a whole, its film industry entered a period of unprecedented decline: between 1946 and 1957 the gross revenues of the ten leading American film companies fell from $968 million to $717 million.[3]

Hollywood responded to this economic crisis in several ways. First, as a means to create an experience which stood apart from that offered by television's small, monochrome image and its thin, monaural sound, an increased value was placed on cinema's potential for spectacle. Color, which had been used intermittently since the 1920s, was employed in most major films from the 1950s onward. The flatness of the television screen was emphasized by films made in an experimental three-dimensional process, which was popular for a brief period in the early 1950s. Measures were also taken to expand the physical dimensions of the cinema screen. The first innovation was made

[1] John Belton, *Widescreen Cinema* (Cambridge: Harvard University Press, 1992), 71.
[2] Ibid., 73.
[3] Irving Bernstein, *Hollywood at the Crossroads: An Economic Study of the Motion Picture Industry* (Los Angeles: Hollywood Association of Film Labor, 1957), 12.

by the Cinerama process in 1952, which created a very wide image using three separate, synchronized film projectors. More practical widescreen processes quickly followed: 20th Century Fox introduced the CinemaScope format in 1953 and the Todd-AO process was launched in 1955.[4] In this way, the challenge posed by the convenient pleasures of television radically and permanently altered the look and the sound of Hollywood films. This new technology was also reflected by changes in distribution practices. In order to stress their 'event' status, major films increasingly followed the 'roadshow' film distribution technique: movies were booked in to a small number of exclusive venues in major cities, often in 'legitimate' theaters rather than cinemas, and tickets were sold at elevated prices on a reserved-seat basis.[5] If the films were popular, they could play at the same venue for several years. Roadshowing had been used sporadically since the 1910s, typically with expensive, prestigious films such as *The Birth of a Nation* and *Gone with the Wind*, but in the 1950s and 1960s the technique became increasingly popular and profitable. Indeed, Peter Krämer has dubbed the period 1949 to 1966 'the Roadshow Era.'[6] Thus, as Hollywood films were abandoned by their massive pre-war and wartime audience and were displaced as the primary medium of the masses, the film industry redefined itself as purveyor of a loftier, more spectacular, and more exclusive form of entertainment.

In addition to these new distribution and exhibition practices, Hollywood studios in the 1950s and 1960s responded to their economic crisis by reducing production costs. One of the most effective methods involved abandoning Hollywood's traditional production base in Los Angeles in search of cheaper facilities abroad, particularly in Europe. In 1957, for example, 17 Hollywood films were filmed in Britain, nine in Italy, six in France, and three in West Germany.[7] By 1964 the number of Hollywood films produced overseas had risen to 48, with just 89 filmed in Hollywood itself.[8] There were several reasons for the growth in these 'runaway' productions. First, shooting abroad saved money because labour and studio space could be hired at much lower rates than in California. The aggrieved Hollywood unions estimated that European wages for film crews were 50 percent lower than those in America.[9] International production also benefitted studios by allowing them to reinvest international profits from older films which were inaccessible

[4] Belton, 85–182.
[5] Hall and Neale, 159–62.
[6] Peter Krämer, *The New Hollywood: From Bonnie and Clyde to Star Wars* (London: Wallflower, 2005), 19.
[7] Bernstein, 54–5.
[8] Peter Bart, "Union Gains Mean Hollywood's Loss," *New York Times*, February 7, 1965, X7.
[9] Aida Hozic, *Hollyworld: Space, Power and Fantasy in the American Economy* (Ithaca: Cornell University Press, 2001), 94.

due to post-war economic protocols, and by giving them access to various film production subsidies made available by European governments. Film programs such as Britain's Eady Levy further incentivized runaway production by offering Hollywood studios substantial payments proportional to the local box office performance of films produced in Britain.[10] International production offered also significant savings for the highly paid stars who dominated the film industry during the era by allowing them to avoid income tax through foreign residence.[11] Moreover, the use of exotic or authentic locations was thought to increase the appeal of spectacle-based films, particularly those actually based in modern or historical Europe. According to an 'industry exec' quoted by *Variety* in 1956,

> The keynote in today's films is realism. You don't get that by building a set in the backlot, particularly with the widescreen processes that so cruelly show up any artificial note. Today, the camera needs real-life backgrounds and producers realize it. [12]

Finally, international production coincided with the increased value of revenue from Hollywood's international market, particularly from Europe. In 1951 MGM estimated that 60 percent of their annual revenue came from overseas business.[13] Producing films in Europe not only saved money, it also raised their status in an increasingly valuable market.

Amid these significant social and economic changes, the historical film became ever more central to Hollywood's business practices. In fact, the major historical films of the era were connected to all of the changes mentioned above: they used new production technologies to create previously unseen levels of spectacle, they were typically distributed on a 'roadshow' basis, they were frequently filmed abroad as runaway productions, often exploiting production subsidies from European governments, and their frequent basis in European rather than American history made them highly saleable to European audiences. Moreover, historical films could be safely marketed to large, diverse audiences in order to maximize earnings. Combining romance, spectacle, moral uplift, and educational value, they traversed gender and age distinctions to provide inclusive family entertainment. Accordingly, historical films also attracted the highest level of investment from Hollywood studios in this period, and were frequently the best performers at the box office.

[10] Jonathan Stubbs, "The Runaway Bribe? American Film Production in Britain and the Eady Levy," *Journal of British Cinema and Television,* 6/1 (2009): 1–20.

[11] Murray Schumach, "Hollywood Asks For Federal Help," *New York Times,* April 24, 1962, 31; Bernstein, 68–9.

[12] "Hollywood Bigness on the Wane?," *Variety,* October 10, 1956, 3.

[13] "Yank's Heaviest Foreign Coin," *Variety,* September 5, 1951, 3.

There were no fewer than eight historical films among the North American top ten in the period 1949 to 1966, including the entire top five: *The Sound of Music* (1965), *The Ten Commandments* (1956), *Doctor Zhivago* (1965), *Ben-Hur* (1959), and *Mary Poppins* (1964).[14] With the exception of *Mary Poppins*, these films were shot (wholly or partially) outside America using cutting-edge widescreen technologies, and were distributed on a roadshow basis. The biggest and most successful historical films in the 1950s and the 1960s thus differed substantially from those which had been successful in the previous decades. The ways in which the genre developed is illustrated by two major historical productions from the mid-1930s which were remade for new audiences in the early 1960s: *Mutiny on the Bounty* (1962) and *Cleopatra* (1963).

Historical inflation: *Cleopatras* and *Bounties*

Cleopatra had been produced by Cecil B. DeMille for Paramount in 1934 and was made again by 20th Century Fox in 1963, whereas *Mutiny on the Bounty* was a MGM release in 1935 and was remade by the same studio in 1962. All four films were high-budget productions featuring some of the biggest stars of their eras: Claudette Colbert and Clark Gable in the 1930s and Elizabeth Taylor and Marlon Brando in the 1960s. The four films were also produced by three of the 'Big Five' studios, which points to the relative stability and concentration of power within the American film industry. Despite major industrial reorganization and the steep decline in cinema attendance, film production in the 1960s was controlled by the same small group of companies which held power in the 1930s. In addition, the repetition of these historical stories points a certain stability in historical filmmaking across the decades. For all the cultural and social changes associated with the middle period of the twentieth century, audiences were evidently entertained by similar stories.[15] However, these apparent continuities across the two eras conceal significant changes to the ways in which Hollywood produced historical films, their inflated modes of visual representation, and the commercial expectations which were placed on them.

Cleopatra was originally conceived as a relatively modest production based on 20th Century Fox's backlot with one of their contracted actors

[14] Krämer, 116.

[15] Several other older historical films were also remade during the same period, including *The Four Horsemen of the Apocalypse* (1921 and 1962), *The Ten Commandments* (1923 and 1956), *Ben-Hur* (1925 and 1959), *King of Kings* (1927 and 1961), *Cimarron* (1931 and 1960), and *The Charge of the Light Brigade* (1936 and 1968).

as the Egyptian Queen. However, the stakes were raised by the casting of Elizabeth Taylor, a major star who had become a free agent following the expiration of her contract at MGM. Taylor signed a deal worth $1 million—a record salary for a single film. In September 1960, with the budget raised to $5 million, the production moved to Pinewood Studios in Britain, partly to provide Taylor with a tax-break on her massive salary.[16] In contrast, *Mutiny on the Bounty* was planned on a grand scale from the outset as MGM's epic follow-up to *Ben-Hur* (1959). With Marlon Brando cast in the lead, photography for *Mutiny on the Bounty* began in October 1960 in Tahiti.[17] Before long, both productions were hit by major delays which led to spiralling costs and bloated shooting schedules. Production on *Cleopatra* was beset by Taylor's serious ill-health and uncooperative London weather, leading the production to relocate to Rome with a new director, a new supporting cast, and a vastly inflated budget. Filming restarted on September 1961, but due to the cast and location changes they began almost from scratch. In Tahiti, *Mutiny on the Bounty* went over-schedule due to delays transporting the replica ship, stormy tropical weather, repeated revisions to the script, and the departure of the original director. The major source of disruption, however, was Brando's reportedly eccentric behavior and the willingness of the studio to indulge it. In a frank interview published before the release of the film, replacement director Lewis Milestone claimed that Brando's behavior had cost the production 'at least' $6 million and had delayed production by months, adding,

> The movie industry has come to a sorry state when a thing like this can happen, but maybe the experience will bring the executives back to their senses. They deserve what they get when they give a ham actor, a petulant child, complete control over an expensive picture.[18]

Mutiny on the Bounty wrapped on October 1961, although the final scene was not filmed until the following year. Photography for *Cleopatra* was completed on July 1962, almost two years after cameras began rolling. By contrast, the 1930s *Cleopatra* and *Mutiny on the Bounty* had been filmed in 8 and 12 weeks respectively.[19]

By any standards, the 1934 *Cleopatra* was a spectacular film, but the 1963 version enlarged, extended, and upgraded its visual pleasures. The repetition of several set-pieces allows a direct comparison between them. In 1934, Cleopatra is carried into Rome in a winged throne on an open palanquin,

[16] Alexander Walker, *Elizabeth: The Life of Elizabeth Taylor* (London: Grove Press, 2001), 224.
[17] Terence Pettigrew, *Trevor Howard: A Personal Biography* (London: Peter Owen, 2001), 222.
[18] Quoted in Bill Davidson, "Six Million Dollars Down the Drain: The Mutiny of Marlon Brando," *Saturday Evening Post*, June 16, 1962.
[19] "*Cleopatra*," *AFI Film Catalog*; Block, 190.

preceded by musicians and dancing women. The emphasis is on Claudette Colbert's body and costume: a fitted gold dress and headpiece based on images of the goddess Isis. However, the lack of depth in the images reveals the limited dimensions of the set and the use of a studio backlot rather than an exterior location. By contrast, the 1963 Cleopatra's entry to Rome was filmed inside an enormous reconstruction of the Roman Forum on location in Rome itself. She is preceded by a parade of exotic performers: trumpeters on horseback, semi-naked women, African dancers, and a moving pyramid which is adorned by winged women and opens to release birds. Cleopatra herself is pulled into the Forum by hundreds of shirtless men atop an enormous sculpture of the Sphinx. As before, she wears a gold dress modeled on Isis, but the film's avoidance of close-ups de-emphasizes and diminishes her body. Instead, the use of low-angle long-shots taken from a frontal position puts the viewer in the position of a Roman spectator in the crowd. The impression made by these images is amplified by the film's use of color, which has obvious advantages in the presentation of Cleopatra's gold costume, and widescreen cinematography. The 70mm Todd-AO widescreen format used in the film reveals an extraordinary level of detail, especially in the numerous shots composed in depth which highlight information on multiple visual planes.

The upgrading of spectacle is also apparent in the 1962 *Mutiny on the Bounty*. Aside from establishing shots filmed by a second unit, the 1935 version was shot on soundstages and on islands around the California coast. The visual limitations of this approach are apparent in the scene where the crew of the *Bounty* sight land in Tahiti. In separate shots, the islanders launch boats, surround the *Bounty* and greet the crew. It is clear from the use of back projection, however, that the island and the main cast on board

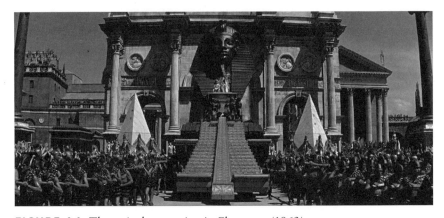

FIGURE 4.1 *The arrival procession in* Cleopatra *(1963)*

FIGURE 4.2 *Images composed in depth in* Mutiny on the Bounty *(1962)*

the *Bounty* were filmed in separate physical spaces. The equivalent scene in the 1962 film edits between the ship sighting the land and the Tahitians sighting the ship. Several geographic spaces on the island are connected as the Tahitians rush to the shore to launch their boats, with images taken from a seaborne camera. The first encounter between the crew and the islanders is captured in a panoramic extreme long-shot, featuring hundreds of Tahitians in the foreground, a rowboat surrounded by the islander's longboats in the middleground, and in the background the *Bounty* and the island's cloud-capped mountains. The islanders, the main cast, Tahiti, and the *Bounty* are thus unified in the same diegetic space. Again, color and widescreen technologies enhance the spectacle: the 70mm Ultra Panavision process used in the film created an image with dimensions even wider than *Cleopatra*. Extensive location shooting combined with more detailed production design, a larger cast, and deeply focused photography thus give the 1962 film a more substantial visual impact.

Visual properties aside, the ballooning budgets and wasteful misman-agement of *Cleopatra* and *Mutiny* made a lasting impact on the American film industry. *Mutiny* finished with a production cost of $19.5 million, whereas *Cleopatra* was reported to have cost 20th Century Fox $44 million.[20] As costs mounted, the president of Fox was forced to resign and studio founder Daryl F. Zanuck was tasked with rebuilding the almost bankrupt company. Fox's fortunes improved when *Cleopatra* was finally released: even with top tickets priced at a record $5.50, the film played for 64 weeks at its New York roadshow engagement. By 1966 the film had earned $38 million inter-nationally and a lucrative TV sale the same year put it into profit, although certainly not to the extent Fox had hoped for.[21] The 1962 release of *Mutiny*

[20] Hall and Neale, 164, 66. Adjusted for inflation, *Cleopatra* is almost certainly the most expensive American film ever made.
[21] Hall and Neale, 166.

was less impressive, and domestic rentals were reported to have been just under $10 million.[22] MGM posted an annual loss on the back of *Mutiny's* failure and its share price dropped considerably, leading Studio Head Sol Siegel and Chairman Joseph Vogel to resign.[23] By contrast, the production costs in the 1930s were lower, even taking into account the rate of inflation, but the profits were much higher: the 1935 *Mutiny* cost $1.9 million and earned $4.5 million internationally, while the 1934 *Cleopatra* doubled its $900,000 production cost in rentals.[24] Both films would have been regarded as extravagant in the 1930s—indeed, *Mutiny* was subject to large budget overruns—but the slickly industrialized, carefully managed nature of studio production during the period kept a lid on excess.

Quite evidently, the business of producing major historical films in the 1960s was a significant departure from previous eras. Budgets were higher, schedules were longer, and production increasingly occurred on locations far from Los Angeles, which made it difficult for studio managers to assert control. Moreover, movie stars who were once controlled by long-term studio contracts were given increasing amounts of power and money due to faith in their ability to draw large crowds. In addition to their huge salaries, the contracts signed by Taylor and Brando guaranteed them both 10 percent of the gross profit for each film.[25] Profit-participation arrangements of this type diminished the potential earnings of the studios, underlining the value they placed in the biggest stars to sell movies. Finally, as audience numbers fell, the film industry began to concentrate investment in the production of fewer, more extravagant films in the attempt to create spectacular 'event' films which would draw the public back into cinemas. This high-stakes business model paid off handsomely when films connected with large audiences, but when expensive films failed, the losses were immense and had the potential to bankrupt studios. *Cleopatra* and *Mutiny* might seem in hindsight to be monuments of Hollywood's poor judgment and folly, but at the time their producers were simply applying proven commercial strategies to historical material which had been popular a generation before. In many respects, they were playing safe in difficult economic circumstances.

[22] "All-Time Boxoffice Champs", *Variety*, January 4, 1967, 9.
[23] Pettigrew, 223.
[24] Eddie Mannix ledger; Hall and Neale, 99.
[25] Stefan Kanfer, *Somebody: The Reckless Life and Remarkable Career of Marlon Brando* (New York: Vintage, 2009), 311; Walker, 224. These arrangements yielded little money in practice, although a clause in Taylor's contract which paid her $50,000 for every week the production went over schedule would have proven highly lucrative.

The emergence of the epic

As *Cleopatra* and *Mutiny on the Bounty* indicate, the major historical films of the 1950s and 1960s were characterized by upgraded production values, excessive budgets, and inflated commercial expectations. This, in other words, was the era of epic cinema. The term 'epic' was frequently used to describe large-scale historical films from the 1910s onward, when it was associated with Italian imports such as *Cabiria* (1914), but the term assumed a new prominence in marketing discourses during the 1950s. Steve Neale has suggested that although the epic film intersects with numerous genres, including westerns, musicals, and war films, it is characterized by an 'emphasis on aural and visual spectacle' and 'a dramatic and thematic concern with political and military power, political and military rule, and political and military struggle.'[26] Vivian Sobchack has suggested that epic films function by linking these two features, expressing the magnitude of past events through excessive modes of representation.[27] Epics can also be defined in terms of their narrative focus on monumental historical events, particularly those involving the destiny of nation or a people. A representative sample might include the Hebrew exodus, the fall of the Roman Empire, medieval Spain's defeat of the Moorish armies, and the founding of modern Israel. As these examples suggest, there is no reason to regard the temporal scope of epic cinema as confined to any given era or location. Nevertheless, typical epic themes—such as the fulfillment of a heroic destiny, the expression of nationhood, or the struggle for freedom from foreign rule—tend to be more plausibly expressed in the remote, even mythic past.[28] It is perhaps for this reason that epic cinema has been identified most closely with representations of Mediterranean antiquity, in particular the Holy Land of the Old Testament era, ancient Egypt, Classical Greece, and the Roman Empire.

The first ancient world epic of the era arrived late in 1949 in the formidable shape of *Samson and Delilah*, a sensational depiction of the Old Testament strongman and his treacherous sister-in-law, climaxing with the spectacular destruction of the Philistine temple. As Neale has pointed out, only three films depicting the ancient world were produced in Hollywood between 1928 and 1948: *The Sign of the Cross* (1932), *Cleopatra* (1934), both directed by Cecil B. DeMille, and *The Last Days of Pompeii* (1935).[29] Fittingly, *Samson and Delilah* was also directed by DeMille and derived from a project he initiated in the mid-1930s, underlining continuities in a form of historical filmmaking

[26] Neale, *Genre and Hollywood*, 85.
[27] Sobchack, "Surge and Splendor," 287.
[28] Burgoyne, *Hollywood Historical Film*, 39.
[29] Neale, *Genre and Hollywood*, 88.

which had lain dormant for 15 years.[30] Although *Samson and Delilah* was adapted from a brief section in the Book of Judges, it was marketed in a way which highlighted its status as a historical film. A prologue stated that the film is based on the 'history of Samson and Delilah in the Holy Bible,' and in a typically calculated marketing move it was reported that DeMille donated the research documents generated during pre-production to the Library of Congress.[31] With worldwide rentals of $14 million, *Samson and Delilah* became the highest grossing film in Paramount's history.[32] This extraordinary success led to a small cycle of similar Old Testament spectacles during the early 1950s, including *David and Bathsheba* (1951), *Sins of Jezebel* (1953), *Salome* (1954), and later in the decade, *Solomon and Sheba* (1959). Not all of these films shared *Samson and Delilah*'s elaborate production values, but they did emulate its gender politics: like Delilah, female characters in these films are associated with hedonism, sensuality, material luxury, and paganism, and endeavor to remove godly men from the righteous path.[33] The seminal impact of *Samson and Delilah* is also expressed in its influence on Italian 'peplum' films set in the ancient world, most famously *Hercules* (1958) and *Hercules Unchained* (1959) starring American bodybuilder Steve Reeves, who DeMille had previously auditioned for the role of Samson.[34] Successfully marketed to audiences in America, they formed a second (albeit lower-budget) wave of Italian historical epics to complement those of the 1910s.

In 1951 MGM released *Quo Vadis*, an adaptation of Henryk Sienkiewicz's bestselling 1896 novel. Its account of the early days of Christianity under Emperor Nero's rule, 30 years after the crucifixion, had been filmed twice before in Italy and plans for a Hollywood adaptation date back to the 1930s. Babington and Evans describe it as a 'Christian/Roman Epic,' a filmmaking cycle set in the Roman Empire which 'place invented, non-biblical protagonists within the world-historical crisis of the beginnings of Christianity as a religion of gentile conversion.'[35] Films of this type were thus able to promote their engagement with history more easily than those based exclusively on biblical material. *Quo Vadis* asserts its historical basis in a spoken prologue, which announces the film's theme as the 'immortal conflict' between the 'proud eagles that top the victorious Roman standards' and the 'humble

[30] Louvish, 383.

[31] "*Samson and Delilah*," *AFI Film Catalog*.

[32] Hall and Neale, 136.

[33] Garth S. Jowett, "The Concept of History in American Produced Films: An Analysis of the Films Made in the Period 1950–1961", *Journal of Popular Culture* 3/4 (1970): 800; Neale, *Genre and Hollywood*, 91.

[34] Louvish, 385.

[35] Babington and Evans, *Biblical Epics*, 177.

cross' of the early Christians. This conflict is dramatized and resolved through a romantic relationship between a persecuted Christian woman and a Roman commander who is eventually drawn to the new religion. Like DeMille's *The Sign of the Cross* (1932), the drama turns on Nero's burning of Rome, a spectacle of destruction comparable to Samson's tearing down of the temple. But whereas *Samson and Delilah* had used backgrounds shot by a second unit in North Africa as a complement to studio work, *Quo Vadis* was lavishly filmed on location and in studios entirely in Italy at a cost of $7.6 million.[36] The film was heavily promoted by MGM, who marketed a reported 100 commercial tie-ins based on the story, and worldwide rentals reached $21 million.[37] Such was the scale of its impact that Hall and Neale suggest that the film gave rise to the term 'blockbuster,' a metaphor derived from World War II bombing raids.[38]

Quo Vadis was followed by *The Robe* (1953), a second Christian/Roman epic which is remembered principally as the debut of 20th Century Fox's CinemaScope and stereophonic sound processes. It too was adapted from a bestselling novel, but unlike *Quo Vadis* it avoided exotic European locations in favor of a California-based shoot. The film depicts the growth of Christianity in Rome through the experiences of a Roman tribune who played dice for the robe worn by Jesus prior to the crucifixion. Heavily marketed as widescreen spectacle, *The Robe* earned $25 million, an extraordinary return on its $4.1 million production cost, and led to the direct sequel *Demetrius and the Gladiators* (1954), a very uncommon occurrence for prestigious films at the time.[39] Like *Quo Vadis*, the Rome depicted in *The Robe* is characterized by slavery, corruption, persecution, and paganism, and is apparently in desperate need of Christianity's redeeming influence.[40] At the same time, and in marked contrast to the piousness of the Christian characters, Rome plays host to spectacles of imperial power, excessive consumption, and luxurious sensuality. In this way the Roman/Christian epic provided contradicting pleasures, juxtaposing the spectacle of Rome with the moral uplift of Christianity.

As a follow-up to *Quo Vadis*, MGM sought to expand the iconographic range of the historical epic by adapting the Walter Scott novel *Ivanhoe* (1952). The same director and lead actor (Richard Thorpe and Robert Taylor) were hired, and in place of Italy the production was sent to studios and locations in England. Drawing on the history of the Crusades as well as the Robin Hood legends, *Ivanhoe* tells the story of the titular knight's struggle to restore the

[36] Hall and Neale, 137.

[37] "*Quo Vadis*," *AFI Film Catalog*.

[38] Hall and Neale, 139.

[39] Hall and Neale, 148. In its advertising materials, *Demetrius and the Gladiators* was branded 'The Continuation of *The Robe*.'

[40] Monica Cyrino, *Big Screen Rome* (Oxford: Blackwell, 2005), 19.

rightful king to the English throne. With international rentals just under $11 million against a production cost of $3.8 million, *Ivanhoe* was very profitable, although not quite to the same extent as *Quo Vadis*.[41] MGM attempted to duplicate *Ivanhoe*'s success with *Knights of the Round Table* (1953), also the studio's first CinemaScope release. The story ostensibly depicted an earlier historical period, but the chivalric iconography was unchanged. *Ivanhoe* and *The Knights of the Round Table* established a successful formula for medieval adventure based around opulent, color visual design, large-scale battle sequences, often on horseback, and stories of self-sacrificing romance. Subsequent releases in this vein included *Prince Valiant* (1954), *King Richard and the Crusaders* (1954), *The Black Shield of Falworth* (1954), and *The Adventures of Quentin Durward* (1955). As with the Robin Hood legend, these narratives commonly centered on the threat posed by a usurping, tyrannical regime and were resolved by the restoration of legitimate, egalitarian rulers.[42] Reviews in *Variety* tended to identify them as 'adventure' or 'swashbuckler' films rather than epics.[43] The 'swashbuckler' label was also applied to a cycle of pirate adventure films which appeared around the same time, including *The Crimson Pirate* (1952), *Blackbeard the Pirate* (1952), and Disney's *Peter Pan* (1953). But whereas the heroes of the medieval adventures tended to embody unambiguous moral goodness, pirates were necessarily positioned outside the social world and did not always find moral redemption at the resolution.[44]

Ancient Egypt received the epic treatment in *The Egyptian* (1954), another early CinemaScope release, and Howard Hawks' *Land of the Pharaohs* (1955). However, neither of these films made the same impact as Paramount's *The Ten Commandments* (1956). Directed again by DeMille, and partly adapted from his 1923 film of the same name, *The Ten Commandments* depicted the life of Moses leading up to the exodus of the Hebrews from slavery in Egypt and the revelation of God's law on Mount Sinai. Filmed in the new VistaVision widescreen process using American studios and Egyptian locations, *The Ten Commandments* was made for the unprecedented cost of $13 million and reported record worldwide rentals of $60 million.[45] As with *Samson and Delilah*, DeMille sought to emphasize the historical basis of what was essentially a Bible story, and the presentation of research materials formed a major part of the film's promotional discourse. Indeed, the research materials and production files generated for the film occupy a quarter of DeMille's archive

[41] Eddie Mannix Ledger.
[42] Taves, 200–20.
[43] See, for example, "Ivanhoe," *Variety*, June 5, 1952; "Knights of the Round Table," *Variety*, December 21, 1953; "The Black Shield of Falworth," *Variety*, August 3, 1954.
[44] Taves, 28.
[45] Hall and Neale, 159, 161.

at Brigham Young University.[46] More than simply a depiction of history, however, *The Ten Commandments* was marketed as a historical event in itself: according to its poster, this was 'The Greatest Event in Motion Picture History!'

As with the Christian/Roman epic, the drama of *The Ten Commandments* was based around a series of oppositions, in this case between Egyptian cruelty and materialism and oppressed Hebrew spirituality. This dichotomy is emphasized by the Oriental Otherness of Yul Brynner, cast as Rameses, and Charlton Heston's blond, blue-eyed Moses. Like the Romans, the Egyptians are shown to be wicked totalitarians. In Tony Shaw's words, they are an 'imperialist enemy... sustained by militarism and surveillance' whose monumental building projects are based on slavery and forced labour camps.[47] Similarly, Steve Cohan has noted the similarity of Egypt's 'monolithic architecture' to Albert Speer's Third Reich creations.[48] The parallels between the Egyptians and America's Nazi and Soviet enemies were in fact foregrounded by statements made by DeMille and by the souvenir program for the film, which contains a statement by Winston Churchill comparing the Pharaoh's 'massive machinery of oppression' to unnamed modern forces 'engaged in mortal combat for the future of mankind.'[49] The Cold War analogy is extended by the association of Hebrew characters first with Christians and secondly with modern Americans. Alan Nadel has noted several instances where the film anachronistically inter-polates iconography from the New Testament, most notably in its visual representation of Moses as a Jesus-like figure.[50] Similarly, Melani McAlister has argued that oppressed Hebrews and Christians in ancient world epics stand in for the American people: simple, freedom-loving, God-fearing, and (potentially) enslaved by Communism.[51] There are of course flaws in these interpretations. The material plenty enjoyed by Egyptians and Romans seems to conflict with Cold War conceptions of Soviet austerity, while the persistent casting of British actors as senior Roman figures suggests parallels with British imperialism. Nevertheless, the Cold War analogies not only indicate how Hollywood epics could be used to speak about the present, they also suggest thematic continuities in films ostensibly depicting very different topics.

[46] Louvish, 409–10.
[47] Tony Shaw, *Hollywood's Cold War* (Edinburgh: Edinburgh University Press, 2007), 121.
[48] Steve Cohan, *Screening the Male: Exploring Masculinities in Hollywood Cinema* (Bloomington: Indiana University Press, 1998), 132.
[49] Quoted in Shaw, 119.
[50] Alan Nadel, "God's Law and the Wide Screen: *The Ten Commandments* as Cold War Epic," *PMLA*, 103/3 (1993): 424–5.
[51] Melani McAlister, *Epic Encounters: Culture, Media and US Interests in the Middle East since 1945* (Berkeley: University of California Press, updated edn, 2005), 64.

The success of *The Ten Commandments* encouraged MGM to examine
their own back catalogue for old epic films suitable to be remade. The result
was *Ben-Hur* (1959): filmed almost entirely in Italy at a cost in excess of $15
million, it earned over $67 million worldwide, displacing *Gone with the Wind*
from its long tenure at the top of the *Variety* 'All-Time Top Grosses' list.[52] The
narrative focuses on Judah Ben-Hur, a young, aristocratic Jew whose refusal
to endorse Roman rule over his people leads to his exile first as a galley
slave and later as a charioteer. On his eventual return to Judea he discovers
that his mother and sister have leprosy and witnesses the crucifixion of
Jesus, whose life has intersected with his own throughout the narrative. In
contrast to the original novel and previous adaptations of it, Ben-Hur does not
convert to Christianity, but he is inspired by Jesus' example to forgive those
who have wronged him. Although it avoids Rome itself, *Ben-Hur* follows the
conventions of the Christian/Roman epic by putting Roman imperialism in
conflict with proto-Christian Judaism. As Wyke observes, the film obliquely
presents Christ as 'the historical agent who ultimately motivates resistance
to pagan, totalitarian rule.'[53] *Ben-Hur is* also the most prominent in a cycle of
epic films either based directly on the life of Jesus, or indirectly with Jesus
as the narrative pivot. They include *The Big Fisherman* (1959), *King of Kings*
(1961), *Barabbas* (1962), *The Greatest Story Ever Told* (1965), and *The Bible*
(1966); the latter is an attempt to narrate the Bible in its entirety. In addition
to its biblical elements, *Ben-Hur* can be seen in the context of contem-
porary Jewish nationalism and the popular support for it in 1950s America.
In this sense, Ben-Hur's struggle for national self-expression in a homeland
oppressed by Roman imperialists resonated with the modern founding
of Israel in British-occupied Palestine.[54] As in *The Ten Commandments*,
however, Jewishness is hard to disentangle from modern Christianity, due
not least to Charlton Heston's westernized appearance. As Michelle Mart
has suggested, the representation of ancient world Hebrews in historical
epics was part of a process whereby Jews were constructed as part of an
American 'Judeo-Christian' system of values and identity to combat atheist
Communism.[55]

In *Spartacus*, produced for Universal in 1960 and shot largely on their
backlot, the historical epic appeared to develop in alternate political direc-
tions. The film is based on the 71 BC slave uprising led by Spartacus, an event
in which an oppressed people fought for freedom against an exploitative
Roman ruling class. Unsurprisingly, the Spartacus legend has long been

[52] Eddie Mannix Ledger; "All-Time Top Grosses," *Variety*, January 4, 1961, 49.
[53] Wyke, 63.
[54] McAlister, 65.
[55] Michelle Mart, "The 'Christianization' of Israel and Jews in 1950s America," *Religion and American Culture*, 14/1 (2004): 109–46.

associated with left-wing and Marxist politics. Moreover, *Spartacus* was written by Howard Fast, on whose novel it was based, and screenwriter Dalton Trumbo, both of whom were 'blacklisted' in Hollywood due to their refusal to cooperate with the House Un-American Activities Committee regarding their alleged Communist affiliations. The decision of the producers to work with these writers, and particularly to 'break' the blacklist by giving them both screenwriting credits, added to the film's left-wing credentials.[56] Many interpretations of the film itself have been influenced by these political circumstances. The conflict established between the rebellious, oppressed slaves and the Romans who exploit, oppress, and eventually defeat them has straightforward revolutionary associations and also resonates with the experiences of African Americans. The iconic 'I am Spartacus!' assertion of comradeship and solidarity can moreover be linked to the experiences of the blacklisted screenwriters. According to Cyrino, the scene 'celebrates the heroism of artists who refused to "name names" when ordered by the committee... and so faced the vindictive reprisals of incarceration and the blacklist.'[57] However, as Wyke has argued, the more conservative ideological conventions of the ancient world epic are also in evidence. In its downplaying of the slave's military victories and its presentation of Spartacus' increasing pacifism, the film characterizes the revolt as an implicitly Zionist attempt to return to a homeland rather than a class struggle to overthrow the oppressive Roman state.[58] In addition, the invented crucifixion of Spartacus at the end of the film seems to be a clear allusion to the Passion of Christ, a comparison which highlights the spiritual nature of his suffering and effectively depoliti- cizes his actions.[59] Thus, even as the conventions of the ancient world epic began to loosen at the end of the 1950s, *Spartacus* identified the struggle for freedom and independence as a religious as well as a political conflict.

During the early 1960s the more conspicuous themes of epic cinema became sufficiently malleable to be transplanted from the ancient world to the Middle East of the twentieth century. *Exodus* (1960) and *Lawrence of Arabia* (1962) thus update the heroic battle for national self-expression and religious freedom in the face of imperialist oppression, while retaining the ancient world epic's massive scale, sense of spectacle, and extended running time. Based on the bestselling novel by Leon Uris, *Exodus* tells the story of the Jewish settlement of Palestine in the late 1940s, under British mandate at the time, and the creation of Israel, thus giving the Zionist founding myth alluded to in *Ben-Hur* and *Spartacus* direct representation. The film draws

[56] Jeffrey P. Smith, "'A Good Business Proposition': Dalton Trumbo, *Spartacus*, and the End of the Blacklist," *Velvet Light Trap*, 23 (1989): 75–100.
[57] Cyrino, *Big Screen Rome*, 117.
[58] Wyke, 70–1.
[59] Ibid., 64.

on the ancient world epic in additional ways, particularly in its construction of protagonist Ari Ben Canaan, whose heroic destiny is entwined with that of the Jewish state. But *Exodus* also tells the story of Kitty, an American traveler who comes to sympathize with the Jewish refugees, falls in love with Ben Canaan, and decides to live in Israel. It can thus be read as a narrative of conversion: just as the Roman commander converts to Christianity in *Quo Vadis* and Moses abandons an Egyptian identity in favor of his Hebrew heritage, *Exodus* charts Kitty's transformation from politically disengaged observer to supporter of Jewish political aspirations. *Lawrence of Arabia*, directed by David Lean and released by Columbia, also bears similarities to the ancient world epics of the previous era. Lavishly produced against an exotic backdrop, it is the story of a heroic uprising against a colonial power under the leadership of an exceptional, visionary individual. However, Lawrence is significantly removed from heroic archetype established in earlier films. Whereas Moses and Spartacus are relatively simple characters, motivated largely by the goals of people they lead and represent, Lawrence is a psychologically unstable individualist who is never shown to be in command of his destiny, and for whom suffering and violence is corrupting rather than redemptive. When he self-consciously likens his attempt to cross the Sinai Desert to Moses, the comparison is ironic and serves to underline his hubris. Lawrence's adoption of Arabic dress and (to an extent) identity as the film progresses might be regarded as a conversion, but the effects of this process are ambiguous. Despite his support of Arab nationalism, Lawrence remains an agent of British imperialism, and his leadership of the Arabs ultimately undermines their political goals and delivers them not to the promised land of freedom but to British rule.

As *Lawrence of Arabia* and *Exodus* demonstrate, epic themes and production values were by no means confined to the ancient world. The same can also be said of *Doctor Zhivago* (1965), Lean's epic follow-up to *Lawrence*, which dwarfed even *Ben-Hur* with worldwide grosses around $100 million.[60] By the late 1950s it became common for non-ancient world historical films to be scaled upward in order to emulate the form of the major epics. Hollywood's first large-scale representations of the Holocaust, 20th Century Fox's *The Diary of Anne Frank* (1959), and United Artists' *Judgment at Nuremberg* (1961) can be regarded as examples of this upgrading practice. In another era they might have been produced on a modest scale suited to their subject matter, but both were given extended running times and exhibited on a roadshow basis, the former in CinemaScope despite its highly enclosed locations. Both were unsuccessful, although the high-minded, prestigious subjects they addressed came to be more closely associated with historical

[60] Hall and Neale, 181.

cinema later in the 1960s. As Hall and Neale have suggested, ancient world epics were to some extent replaced by the middle of the decade with historical films 'marked less by scale than by the prestige conferred by literary or theatrical origins, and by an emphasis on dialogue rather than actions.'[61] *Becket* (1964) and *A Man for All Seasons* (1966) were the most prominent examples of this tendency. Both adapted from contemporary plays and based on relatively unfamiliar events in English history, they nevertheless proved more profitable than more traditional ancient world epics such as *The Fall of the Roman Empire* (1964), which had a production cost of $17.8 million but earned just $1.9 million in North America.[62] By the mid-1960s, then, the ancient world epic cycle had runs its course, at least temporarily. But for 15 years, it had produced some of the most extravagant, expensive, and profitable films ever produced in Hollywood.

War films and historical musicals

The colossal presence of the ancient world epic has tended to overshadow alternate engagements with history during the 1950s and 1960s. The continued popularity of the western ensured that frontier-era America remained a constant presence on Hollywood production slates, but a different perspective on the past emerged in a popular cycle of World War II war films and a series of high-profile musicals derived from historical events.

The World War II films of this era dramatized historical events from the very recent past and generally fall within Jeanine Basinger's 'combat film' classification. According to her definition, combat narratives are organized around a group of soldiers of mixed socio-ethnic backgrounds and varying levels of experience, led by an officer who separates himself from the group and is tasked with a military objective against a generally faceless enemy.[63] In this way, the vast proportions of the war are distilled into a form which is consistent with the narrative conventions of Hollywood cinema. *Sands of Iwo Jima,* produced by the small Republic studio in 1949, might be regarded as representative of the World War II combat film. Based on the 1945 Battle of Iwo Jima in the Pacific, the film follows a platoon of marines led by the unpopular but valiant Sergeant Stryker, played by John Wayne. As Basinger has suggested, the film is largely realistic in its depiction of combat, but the realism is motivated not by a political impulse to reveal the horrors of

[61] Ibid., 181.
[62] Ibid., 179.
[63] Basinger, 56.

war but rather by the influence of newsreel photography.[64] Indeed, the film incorporates newsreel footage taken during the Pacific campaign throughout its combat scenes, largely to reduce costs but also to add authenticity to the action. The film further engages with historical material by recreating the iconic Joseph Rosenthal photograph, taken in 1945, of a group of Marines raising the American flag on Mount Suribachi. The reconstruction occurs at the climax of the film but moments after the sudden death of Sergeant Stryker, thus tempering the triumphalism of the image with a sense of loss. The reconstructionist approach to World War II films reached its apex in 1962 with *The Longest Day* (1962). Adopting a realistic style which Basinger describes as 'storytelling newsreel,' the film benefits from extensive location work and access to authentic military hardware and features a significant amount of French and German dialogue. *The Longest Day* also departs from earlier combat films by reconstructing the D-Day landings from multiple narrative positions: American, German, French, and British; military commanders, enlisted soldiers, and civilians.[65] Rather than presenting the conflict through the experiences of a small, representative group, the film attempts to create a narrative panorama, moving rapidly between spaces and shunning central characters. In keeping with this even-handedness, the film presents the German military as competent professionals rather than anonymous villains. This unorthodox approach is to some extent mitigated by the casting of major American and British stars, including John Wayne, Henry Fonda, and Richard Burton. In this way, Allied soldiers are made attractive and sympathetic without extensive individual characterization. Despite its unusual structure, *The Longest Day* proved to be immensely popular, earning over $30 million worldwide.[66]

Although World War II has largely been depicted by Hollywood in terms which emphasize 'valour, patriotism and meaningful sacrifice,' a smaller number of films expressing dissenting views emerged in the 1950s.[67] Released in 1957, Stanley Kubrick's *Paths of Glory* tells the story of French World War I soldiers who fail to complete a 'suicide mission' in German territory. Accused of cowardice by the careerist general who orders the attack, three representative soldiers are court-martialed and executed. As Steve Neale notes, whereas other combat films stress solidarity across military ranks, *Paths of Glory* creates an 'opposition of interests' between ordinary soldiers and their commanding officers. Moreover, it is the corrupt culture of the officer classes rather than the unseen enemy in the opposing

[64] Ibid., 154.
[65] Ibid., 171.
[66] Hall and Neale, 166.
[67] Barry Langford, *Film Genre: Hollywood and Beyond* (Edinburgh: Edinburgh University Press, 2005), 107–9.

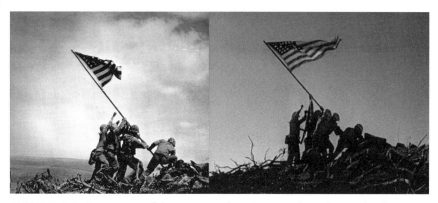

FIGURE 4.3 *Recreation of the iconographic photograph in* The Sands of Iwo Jima *(1949)*

trenches who cause the enlisted soldiers the most suffering and misfortune.[68] The film is reminiscent of *The Life of Emile Zola* (1937) in its courtroom grand-standing and criticism of French military justice, although its considerably more strident tone led to it being banned in France until the 1970s.[69] But rather than attacking the French army in particular, *Paths of Glory* perhaps intended to target military culture in general. This universal context was reinforced by the film's publicity campaign, which avoided promotional images of cast members in period uniforms in order to modernize the film's anti-war message.[70] Anti-war themes can also be identified in *The Bridge on the River Kwai*, which was released the same year. Set in a World War II Japanese prisoner-of-war (POW) camp, the film concerns a division of British soldiers who are forced to build a railway bridge for the Japanese army. The phleg-matic Colonel Nicholson sees this as an opportunity to maintain morale and takes command of construction, despite its value to the enemy. Like *Paths of Glory*, a conflict is established between the interests of rank-and-file soldiers and their commander, although Nicholson's behavior seems to be motivated by psychological instability rather than careerist ambition. Indeed, *The Bridge on the River Kwai* was among the first World War II films to associate war and military culture with insanity, a connection made explicit in the final words of the film—'madness, madness!'—which are spoken by an officer as he surveys the destruction caused by the detonation of Nicholson's bridge. Produced at a cost of just $2.8 million, *The Bridge on the River Kwai* earned

[68] Steve Neale, "Aspects of Ideology and Narrative Form in the American War Film," *Screen,* 32/1 (1992): 40.

[69] Tino Balio, *United Artists: The Company that Changed the Film Industry* (Madison: University of Wisconsin Press, 1987), 158.

[70] Eldridge, *Hollywood's Historical Films,* 54.

more than $30 million worldwide, making it among the most successful films of the decade.[71]

The influence of *The Bridge on the River Kwai* can be seen, in somewhat depoliticized form, in a sequence of films made in the 1960s which present World War II as a site for heroic, masculine adventure. Filmed in Greece and Britain, *The Guns of Navarone* (1961) depicts a Commando unit charged with a fictional 'special mission' to sabotage a garrison of heavy artillery stationed on a Nazi-occupied island. In many ways the film extends the narrative formula established in older combat films by depicting a group of soldiers engaged in an audacious mission. But rather than creating a realistic tone and presenting the platoon in terms of their ordinariness and everyman status, the film highlights the specialized talents of individual group members (rock climbing, explosives, knife fighting) and presents the mission as a showcase for skilled heroism rather than a battle for survival. The movement from realism to playfulness is also signaled by film's dressing-up motif: the soldiers are disguised as Greek fishermen in the initial part of their mission and spend much of the latter part wearing stolen Nazi uniforms. *Kwai*'s depiction of the POW camp became the focus of *The Great Escape* (1963), based on a 1944 attempted escape from the Stalag Luft III. The mission was largely unsuccessful and led to the execution of many Allied officers, but a great deal of pleasure is created by the film's attention to the procedural aspects of the breakout (forging documents, faking Nazi costumes, digging tunnels), the prisoner's outsmarting of Nazi guards, and the value placed on acting as part of the mission. In a sense, the film depicts the POW camp as a game. The popularity of *The Great Escape* led to a small cycle of POW escape films, while *The Guns of Navarone* was followed by a series of 'special mission' films, notably *The Dirty Dozen* (1967), in which the upright soldiers of earlier World War II films were replaced by violent criminals. In the process, as World War II receded from memory, the war film became ever more estranged from the unpleasant realities of the actual conflict.

History was treated in a rather different way by a sequence of high-profile period musicals during the 1950s and 1960s. Released in 1951, MGM's *Singin' in the Rain* gave Hollywood filmmakers the opportunity to light-heartedly mythologize the history of their industry, dramatizing the arrival of talking pictures during the 1920s as both a love story and a rags-to-riches melodrama. Like several other celebrated MGM musicals of the period, *Singin' in the Rain* (1952) was written specifically for the screen and followed a style which in many ways was distinct from musical theater. However, the most successful musical films of the era were in fact adapted directly from successful Broadway plays, in particular the work of Richard Rodgers and

[71] Hall and Neale, 161.

Oscar Hammerstein, who frequently tackled historical subjects. First staged on Broadway in 1943, *Oklahoma!* depicts the creation of a 'brand new state' in early twentieth-century Oklahoma territory, an area previously set aside for Native Americans. As Tim Carter suggests, the territory is presented as a pastoral, Arcadian space, full of promise for the future and populated by a community of child-like characters. But in order for the community to survive in its reconstituted form it is necessary for undesirable elements to be expelled, in this case the 'bullet-colored' sociopath Jud.[72] As Babington and Evans suggest, the coherence and optimism of this community is also dependent on the off-stage repression and exclusion of Native Americans.[73] Nevertheless, the appeal of such idyllic, innocent Americana struck a chord among wartime urban audiences, and *Oklahoma!* played on Broadway for a record 2,212 performances. This sustained success delayed the production of a film adaptation until 1955, when it was released using the newly developed Todd-AO widescreen process. This new technology, combined with the prestigious Broadway pedigree of the source material, allowed *Oklahoma!* to be marketed as a theatrical experience rather than a Hollywood movie. The film was produced independently of the major Hollywood studios and given a roadshow release with top tickets priced at a new high of $3.50.[74] Due in part to the pre-sold nature of the material, but also due to the close involvement of Rodgers and Hammerstein (who claimed 40 percent of the profits), the film barely departed from its source.[75] Indeed, *Films and Filming* complained, 'this is *not* a film musical. It is a wide-screen record of the stage show.'[76] Perhaps the most significant change was the toning down of the play's occasional sexual frankness, although *Motion Picture Herald* nevertheless noted that the film contained 'unusually explicit dialogue references, uncommonly explicit lyrics.'[77] With rentals from its North American roadshow run of around $9 million, *Oklahoma!* may have fallen slightly short of expectations, but it pioneered the profitable crossover of prestigious Broadway musicals to large-scale roadshow spectacles.[78]

Oklahoma's depiction of cultural integration was extended and projected on an international scale in two further Rodgers and Hammerstein adaptations from the 1950s, *The King and I* (1956) and *South Pacific* (1958).[79] Set

[72] Tim Carter, *Oklahoma! The Making of an American Musical* (New Haven: Yale University, 2007), 186–92.

[73] Bruce Babington and Peter Evans, *Blue Skies and Silver Linings: Aspects of the Hollywood Musical* (Manchester: Manchester University Press, 1985), 189.

[74] Press advert, *Life*, October 17, 1955.

[75] "Oklahoma in C'Scope Version," *Boxoffice*, July 28, 1956.

[76] "Oklahoma!," *Films and Filming*, October 1956.

[77] William R. Weaver, "Oklahoma!," *Motion Picture Herald*, October 8, 1955, 52.

[78] Hall and Neale, 151.

[79] Babington and Evans, *Blue Skies*, 189.

respectively in nineteenth-century Southeast Asia and the Pacific Islands during World War II, both films resonate, as Christina Klein has argued, with post-war American expansion in these areas.[80] Produced by 20th Century Fox, *The King and I* is based on the experiences of English schoolteacher Anna Leonowens who worked as a governess in the court of the King of Siam. Anna is employed to educate the King's wives and children in Western ideas and behavior, and much of the drama concerns the conflict between the autocratic king and the modern, democratic values which Anna persuades him to embrace. Anna is perhaps identified more closely with American rather than English culture, particularly in her endorsement of President Lincoln's ideals. In this way, the film sidesteps the discredited politics of European imperialism and projects the more benevolent, modernizing form of influence which American foreign policy in Southeast Asia attempted to promote during the 1950s.[81] *South Pacific* concerns the wartime experiences of American servicemen and women, but in stark contrast to the combat films of the era the island is a romantic, enchanted space. With wartime adversaries on the margins of the narrative, conflict is internalized as the ideological obstacles which impede relationships between people of different ethnicities. The song 'You've Got to be Carefully Taught' argues that the fear of racial difference is ingrained by culture rather than nature. The film's antiracist message is stronger in theory than in practice, however; both of the interracial relationships it depicts are curtailed by death. Nevertheless, the message of cultural integration resonated both with the emerging Civil Rights movement and America's post-war expansion in the Pacific. Like *Oklahoma!*, *South Pacific* was produced and roadshown independently of the Hollywood studios. With rentals of $17.5 million in North America, plus record earnings from British cinemas, the film proved even more popular than its Broadway predecessors.[82]

In the 1960s a small number of Broadway adaptions reached even greater commercial heights. In particular, Rodgers and Hammerstein's *The Sound of Music* (1965), produced by 20th Century Fox, rapidly became the most successful film of all time with worldwide rentals estimated between $115 and $125 million.[83] Set in Austria around the time of its annexation with Nazi Germany, the film is based loosely on the real-life experiences of the Von Trapp family. Echoing *The King and I*, it depicts a governess entering a dysfunctional family and using education (in this case musical) as a means to resolve its problems. The other major Broadway adaptation of the 1960s

[80] Christina Klein, *Cold War Orientalism: Asia in the Middlebrow Imagination, 1945–61* (Berkeley: University of California Press, 2003), 143–223.
[81] Ibid., 194–5.
[82] "All-Time Boxoffice Champs," *Variety*, January 4, 1967, 9; Hall and Neale, 184.
[83] Hall and Neale, 184.

was *My Fair Lady* (1964), adapted from the Alan Lerner and Frederick Loewe musical set in Edwardian England. Confident that it would transfer success-fully to film, Warner Bros. invested $17 million in the production, including a record $5.5 million for the film rights.[84] The film earned an estimated $55 million worldwide.[85] The success of these musicals encouraged the major studios to invest in additional Broadway properties, although as the decade progressed, the returns became less impressive. Among them was *Camelot* (1967), also adapted from another Lerner and Loewe musical. Perhaps aware that popular tastes were changing, Warner Bros. attempted to update the Arthurian drama through innovative production design, which departed from the staged version, and by casting actors who were not associated with musical roles. The souvenir program for the film emphasized this modern-izing process, describing the film as 'mod-medieval' and boasting that stars Vanessa Redgrave and David Hemmings came 'straight out of the most Mod film of all, *Blow Up!*'[86] Produced for a cost of $12 million, the film emerged as a box office failure.[87] Spectacular roadshow adaptations of historical Broadway shows were highly lucrative during the 1950s and for much of the 1960s, and perhaps even more than the historical epic they expressed Hollywood's policy of investing heavily in a small number of high-profile releases. Like the epic, however, the high costs of production made the cycle vulnerable to changing audience tastes.

Historical films occupied a privileged position in the American film industry of the 1950s and 1960s: they attracted a large proportion of the money invested in film production, and in turn they generated a large proportion of Hollywood's profits. According to David Eldridge, more than 40 percent of the films produced in America during the 1950s were set in the past.[88] It is also striking that the majority of the most popular films of the period avoided American settings. Whereas in the 1930s and the 1940s depictions of American and European history operated more or less in balance, the dominant historical films of the 1950s and 1960s focused on Europe and the Middle East, particularly during the ancient world period. The principal exception, of course, was the western, which remained popular throughout the era. But if American historical settings were sidelined, contemporary American politics were not. Many ancient world epics, war films, and musicals can be interpreted as expressions of American Cold War ideology as the nation adjusted to the post-war balance of power and faced off against the Red Menace. It was perhaps from this conflict that the epics of the period

[84] Stubbs, *Runaway Bribe*, 15–16.
[85] Hall and Neale, 184.
[86] *Camelot* Souvenir Program. Pressbook Collection, Margaret Herrick Library, Los Angeles.
[87] Bill Ornstein, "Josh Logan Introducing Many Firsts," *Hollywood Reporter*, February 28, 1967.
[88] Eldridge, *Hollywood's Historical Films*, 1.

generated the 'moral intensity' which Raymond Durgnat identified with the form.[89] To return to Deleuze's metaphor, the association of the ancient world with the modern era can also be regarded as telling history 'via the peaks,' a reductive but powerful approach based around analogies between past and present.[90]

As Peter Krämer has suggested, the 'roadshow era' was a period in which the American film industry ceased to mass-produce films for a large audience of habitual cinemagoers, and focused instead on the production of fewer, bigger films which were promoted in terms of their 'event' status.[91] Historical films of the era thus emphasized spectacle, were adapted from presold properties, marketed in ways which accentuated their prestige value, and distributed on a roadshow basis to family audiences. Of course, other filmmaking genres could in theory have been upgraded to meet some of these requirements, but the historical film proved to be the most suitable. In short, historical films—particularly ancient world epics, Broadway musicals, and war films—met the demands of the era. As the financial stresses caused by the spiraling budgets of *Cleopatra* and *Mutiny on the Bounty* indicated, however, investment in spectacular historical films was a high-risk strategy. Interestingly, the failure of *Cleopatra* and *Mutiny* did not in fact terminate the big-budget epic cycle. The end came several years later following the cumulative impact of several of lower-profile failures, including the period musicals *Doctor Dolittle* (1967) and *Hello, Dolly!* (1969) and the war film *Tora! Tora! Tora!* (1970). As Hall and Neale suggest, the Hollywood studios were undone by 'a combination of overproduction, overspending, and overestimation of the market's value.'[92] With the benefit of hindsight, Hollywood's high-spend mode of production was unsustainable, especially as Hollywood's audience began to fragment along generational lines and became less susceptible to the attempted inclusivity of family-orientated films. As we will see in the final section of this historical overview, history films continued to play a high-profile role in the period which followed, but they were never again to be the cornerstone in Hollywood's global empire.

[89] Raymond Durgnat, "Epic," *Films and Filming*, 10/3 (1963): 11.
[90] Deleuze, 149.
[91] Krämer, 21.
[92] Hall and Neale, 194.

5

New Hollywood, new histories

The post-epic era

Before the 1970s the most successful films produced by the Hollywood studios could be identified with the historical film genre, among them *The Birth of a Nation* (1915), *The Four Horsemen of the Apocalypse* (1921), *Gone with the Wind* (1939), *Ben-Hur* (1959), and *The Sound of Music* (1965). In this period, historical cinema consistently attracted the highest levels of investment from Hollywood filmmakers, and despite numerous high-profile failures they provided handsome returns at the box office with regularity sufficient to justify the risk. With a few exceptions, this ceased to be the case in the decades which followed. Perhaps even more than preceding era, the 1970s and 1980s were a time of considerable change in Hollywood: the traditional American studios were absorbed by multimedia entertainment conglomerates, and major films were increasingly positioned as the linchpin in a range of products promoted across interconnected media and markets.[1] Hollywood executives in the 1950s had used expensive historical cinema as a means to stabilize the industry and win back audiences, but in the period which followed the genre no longer provided the same security. Broadway adaptations, often with period settings, continued to attract audiences during the 1970s—notably *Fiddler on the Roof* (1971) and *Cabaret* (1971)—but historical epics became uncommon. As Hall and Neale have noted, many of the films most closely related to the epics of the roadshow era now originated outside America. Examples include *Waterloo* (1970), a Soviet-Italian co-production, and *Mohammad, Messenger of God* (1976), financed

[1] Krämer, 79; Thomas Schatz, "The New Hollywood" in Jim Collins, Hilary Radner, and Ava Preacher Collins (eds), *Film Theory Goes to the Movies* (New York: Routledge, 1993), 33.

by Libyan sources and filmed in both English and Arabic-language versions.[2] Ancient world settings became extremely rare in mainstream Hollywood cinema during this period, and relatively few high-profile films were based on World War II combat. In their absence, film genres such as science fiction and horror, which had previously been associated with low-budget production, were inflated to event-picture status and replicated through sequelization.

Other elements associated with the roadshow era also declined during the 1970s and 1980s, not least the practice of roadshowing itself. By the end of the 1960s the roadshow market was essentially saturated and films which had been produced with roadshow distribution in mind were released in regular cinemas.[3] The unexpected success of *The Graduate* (1967) pointed to the financial dividends available through regular distribution practices. With American rentals in excess of $44 million, the film became the most successful non-roadshow release to date, and due to a slender $3.1-million budget it was considerably more profitable than the historical epics of its era.[4] In the years which followed, Hollywood distributors developed new strategies for releasing films in multiple locations over short periods of time, compressing profits, and priming the audience for increasingly valuable home release formats. In addition, the post-roadshow period was marked by the apparent decline of the family audiences who were often associated with historical epics. As Peter Krämer has noted, many of the major films of the late 1960s and 1970s responded to the weakening of Hollywood's production code after 1966 by featuring relatively strong sexual and violent content.[5] The temporary marginalization of family-orientated films can be attributed in part to the post-war 'baby boom.' By 1970, 16- to 24-year-olds made up 18 percent of America's population and formed an increasingly lucrative segment of Hollywood's audience.[6] Amid further social and industrial transformation, then, the historical film was displaced from the center of Hollywood's business operations. In the aftermath of the epic excesses and overproduction of the roadshow era, it was no longer regarded as an effective means to galvanize audiences. However, as this chapter will demonstrate, a variety of historical films and film cycles nevertheless played significant roles in Hollywood cinema, culminating to some extent in the eventual return of the historical epic in the late 1990s.

[2] Hall and Neale, 203.
[3] Ibid., 196.
[4] Ibid., 191.
[5] Krämer, 33–4.
[6] Ibid., 60.

Returning to American history

The 'New Hollywood' period has often been presented as a clean break in Hollywood's history, characterized by the emergence of a new generation of young talent, a European-influenced formal innovation, and a post-censorship boldness in depictions of sex and violence. According to Peter Biskind's influential, occasionally hyperbolic account of the period, 'the New Hollywood was a movement intended to cut film free of its evil twin, commerce, enabling it to fly high through the thin air of art'.[7] But despite its apparent rejection of the old, the New Hollywood era (roughly the late 1960s to the late 1970s) was closely connected with representations of history, particularly the history of the early twentieth century. The key difference was that whereas the major historical films of the roadshow era had almost completely avoided the American past in favor of European and Holy Land locations, the New Hollywood films took the opposite tack, spurning the Old World in favor of the New. Indeed, the New Hollywood period arguably commenced with the unexpected success of *Bonnie and Clyde* in 1967, set in the 1930s American South, and was arguably brought to a close by Michael Cimino's unmarketable epic western *Heaven's Gate* in 1980. In between, *Chinatown* (1974) and *The Godfather* films (1972 and 1974) turned to the past to produce new variations on the crime film, and *The Last Picture Show* (1971) and *American Graffiti* (1973) evoked the youth culture of America's recent history. In addition, prominent cycles of westerns and war films addressed dominant attitudes towards violent conflicts in American history, both overseas and on America's frontier. Hall and Neale have suggested that this return to American subjects and American history can be attributed in part to a 'shift in the balance of worldwide revenues back towards the domestic market.'[8] The swing might also be understood as an attempt to differentiate new historical films from the commercially unviable epics of the roadshow era. In any case, far from being a period in which historical cinema was marginalized, the New Hollywood period was marked by a bold reconnection with America's past.

This reconnection was signaled by the credit sequence of *Bonnie and Clyde*. Interspersed with blood-red title cards, a series of 30 sepia snapshots are flashed on the screen accompanied by the sound of a camera shutter. Each one is held for just a fraction of a second, foreshadowing the rapid editing of the film's violent conclusion. The pictures appear to depict the childhood of the film's protagonists, progressing from images of babies to children and later adults. Two photos featuring a young girl in a beret alludes to Bonnie's

[7]Peter Biskind, *Easy Riders, Raging Bulls: How the Sex-Drugs-and Rock 'n' Roll Generation Changed Hollywood* (London: Bloomsbury, 1999), 17.
[8]Hall and Neale, 202.

iconic costume, and images of men with guns and a woman posing on the bumper of a car refer to scenes in the film itself and may in fact be images of the real Barrow gang. The final two pictures show the actors playing Bonnie and Clyde and are accompanied by text briefly summarizing their lives prior to their criminal notoriety. The drama is thus contextualized and authenticated by a visual backstory which appears to bridge the gap between the historical record and the film's depiction of it. The sequence also reinforces Bonnie and Clyde's attempts to control their media representation: later in the film they pose for photos with their cars and guns, and Bonnie writes a fatalistic verse autobiography for a newspaper. In this way, *Bonnie and Clyde* emphasizes the mythic dimensions of the story as well as its historical context. Unlike other historical film depictions of the 1930s American South, relatively little attention is paid to the human cost of the financial crisis. Although they encounter various people who have been ruined by the Depression, Bonnie and Clyde are afflicted less by economic pressures and more by violent social institutions which are hostile to their (obviously destructive) lifestyle. This depiction of societal conflict and institutional violence fed into the reception of the film. Among others, *Newsweek* reviewer Joe Morgenstern interpreted *Bonnie and Clyde* as an exposé of the violence innate to modern American society, arguing that the film shows that 'violence is not necessarily perpetrated by shambling cavemen and quivering psychopaths but may also be the casual, easy expression of only slightly aberrated citizens.'[9] The film proved to be an unexpected box office success. Following an attenuated first run, *Bonnie and Clyde* was re-released amid growing critical acclaim and generated domestic rentals of $23 million.[10]

Several years later, *The Godfather* presented a similar blend of American history, violence, and myth. However, the criminals of *The Godfather* could hardly be regarded as outlaws; instead they are shown to co-exist with and even replicate 'legitimate' social institutions. Like *Little Caesar* (1931) and *Scarface* (1932), the film invents characters and storylines (it was adapted from Mario Puzo's bestselling novel) but it has its basis in history, in this case the post-war conflict between the five families who controlled organized crime in New York. Much of the detail presented in the film derives from the 1963 Senate Committee investigation into organized crime and the testimony of former Cosa Nostra 'soldier' Joseph Valachi, which exposed the once-secretive criminal underworld. But despite the inclusion of characters seemingly based on Frank Sinatra and the gangster Bugsy Siegel, *The Godfather* exists in a somewhat enclosed cultural context. Its sequel, *The*

[9] Joseph Morgenstern, "The Thin Red Line" in Stephen Prince (ed.), *Screening Violence* (New Brunswick: Rutgers University Press, 2000), 47.
[10] Krämer, 6.

Godfather Part II, is much more explicit in its engagement with American history, mapping connections between organized crime and mainstream American politics and business. It was also significantly less successful: *Part I* earned an extraordinary $87 million domestically, while *Part II* reported rental earnings of $31 million.[11] Tellingly, the sequel dramatizes the Senate Committee hearings (although it transplants them to the late 1950s), thus marking the moment when post-war organized crime entered mainstream American culture. David Cook suggests that *Part II* provides a portrait of an America in which 'legitimate and illegitimate power are very closely intertwined.'[12] As such, Cuban dictator Fulgencio Batista is supported not only by the American Government, but also by American crime syndicates who collaborate with thinly fictionalized American corporations—'General Fruit' and 'United Telephone and Telegraph'—to take over the Cuban gambling industry.[13] Throughout the film, Michael Corleone's ruthless, globalized criminal operation is rather sentimentally contrasted with its humble, more honorable beginnings among Italian immigrants in the early twentieth century. As Cook suggests, the history of criminal America is thus shown to resemble that of corporate America, and in this way, the film provides an ironic response to Michael's earlier promise to make the family business 'completely legitimate.'[14] Similar themes can be observed in *Chinatown*, released the same year, which derived in part from Cary McWilliams' historical work on the intrigue surrounding Los Angeles' water supply.[15] Adopting the form of a detective story and emulating visual elements from pre-war Hollywood crime cinema, the narrative gradually reveals a society in which powerful, corrupt individuals are free to bypass social institutions and to manipulate, dominate, and even destroy those who impede their desires. In its notoriously pessimistic conclusion, efforts to defy this institutionalized, omnipresent evil are shown to be futile and counterproductive.[16].

The conspiratorial tone of *Chinatown* and *The Godfather Part II* and their overriding theme of massive institutional corruption can be traced in part to the Watergate scandal, which began in 1972 and led to the resignation of Richard Nixon in 1974. The event was depicted directly in *All the President's Men* (1976), based on the trailblazing investigations of *Washington Post* reporters Bob Woodward and Carl Bernstein. The film meticulously reconstructs

[11] Ibid., 108–109.
[12] David A. Cook, *Lost Illusions: American Cinema in the Shadow of Watergate and Vietnam, 1970–79* (New York: Charles Scribner's Sons, 2000), 136.
[13] Ibid., 187.
[14] Ibid., 185.
[15] Peter Lev, *American Films of the 70s: Conflicting Visions* (Austin: University of Texas Press, 2000), 54.
[16] Ibid., 59.

Woodward and Bernstein's investigation, hardly sparing the patience of the viewer as it shows the pair sorting through library file cards and doorstepping dozens of Nixon affiliates. Indeed, far more attention is devoted to the procedures of investigative journalism and the politics of the newsroom than to Nixon's actual misdeeds. Insight into the private lives of the two journalists is also conspicuously absent: in contrast to standard Hollywood practices, they are defined entirely by their professional lives. Throughout, *All the President's Men* contrasts the brightly lit space of the newsroom with the unsettling darkness of the Watergate Hotel and the underground parking lot where Woodward meets enigmatic informer 'Deep Throat.' The work of journalists is thus represented as dragging the truth out of the shadows and into the light of the media. To quote Arthur M. Schlesinger Jr.'s criticism of Oliver Stone, the message of the mid-1970s conspiracy films seems to be that history 'is made at night: appearances are an illusion; reality subsists in the shadows.'[17] In *All the President's Men*, at least, good triumphs over wrongdoing. Unlike Gittes' investigation in *Chinatown*—or indeed the investigations of post-Watergate films such as *The Conversation* (1974), *The Parallax View* (1974), or *Night Moves* (1975)—Woodward and Bernstein's efforts are not doomed to end in ignominy and failure. Indeed, Robin Wood has described the film as an 'ambiguous' celebration of 'democratic systems that can expose and rectify wrongdoing.'[18] But despite its optimism, *All the President's Men* could hardly be accused of grandstanding in its presentation of Nixon's eventual downfall or its vindication of the journalists. As a television broadcasts Nixon's 1973 swearing-in ceremony, the pair diligently type their story. The scene dissolves to an image of a newsroom teleprinter which rapidly produces a series of wire-service bulletins tracing the development of the scandal and Nixon's eventual resignation. Woodward and Bernstein's heroism, as well as Nixon's villainy, are thus kept off-screen, subordinated by the impassive apparatus of the news media. Government institutions may be corrupt, but the fourth estate is untainted.

The New Hollywood period was also characterized by a trend for historical revisionism and a cycle of films which internationally undermined and reconstructed conventional historical narratives. An early example of this tendency can be seen in *The Charge of the Light Brigade* (1968), a British-based production financed by United Artists which depicted the infamous episode from the Crimean War. The film attempts to undo the mythologization of the 1854 charge (not least its representation in the 1936 Warner Bros.' film) by

[17] Arthur M. Schlesinger Jr., "On *JFK* and *Nixon*" in Robert Brent Toplin (ed.), *Oliver Stone's USA* (Lawrence: University of Kansas Press, 2000), 215.
[18] Robin Wood, *Hollywood from Vietnam to Reagan* (New York: Columbia University Press, 1986), 162.

painting it as a disaster whose human cost might easily have been avoided. As James Chapman suggests, the film is 'a lampoon of the values and attitudes of the military caste' which establishes a connection between the class structures dividing the army and its calamitous actions on the battlefield.[19] Much of this reflected contemporary attitudes towards social hierarchies, warfare, and the intervention of Western countries overseas. Modern parallels were extended in the film's depiction of a peaceful anti-war protest in London, which is violently suppressed by Lord Cardigan's Hussars who can be heard shouting 'Go back to Russia!'[20] However, historical revisionism and contemporary political analogy in this era was most commonly associated with the western. The early 1970s featured a small cycle of films which Douglas Pye has dubbed 'Vietnam westerns.'[21] Due in part to the difficulty of representing the ongoing Vietnam War directly, these films invoked the 'taming of the west as a metaphor for American involvement in Vietnam,' drawing parallels between the expansion of America's frontier in the nineteenth century and its violent and overbearing foreign policy in the twentieth century.[22] The atrocities of the American Indian Wars, marginalized in the traditional western, came to the fore as a means to question dominant western mythology and to associate it with contemporary American military violence. In particular, *Soldier Blue* (1970) depicted the 1864 Sand Creek massacre of Cheyenne Indians in highly graphic terms. Several contemporary critics noted that scenes from the film evoked (intentionally or otherwise) the horrific images of the 1968 My Lai Massacre in Vietnam: a *Variety* review, for example, called its correlation with contemporary events 'obvious.'[23] A number of westerns from this period are also notable for their relatively positive and detailed depiction of Native American characters. At the end of *Soldier Blue* the main female character elects to remain with the brutalized Cheyenne, while *A Man Called Horse* (1970) depicts the initiation of an English aristocrat into a Sioux tribe. These 'Vietnam westerns' thus challenged the affirmative mythologies of the traditional western—the superiority of white culture, violence as redemption, the inevitability of America's westward expansion—firstl by emphasizing violent and racist aspects of America's past, and secondly by suggesting parallels with the violence and racism of America's present.

Little Big Man (1970) was by far the most successful of the Vietnam westerns, earning $15 million domestically.[24] The film is a historical picaresque depicting the adventures of Jack Crabb, the self-proclaimed 'sole white

[19] Chapman, 242.
[20] Ibid., 250.
[21] Douglas Pye, "Ulzana's Raid," *Movie*, 27–28 (1980–1): 79.
[22] Cook, *Lost Illusions*, 174.
[23] "Soldier Blue," *Variety*, December 31, 1969.
[24] Krämer, 109.

survivor of the Battle of Little Big Horn.' Its narrative is framed by sequences featuring the 121–year-old Crabb in a modern-day nursing home as he is interviewed by a 'historian.' Crabb's reference to Little Big Horn prompts the historian to superciliously describe the Indians Wars as the 'near genocide of the Indians... the killing of an entire people,' adding, 'but of course I wouldn't expect an old Indian fighter like you to understand.' Outraged by the implication of his complicity and ignorance, Crabb begins to tell his life story. The founding of the film's narrative on a conflict between Crabb's story and the historian's revisionist conception of the past establishes, as Thomas Schatz suggests, 'a basic opposition between history and popular mythology.'[25] Like *A Man Called Horse*, *Little Big Man* attempts to present Native American culture from the inside through an acculturated white man. However, its portrait of the Cheyenne, who refer to themselves as 'human beings,' is sentimental and identifies their peace-loving lifestyle with contemporary American counter-culture. As Pye puts it, they are the 'positive inverse of corrupt white society.'[26] And like *Soldier Blue*, the film's narrative turns on scenes of gruesome violence committed by American Cavalry against Native Americans, in this case the 1868 Battle of Washita River. At the same time, the massacre is attributed primarily to the will of the preening, eccentric Colonel Custer rather than to broader governmental policies towards American Indians. As Crabb's narrative ends, the historian seems shocked and murmurs, 'I didn't know.' The implication seems to be not that Crabb's narrative has compromised his revisionist understanding of American history, but rather that he has bought it to life. However, *Little Big Man*'s effectiveness as a critique of western myths is undermined by the improbability of Crabb's fantastic story. The promotional posters used to market the film emphasized this reading, describing Crabb as 'Either The Most Neglected Hero in History or a Liar of Insane Proportion!'

A more extensive, though less commercially successful, revision of western mythology was made in the Robert Altman film *Buffalo Bill and the Indians, or Sitting Bull's History Lesson* (1976). The film is based on the circus-like Wild West shows which appeared in America at the end of the nineteenth century following the closure of the frontier. The star performer is Buffalo Bill, a former Indian scout who is successfully marketed as the greatest hero of the Old West. The show is joined by aging Sioux Chief Sitting Bull, a box-office attraction branded the 'killer of Custer.' Bill is vain, much like *Little Big Man*'s Custer, but also a fraud who has been overwhelmed by the lucrative mythology which has developed around him. Described at different

[25] Thomas Schatz, "The Western" in Wes D. Gehring, *Handbook of American Film Genres* (Westport: Greenwood Press, 1988), 34.
[26] Pye, 83.

points as 'America's national hero' and 'America's national entertainer,' Bill is shown to bridge the gap between the frontiersmanship of America's past and the showbusiness of its future.[27] When President Cleveland, who attends the show, enthusiastically states that 'it's a man like that who made this country what it is today,' the sentiment is obviously double-edged. In a rather too deliberate contrast, Sitting Bull has a solemn dignity and endeavors to use his appearances in the Wild West show to lobby on behalf of the Sioux people. Bill and the show's producers plan to feature Sitting Bull in a 'historical re-enactment' of his dishonorable killing of Custer, but Bull states that this did not happen and proposes a re-enactment depicting American soldiers massacring his people. Annie Oakley tells Bill that Sitting Bull simply wants to 'show the truth,' but Bill replies that 'he has a better sense of history than that.' Bill's 'sense of history' ultimately wins out after Sitting Bull is killed in an event apparently unrelated to the show. In the film's final scene, Bill 're-enacts' his scalping of Sitting Bull using a stand-in to take the Chief's place: in an instant, Bill's opportunistic fabrication of the past is established as historical myth. By depicting the emergence and commodification of the Old West mythology, the film suggests that the Native Americans are annihilated not only by military violence but by the systematic misrepresentation of their past in American popular culture.

The New Hollywood period also featured a cycle of films depicting small–town, American teen culture of the 1950s and early 1960s. The popularity of these films reflects the dominance of Hollywood's baby-boomer youth audience during the 1970s and suggests a nostalgic engagement with the pop culture of the recent past, although the attitudes they adopt towards their historical settings differ significantly. Released in 1971, *The Last Picture Show* is a coming-of-age story set in a bleak, depopulated Texan town in 1951. Produced at a time of rapid social change and generational conflict, the film paints a community gripped by a deadening stasis where teenage characters seem destined for the same future as the older generation. Indeed, the most significant relationship to emerge from the film's many sexual awakenings is formed between a teenage boy and an older, married woman. The sudden deaths of Sam the Lion and Sonny suggest one form of escape, although both are de-dramatized and occur off-screen. Duane's decision to enlist and fight in Korea appears to portend something similar: his parting comment, 'See you in a year or two, if I don't get shot' is more than ominous. The closure of the town's cinema and the film's final, lingering shot of its dilapidated facade would appear to be a metaphor, but the meaning is ambiguous rather than simply elegiac. Change has come to the community, but its past is unlikely

[27] Keith M. Booker, *From Box Office to Ballot Box: The American Political Film* (Westport: Greenwood Press, 2007), 120.

to be remembered fondly and its future seems equally bleak. Despite its despondent tone and unfashionable black–and–white cinematography, *The Last Picture Show* earned $13 million domestically, generating significant returns on its small budget.[28] Arriving in cinemas two years later, *American Graffiti* (1973) follows a group of similarly aged but much more affluent male characters during a 15-hour period in 1962. With its classic car iconography, rock 'n' roll soundtrack, and rather more tender approach to sexuality, the film is much more optimistic than *The Last Picture Show*, and to some degree it does project the recent past as a time of lost innocence. The date is perhaps auspicious: Peter Lev suggests that 1962 was 'the last possible year of teenage innocence before the assassination of President Kennedy, the beginnings of the Vietnam War, and the various social movements of the 1960s.'[29] However, the note of escape and transcendence which the film strikes in its final scene, as Curt literally flies away, is tempered by a sense of unease about the years to come. The 'postfilm trajectories' outlined for the major characters in the epilogue text point to an uncertain and violent future: Steve has become an insurance agent, but Curt has moved to Canada, presumably to avoid the draft, Terry is missing in action in Vietnam, and Milner has been killed by a drunk driver.[30] Produced on a very small budget, *American Graffiti* was one of the most successful films of the early 1970s, earning $55 million domestically.[31]

The teen culture of America's recent past also featured in two of the most popular films of 1978: *Grease* and *Animal House*, which earned $96 million and $71 million respectively.[32] The latter drew liberally from narrative elements of *American Graffiti*, including its 1962 setting, but its university fraternity setting allowed the comedy to adopt a more ribald tone. *Grease* was adapted from a successful Broadway musical and is set in and around a 1950s high school. In its use of cars and music it repeats elements of *American Graffiti*, but *Grease* takes a more ironic, self-conscious approach to its historical setting. In her commencement speech, for example, the head teacher tells her students that there may be a future 'Vice President Nixon' among them. As Deborah Thomas suggests, *Grease* is a 'fifties movie embedded in a seventies mentality,' a feature most clearly signaled by its disco-styled title music. A parody of 1950s teen culture rather than a memory of it, *Grease* suggests that its past is 'already irrecoverably lost.'[33] American teen culture of the 1950s and early 1960s retained its high profile in a number

[28] Krämer, 108.
[29] Lev, 91.
[30] Ibid., 94.
[31] Krämer, 108.
[32] Cook, *Lost Illusions*, 501.
[33] Deborah Thomas, "Grease," *Movie*, 27–28 (1980–1981): 94–8.

of popular films released during the following decade, most notably the time-travel comedy *Back to the Future* (1985). As with the 1970s films, it is a coming-of-age story based on the experiences of a male hero. Unlike those films, however, Marty McFly finds that small-town 1950s America is not a time of lost innocence or a site for sexual exploration but rather an uncanny, Oedipal nightmare which threatens to rob him of his very existence. Despite apparently inventing skateboarding, rock 'n' roll and science-fiction, he takes absolutely no enjoyment in the past and the film is structured as his attempt to escape from it completely.

The Vietnam effect

American cinema in the 1970s and 1980s was also marked by the nation's polarizing and traumatic experiences in Vietnam. The influence of the Vietnam War can be observed during the late 1960s and early 1970s in the heightened violence of crime films such as *Bonnie and Clyde* and in the representation of the Indian Wars as genocide in *Little Big Man*. The film industry was initially unwilling to depict the war directly, however, due largely to the divisiveness of the conflict and uncertainty about how America's apparent defeat might be reconciled with the conventions of the traditional war film.[34] The conspicuous exception was *The Green Berets* (1968), directed by John Wayne, which attempted to reclaim America's ongoing experience in Vietnam as victorious and honorable. The highest profile war films of the early 1970s focused instead on the more familiar and, arguably, less morally ambiguous events of World War II. Released by 20th Century Fox in 1970, *Tora! Tora! Tora!* depicted the build-up to the Japanese attack on Pearl Harbor in an epic manner reminiscent of the roadshow-era war films. Specifically, its multi-perspective, documentary-style narrative and its relatively even-handed depiction of America's enemy emulated *The Longest Day* (1962), another Fox release. In fact, *Tora! Tora! Tora!* went one step further than *The Longest Day* by not only engaging a Japanese cast and crew but also partnering with a Japanese production company. From an American point of view, however, the film seems strangely defeatist, depicting the Japanese attack but not the American response to it. Instead, the narrative closes with Admiral Yamamoto's ominous suggestion that the attacks have 'woken a sleeping giant.' As he looks out on an empty Pacific Ocean, the giant remains conspicuously off-screen. Throughout the film, American military culture is shown to be mired by miscommunication, excessive bureaucracy, and ineffective

[34] Neale, *Genre and Hollywood*, 131.

FIGURE 5.1 *The General's opening speech in* Patton *(1970)*

leadership, while the Japanese are shown to be decisive, well-organized, and, in the film's attenuated time-frame, entirely victorious. Moreover, while the attack is carefully explained to the audience, the American characters remain entirely ignorant of it, which makes them rather difficult to engage with. Despite studio boss Daryl Zanuck's attempt to reposition the film as a cautionary tale promoting H-bomb preparedness, *Tora! Tora! Tora!* was derided on release as unpatriotic.[35] The film failed conspicuously at the box office, its $15 million domestic earnings falling well short of its massive budget.[36]

A different perspective on World War II was presented in the biopic *Patton*, also released in 1970, which successfully marketed an egocentric American war hero to a Vietnam-era audience. From the outset, the film's portrayal of General Patton is highly ambiguous. In the opening scene he delivers a rousing speech to an unseen military audience, declaring that 'Americans have never lost, and will never lose a war.' His overblown rhetoric is emphasized by the enormous stars-and-stripes backdrop, and the effect borders on parody. His optimistic description of combat is further undermined as the speech cuts to the image of a vulture surveying a battlefield in Tunisia. In action, Patton is established as an eccentric but highly effective leader, although the high esteem in which he is held by the German command is perhaps intended to call his character into question. His brutalization of a young soldier suffering from shell shock also works against him and may have resonated with contemporary American experiences of military culture. At the same time, the film emphasizes Patton's talent, charisma, and his shabby

[35] Bernard F. Dick, *The Star Spangled Screen: The American World War II Film* (Lexington: University Press of Kentucky, 1996), 244.
[36] Krämer, 107.

treatment at the hands of the Allied military hierarchy, rendering him by far the most appealing character in the narrative. When he complains 'An entire world at war and I'm left out of it?' he appears simultaneously sympathetic and deplorable. Perhaps intentionally, *Patton* appealed to both Vietnam-era doves and hawks. Among the latter, its highest-profile admirers were Richard Nixon and Henry Kissinger, who reportedly screened the film at the White House while planning the American bombing campaign in Cambodia.[37] The most successful war film of the early 1970s, however, was *MASH* (1970), which was set in the Korean War during the early 1950s. A less divisive subject than Vietnam, the Korean conflict had been the subject of several Hollywood films during the 1950s, most notably *Pork Chop Hill* (1959). But in contrast to these conventional combat narratives, *MASH* is episodic, unstructured, and unheroic, adopting an attitude which Andrew Britton describes as 'nihilistic cynicism.'[38] *MASH* castigates the bureaucracy of modern warfare and lampoons conventional military culture while emphasizing the conflict's human cost through unsparingly gruesome hospital scenes. The affinity between *MASH*'s Korea and the ongoing Vietnam War has been widely remarked upon. As Barry Langford puts it, Korea is used as 'a transparent mask for Vietnam.'[39] It is perhaps misleading to suggest that *MASH* ought to be read principally as an account of the Vietnam War and not, at least to some extent, as a historical depiction of the Korean conflict. Nevertheless, such interpretations point to the long shadow which the Vietnam War cast over Hollywood's historical war films during the decade.

From the late 1970s onwards, as American troops returned from Southeast Asia, direct representations of the Vietnam War became more common. Indeed, in this period Vietnam began to displace World War II as the favored site for the Hollywood war film. Films such as *Go Tell the Spartans* (1978) took their cue from the conventions of the World War II combat genre, but several more successful releases adopted an innovative approach to the representation of war, generating a new iconography for the conflict and reflecting public ambivalence towards America's overseas engagements. Released in 1978, *The Deer Hunter* is based around the interplay between the Vietnam conflict zone and the home front, in this case a blue-collar mining town in Pennsylvania. Unfolding at a deliberate pace, the first hour of the film illustrates the social rituals which underpin the home-front community, only to see them violently destabilized as three of the male characters go to war and are almost immediately captured by Vietcong soldiers. *The Deer Hunter* is much more concerned with Vietnam's impact on ordinary American lives

[37] Block, 539.
[38] Andrew Britton, "Hollywood in Vietnam," *Movie*, 27–8 (1980–1981): 5.
[39] Langford, 121.

than the political rights or wrongs of the conflict. Nevertheless, war is established not simply as brutal and unheroic, but as something which corrupts, deranges, and dehumanizes those who come in contact with it. In particular, Nick is, as Robin Wood notes, 'part traumatized, part seduced by Vietnam,' and Michael's attempt to return him to American civilization echoes Orpheus' unsuccessful journey out of the underworld.[40] Despite its pessimism and understated pacing, *The Deer Hunter* made a significant impact at the box office with domestic earnings of $28 million.[41]

Francis Ford Coppola's *Apocalypse Now* (1979) became the most commercially successful of the 1970s cycle of Vietnam films, recording domestic earnings of $38 million.[42] Much of the commentary generated by the film has drawn parallels between its troubled production history and the war itself. As Jean Baudrillard commented, 'Coppola makes his film like the Americans made war... with the same immoderation, the same excess of means, the same monstrous candour... and the same success.'[43] To some degree the film was based in historical events. According to Peter Lev, early drafts of the script derived from the 1969 Green Beret Affair in which American Special Forces soldiers, led by Colonel Rheault, were tried for the unauthorized execution of a Vietnamese double agent.[44] However, *Apocalypse Now*'s representation of the war becomes increasingly abstract and psychological as Captain Willard journeys further up the river to meet Colonel Kurtz. Unlike the protagonists of *MASH* and *The Deer Hunter*, Willard is engaged in the type of clearly defined combat mission which characterized older war films, but the strategic value of his assassination of Kurtz is overwhelmed by the psychedelic and mythical imagery in which it is embedded. As Britton puts it, the Vietnam War is thus represented as 'the external form for a Manichean psychic dualism,' and in this way war ceases to be a political conflict embedded in a broader Cold War context and instead is internalized as a conflict of the mind.[45]

During the 1980s Vietnam veteran Oliver Stone became the most recognizable chronicler and critic of America's Vietnam experience. Widely acclaimed on release in 1986, *Platoon*'s publicity discourse emphasized its basis in the director's own experiences during the late 1960s and thus, as Martin Fradley suggests, allowed to it be read as a kind of 'survivor testimony.'[46] As its title implies, *Platoon* draws self-consciously on the conventions of the traditional

[40] Wood, *Vietnam to Reagan*, 278; Britton, 19.
[41] Cook, *Lost Illusions*, 501.
[42] Ibid., 502.
[43] Jean Baudrillard, "*Apocalypse Now*" in Gilbert Adair (ed.), *Movies* (London: Penguin, 1999), 265.
[44] Lev, 118.
[45] Britton, 15.
[46] Martin Fradley, "Oliver Stone" in Yvonne Tasker (ed.), *Fifty Contemporary Filmmakers* (London: Routledge, 2002), 330.

combat film, depicting a group of ethnically and culturally mixed soldiers doing battle against a mostly faceless enemy. Private Taylor, who narrates the film through letters written to his grandmother, stands out from the rest of the soldiers due to his decision to join the infantry as a volunteer. His idealism is quickly broken, though less by the brutality of war than by the social divisions within the platoon, which he likens to a 'civil war.' In the final voiceover, Taylor claims, 'We did not fight the enemy; we fought ourselves. The enemy was in us.' To some extent this statement resonates with *Apocalypse Now*'s depiction of war as an internalized, psychological conflict, but it also refers to the polarizing effect of the Vietnam War within American society. Whereas *Platoon* is set entirely in the combat zone, Stone's second Vietnam film, *Born on the 4th of July* (1989), focuses on the war's impact among veterans attempting to rejoin American society. A biopic adapted from the autobiography of Ron Kovic, whose experiences were indirectly represented in *Coming Home* (1978), the film depicts Kovic's transformation from idealistic soldier, to traumatized veteran, to anti-war campaigner. The most internationally successful Vietnam films of the 1980s, however, belonged to the *Rambo* franchise: *First Blood* (1982), a new take on the familiar theme of the Vietnam veteran re-entering civilian life, and its sequel *Rambo: First Blood Part II* (1984), in which John Rambo makes a triumphant return to the jungles of Southeast Asia. Bearing a greater resemblance to Sergeant Stryker than to Captain Willard, Rambo's unreflective aggression and extreme individualism have frequently been interpreted as a troubling symptom of American foreign policy.[47]

These cycles of Vietnam films—plus depictions of contemporary American military adventure such as *Commando* (1985), *Top Gun* (1986), and *The Hunt for Red October* (1990)—contributed to the relative marginalization of World War II films in Hollywood for much of the 1980s and 1990s. Nevertheless, the conflict was a recurring element in the career of Steven Spielberg, the most commercially significant filmmaker of the era. His combat comedy *1941* (1981) and the Japanese prison camp drama *Empire of the Sun* (1987) number among his less profitable productions, but inclusion of Nazi antagonists in *Raiders of the Lost Ark* (1981) and *Indiana Jones and the Last Crusade* (1989) proved much more successful. In 1993 Spielberg directed *Schindler's List* (1993), a depiction of the Nazi Holocaust presented through the wartime biography of German munitions manufacturer Oskar Schindler. Adopting a high-contrast, coarsely grained cinematography which emulated documentary filmmaking and newsreel images of the conflict, *Schindler's List* was widely praised for its realism. At the same time, the film emphasizes survival and redemption

[47] See, for example, Susan Jeffords, *Hard Bodies: Hollywood Masculinity in the Reagan Era* (New Brunswick: Rutgers University Press, 1994).

and depends on suspenseful narrative devices more typically associated with escapist Hollywood thrillers and melodramas. The contrast between the sickening subject matter and the generic contours of the narrative was criticized in some quarters; J. Hoberman memorably asked, 'Is it possible to make a feel-good entertainment about the ultimate feel-bad experience of the 20th century?'[48] Nevertheless, the film was a remarkable success, grossing $96 million domestically and $221 million overseas.[49] Spielberg returned to World War II with *Saving Private Ryan* (1998), a D-Day platoon film which engages explicitly and unironically with combat film conventions established in the 1940s. As Langford has suggested, the film can be regarded as 'post-Vietnam' in the realistic, newsreel-influenced violence of its beach-landing scene, but also in its attempt to redeem and 'correct' a genre which had over previous decades lost its heroic associations and now appeared to be morally ambiguous.[50] Significantly, the film's narrative is framed by contemporary scenes where the rescued Private Ryan visits the grave of Captain Miller and reflects on whether he has 'earned' the loss of life incurred by his rescue. In this way, the film imagines a dialogue between an older generation who died on the battlefield and an indebted younger generation who were given the opportunity to prosper in peacetime America. *Saving Private Ryan* thus reaffirms the status of World War II in the American imagination as a 'good war' characterized by noble and meaningful sacrifice for a larger, humanitarian cause. As Burgoyne suggests, the film 'constructs the memory of World War II... as a resource for American national identity after Vietnam.'[51] Recording worldwide grosses of $480 million, *Saving Private Ryan* became the most successful release of 1998.[52] Its commercial impact was underlined by the cycle of World War II combat films produced in its wake, including *The Thin Red Line* (1998) *U-571* (2000), *Enemy at the Gates* (2001), *Windtalkers* (2002), *Flags of Our Fathers* (2006), and *Letters from Iwo Jima* (2006).[53] The most successful film in this cycle was *Pearl Harbor* (2001), which grossed $449 worldwide.[54] Perhaps learning from the commercial failure of *Tora! Tora! Tora!*,

[48] J. Hoberman, "Spielberg's Oskar," *Village Voice*, December 21, 1993, 63.

[49] James Russell, *The Historical Epic and Contemporary Hollywood: From Dances with Wolves to Gladiator* (London: Continuum, 2007), 78. During the 1980s, box office performance began to be reported in 'gross income' rather than rental income. A film's gross income is the total money collected from ticket sales.

[50] Langford, 127.

[51] Burgoyne, Hollywood Historical Film, 71–2.

[52] Russell, *Historical Epic and Contemporary Hollywood*, 106.

[53] Perhaps more significantly, the success of the film can be linked to a cycle of video-game franchises based on the American combat experience of World War II, including *Medal of Honor* (1999), which was developed in association with Spielberg, *Battlefield 1942* (2002) and *Call of Duty* (2003).

[54] "Pearl Harbor," *Box Office Mojo*. Accessed December 11, 2011, http://boxoffice mojo.com/movies/ ?id=pearlharbor.htm.

the film presents the Pearl Harbor attacks as the backdrop to a love story, and widens the narrative frame to incorporate the Doolittle raid on Tokyo, thus concluding with a reassuring American victory.

The return of the epic

The cyclical nature of Hollywood production was demonstrated by the re-emergence of the big-budget historical epic, including epics set in the ancient world, at the end of the 1990s. Writing in 1989, more than 20 years into the historical epic's dry spell, Allen Barra complained that 'like so many things with which Americans are obsessed – radios, automobiles, swimsuits, the dollar – the American film started out big but has lately gotten small.'[55] But like the American automobile, historical filmmaking was due for a growth spurt. As James Russell writes in his account of the historical epic's resurgence in the late 1990s, filmmaking of this sort 'moved from the absolute periphery of Hollywood production to the apex of mainstream film production and popular interest.'[56] Of course, the historical epic did not vanish entirely from the screen. Warren Beatty's *Reds* (1981) drew on epic tropes in its biography of journalist John Reed and its depiction of the Russian Revolution, but the film proved to be commercially marginal. Other productions reminiscent of the historical epic emerged from the peripheries of the American film industry, produced on medium budgets either by international or independent American sources. For example, *Gandhi* (1982) was made with British and Indian funding, *A Passage to India* (1984) was a British production supported by an American cable TV company, and *The Last Emperor* (1987) was funded principally by British and Chinese sources. Although it was released several years later, *The English Patient* (1996) might be similarly associated with the tendency to revisit tropes of the historical epic in mid-budget, adult-orientated films produced on the margins of the American film industry. These films were afforded prestige status comparable to the epics of the roadshow era (*Gandhi, The Last Emperor* and *The English Patient* won Best Picture Academy Awards), but their financial returns were of a lesser magnitude. It also seems significant that each of them represents events from the early twentieth century, in particular colonial British encounters with Asian culture. As Amelia Arenas has noted, 'rather than taking us into grand, archetypal eras, these movies take us into a sort of antiquity that's still alive within modernity,'

[55] Allen Barra, "The Incredible Shrinking Epic," *American Film,* 14/5 (1989): 41.
[56] James Russell, *Past Glories: The Historical Epic in Contemporary Hollywood* (PhD thesis, University of East Anglia, 2005), 10.

thus steering clear of the myth-making characteristics of earlier epics.[57] It has also been suggested that the historical epic survived on television in the form of popular miniseries such as *Roots* (1977), *Holocaust* (1977–8), and *War and Remembrance* (1988).[58] But despite their high production values, their prestigious status, and the breadth of their narrative scope, these TV dramas lacked the spectacle and visual scale of the cinematic epics.

Russell has argued that historical epic was initially re-established through the efforts of individual filmmakers who traded on their commercial success in other genres in order to realize personal projects which were regarded as financially unpromising. Describing this cycle of films as 'maverick epics,' Russell identifies Kevin Costner's *Dances with Wolves* (1990), Spielberg's *Schindler's List*, Mel Gibson's *Braveheart* (1995), and James Cameron's *Titanic* (1997) as the key releases responsible for the regeneration of epic historical filmmaking.[59] In many ways *Dances with Wolves* was a conventional western, although its focus of the comradeship between a white soldier and a tribe of Native Americans reflects relatively recent developments in the genre. However, perhaps due to the diminished commercial status of the western genre following *Heaven's Gate*, the term 'epic' was more frequently used in the film's promotion and merchandising. Its tie-in book, for example, was titled *Dances with Wolves: The Illustrated Story of the Epic Film*. This rebranding process was supported by many press reviewers, who identified the narrative scope and extended duration of the film with the historical epic.[60] Produced for a relatively low budget of $18 million, the film grossed over $420 million in cinemas worldwide.[61]

Costner's success as director and star in *Dances with Wolves* was emulated five years later by Mel Gibson in *Braveheart*, which was based on William Wallace's struggles against the occupying armies of King Edward I in thirteenth century Scotland. The film's iconography owes much to the medieval swashbuckler cycle of the early 1950s, as does its presentation of oppressed people fighting to overturn an unjust and tyrannical regime. But as a hero, Wallace seems to be modeled after Spartacus or Judah Ben-Hur; charged with a sense of heroic destiny, he inspires his people to confront foreign rule and assert their independence. In a trope which would become commonplace in the ancient world epics which followed, Wallace's political rhetoric achieves its clearest expression in a rousing pre-battle speech: the enemy 'may take our lives,' he tells his troops, 'but they'll never take our freedom!' In this

[57] Arenas, 10.

[58] Russell, *Past Glories,* 81–2.

[59] Ibid., 11.

[60] Ibid., 96–7.

[61] "*Dances with Wolves*," *Box Office Mojo*. Accessed December 11, 2011, http://boxofficemojo. com/ movies/?id=danceswith wolves.htm.

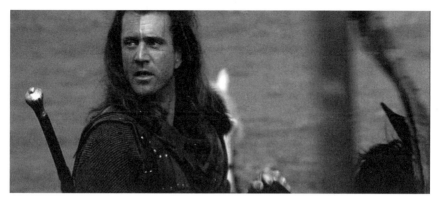

FIGURE 5.2 *The battlefield speech in* Braveheart *(1995)*

way, the complicated objectives of a historically remote medieval leader are redefined as a universal human aspiration. Like Costner before him, Gibson's risk proved to be well-judged and *Braveheart* grossed more than $210 million worldwide.[62] The final 'maverick epic' of the 1990s was also the riskiest and the most profitable. With a production budget of around $200 million, *Titanic* was comfortably the most expensive film made to date, underlining renewed confidence in the commercial potential for extravagant, large-scale historical filmmaking. Whereas *Braveheart* had drawn on themes from the ancient world epics of the 1950s, *Titanic*'s depiction of doomed romance against a broader historical backdrop was more reminiscent of *Doctor Zhivago* (1965) or *Gone with the Wind* (1939). Many suspected that the film would falter at the box office, but its worldwide gross of $1.8 billion put the commercial potential of the historical epic beyond question. From this point on, the epic was no longer simply the province of 'maverick' directors or producers on Hollywood's margins.

Dances with Wolves and *Titanic* might be said to engage with the tropes of the historical epic indirectly, emulating the scale, spectacle, and duration associated with the roadshow-era filmmaking rather than its specific narrative or iconographic elements. *Gladiator* (2000), on the other hand, is quite overtly indebted to the ancient world epics of the 1950s and 1960s. Critics were quick to make the connection: J. Hoberman in the *Village Voice* described the films as a 'relentlessly high-tech revival of deeply retro material' while *Variety* prefaced their review with a potted history of the 'historical/biblical/war spectacle' and its decline after the mid-1960s.[63] Repeating one of the major

[62] "*Braveheart*", *Box Office Mojo*. Accessed December 11, 2011, http://boxoffice mojo.com/ movies/ ?id=braveheart.htm.
[63] J Hoberman, "*Natural Selection*," *Village Voice*, May 2, 2000; "*Gladiator*," *Variety*, April 23, 2000.

features of Babington and Evans' 'Christian/Roman Epic,' *Gladiator* depicts the culture of Imperial Rome as decadent, cruel, and corrupt, and associates the degeneration of its Republican ideals with the debauched sexuality of its ruling elite. As with the heroes of *Quo Vadis* (1951) and *Ben-Hur* (1959), Maximus initially occupies a favored position within the Roman governing elite, and like the hero of *Spartacus* (1960) he leads and is ultimately killed in a violent revolt against tyrannical Roman rule. In addition, the film features several historical characters who were represented in *The Fall of the Roman Empire* (1964).[64] For Robert Burgoyne, these textual correlations provide 'a striking example of the resilience of generic forms,' creating a 'complex dialogue' with the epic tradition.[65] However, it is also interesting to consider the ways in which *Gladiator* departs from this tradition. In his *Braveheart*-esque battle speech from the film's opening section, Maximus motivates his troops not with idealistic homilies to freedom but with the more pragmatic promise of returning home. As Arenas has noted, whereas the heroes of the roadshow era epics tended to be symbolic leaders of persecuted people— Hebrews, Christians, slaves—Maximus is portrayed as an individualist whose story is 'only circumstantially political':

> His only cause is revenge – a motivation which would have been insuf-
> ficient, and perhaps morally suspect in the more political earlier epics. He
> does not fight for the slaves, for Rome, for the memory of Marcus Aurelius,
> or even for the safety of Lucilla... He represents no one but himself.[66]

Tellingly, Maximus is offered a conventionally heroic role early on in the narrative: the dying Emperor Marcus Aurelius, who still has faith in 'the dream that was Rome,' charges Maximus with the task of returning the empire to Republican rule. Maximus demurs and is usurped by Commodus, an antagonist who to some extent shares Maximus' lack of political ambition. Instead, Commodus is driven by personal hatred stemming from the pain of being rejected by both his father and his sister, and his desire for public adulation. In the end, *Gladiator* is concerned less with the endurance of the Roman values embodied by Marcus Aurelius and more with the personal conflict between individual characters. Fittingly, the climax of the film is not an epic battle but a hand-to-hand fight between Maximus and Commodus. Although some of the film's themes resonate with its immediate historical context, particularly its depiction of imperial decline and its association of politics with spectacle and entertainment, *Gladiator* largely avoids the political analogies of its roadshow

[64] Russell, *Past Glories*, 217.
[65] Burgoyne, *Hollywood Historical Film*, 74.
[66] Arenas, 12.

predecessors. Indeed, Monica Cyrino has suggested that the film's lack of political engagement is in itself a political statement, and that 'Maximus' disaffection with the idea of Rome offers a compelling analogy to the modern sense of estrangement from politics in all its corrupt irrelevance.'[67] In any case, Gladiator was immensely popular at the box office, reporting worldwide grosses of $457 million, and initiating a small cycle of large-scale films in the epic mold.[68]

No fewer than four Hollywood ancient world epics with ties to the roadshow-era were released in 2004. The first of them was also the least typical. Mel Gibson's The Passion of the Christ (2004) is perhaps the most 'maverick' epic of all. The film is based on the story of Jesus' crucifixion, but it departs from previous accounts through its exclusive use of Latin and Aramaic dialogue and the gruesome detail in which Jesus' physical suffering is presented. Whereas Gladiator omitted references to early Christianity, The Passion of the Christ is explicitly religious and, as Russell has suggested, it was marketed as a 'transformative spiritual experience.'[69] To some degree the film represented a return to the biblical filmmaking of the 1950s and 1960s, which like other ancient world material had fallen out of popular favor. The only successful biblical epic produced in the post-roadshow period was The Prince of Egypt (1998), an animated adaptation of the exodus story.[70] But in its stripped-down narrative, its evasion of conventional spectacle, and its unsuit-ability for family viewing (the film was given a restrictive classification in most countries), The Passion of the Christ plainly avoids the tropes associated with ancient world epics. Funded partly by Gibson himself through his independent production company, the film was initially marketed to Christian audiences, but its $612 million international gross (the bulk of which came from the North American market) underlined the film's mainstream success.

Released later in 2004, Troy, Alexander, and King Arthur followed the conventions of the historical epic more closely, although each avoided the Roman and Christian settings most common to the epic tradition. Troy is set in the ancient Greek world and adapts elements of the Iliad to depict the Trojan War. Like Gladiator, the film presents a highly individualistic form of masculine heroism based around revenge, personal accomplishment, and the maintenance of family bonds. Despite its digital rendering of spectacularly large armies, the film follows Gladiator again in its narrative concentration

[67] Monica Cyrino, "Gladiator and Contemporary American Society" in Marvin M. Winkler (ed.), Gladiator: Film and History (London: Blackwell, 2004), 136.
[68] "Gladiator," Box Office Mojo. Accessed December 11, 2011, http://boxofficemojo .com/ movies/?id=gladiator.htm.
[69] Russell, Past Glories, 244.
[70] Ibid., 243.

on what Kirsten Moana Thompson calls the 'formula of solo combat.'[71] On the Greek side, Achilles isolates himself from other soldiers and resolves to fight only on his own terms, prioritizing immortality and personal fame over the victory of the Greek military. His eventual decision to enter the fray is motivated entirely by the desire to revenge the killing of his friend. The principal Trojan character, Hector, is perhaps more conventionally heroic, but he is primarily driven by a self-sacrificing love for his wife, brother, and sister. In contrast to many of the roadshow-era epics then, *Troy* presents epic heroes who have little interest in the epic political aspirations of the national communities they appear to lead. The same might be said of Alexander the Great in *Alexander*, which is also set in the ancient Greek world but several hundred years after the events depicted in *Troy*. Throughout the film, Alexander's extraordinary military accomplishments are presented not as the fulfillment of a heroic destiny but in terms of his desire to eclipse the achievements of his unappreciative father and to escape the influence of his overbearing, sexualized mother. As with Commodus, his characterization owes more to the tropes of twentieth-century psychoanalysis than to the classical tradition.

King Arthur is ostensibly set in medieval Britain, but by linking Arthurian legend to the decline of the Roman Empire it recasts the setting as an extension of the Mediterranean ancient world. Echoing *Gladiator* (with which it shared a screenwriter) the Arthurian Knights are initially motivated by an unfulfilled desire to return home. And echoing *Braveheart*, they are subsequently driven to risk their lives on the battlefield for the sake of a non-specific, universal type of freedom. In another pre-battle speech, Arthur declares:

> Knights! The gift of freedom is yours by right. But the home we seek resides not in some distant land, it's in us, and in our actions on this day! If this be our destiny, then so be it. But let history remember, that as free men, we chose to make it so!

A remarkably similar appeal to freedom and free will is made in *Alexander*. On the eve of battle, Alexander spurs his outnumbered troops to victory by arguing that they are 'free men' fighting for the 'freedom and glory of Greece,' while their Persian opponents are 'enslaved' by their king and fight not through choice but because they have been forced to do so. The opposition implied between freedom and slavery echoes the anti-Communist rhetoric of roadshow epics. But the freedom for which the protagonists of *King Arthur*

[71] Kirsten Moana Thompson, "'Philip Never Saw Babylon': 360-Degree Vision and the Historical Epic in the Digital Era" in Robert Burgoyne (ed.), *The Epic Film in World Culture* (London: Routledge, 2011), 47.

and *Alexander* fight (and urge others to fight) is less a concrete political aspiration, as it is to some extent in *Braveheart* and some of the roadshow-era epics, than it is the expression of their heroic identity. The battlefield is not simply a space where freedom is won, but also where freedom may be exercised. The epics of 2004 proved less successful than their predecessors. *Troy* recorded an international gross of $497 million, a slight advance on *Gladiator*'s figure but a disappointment given its enormous budget. *King Arthur* and *Alexander* grossed $203 million and $167 million respectively and were regarded as flops.[72]

The financial returns of the new epic cycle continued to disappoint with the release of *Kingdom of Heaven* (2005), which grossed $211 million internationally.[73] The film is set in the Middle Ages, specifically the Fourth Crusades of the twelfth century, but like *King Arthur* it maintains significant parallels with the ancient world epic. *Kingdom of Heaven*'s depiction of European knights battling Muslim soldiers in the Holy Land was also bound to prove contentious given the post-9/11 context in which the film was released, and more than any other historical epic of the 2000s the film was scrutinized for contemporary parallels. Months before the film appeared in cinemas, journalists in America and Britain reported provocative sound bites from academics based on early versions of the screenplay. According to one historian, the narrative was 'Osama bin Laden's version of history'; conversely, another academic predicted that the film would 'teach people to hate Muslims.'[74] In fact, the completed film appeared to confound pre-release expectations by endorsing peaceful, secular solutions to the problems created by religious conflicts in the Middle East. Balian, the chivalric hero of the film, appears to reject Christianity in favor of a distinctly modern religious pluralism, and attempts to protect Jerusalem from religious fanatics of all creeds. Addressing the people of Jerusalem as they prepare to defend the city, Balian asks, 'Which is more holy? The Wall? The Mosque? The Sepulchre? Who has claim? No one has claim. All have claim!' As Arthur Lindley suggests, the film 'displaces the conflict between Christian and Muslim' into a conflict between tolerant and fanatical elements from both religions, and thus reflects 'the priorities of 2005 more than the realities of 1187.'[75] Indeed, the relationship between the film's historical narrative and its modern context is made ‚explicit by its epilogue

[72] Based on statistics from Box Office Mojo. Accessed December 11, 2011, http://boxofficemojo. com.

[73] "*Kingdom of Heaven*," Box Office Mojo. Accessed December 11, 2011, http://boxofficemojo. com/ movies/?id=kingdomofheaven. htm.

[74] Charlotte Edwardes, "Ridley Scott's New Crusades Film 'Panders to bin Laden,'" *Daily Telegraph*, January 17, 2004; Sharon Waxman, "Film on Crusades Could Become Hollywood's Next Battleground", *New York Times,* August 12, 2004.

[75] Lindley, 22–3.

text which states that 'nearly a thousand years' after Richard the Lionheart's struggle against Saladin 'peace in the Kingdom of Heaven remains elusive.'

Kingdom of Heaven struggled at the box office, but the success of *300* (2006) indicated that depictions of the ancient world remained profitable if alternate approaches were taken. Returning to the ancient Greek setting of *Troy* and *Alexander*, *300* echoed *Kingdom of Heaven* in its seemingly topical depiction of violent confrontation between Western and Middle Eastern armies. The fact that the Spartan army is vastly outnumbered and ultimately defeated by the Persian horde complicates the contemporary parallels, but as a *New York Times* article suggested, public debate regarding the film's allegorical significance in fact served to enhance its profile.[76] *300* can also be regarded as a high point in the creeping use of computer-generated imagery (CGI) in new historical epics. According to Thompson, some 1,450 shots from the film feature digital effects and the postproduction work was undertaken by nine separate production companies.[77] In much the same way as the roadshow epics were associated with innovative widescreen processes, the new epic cycle increasingly showcased developments in CGI technology. Produced with a lower budget than the earlier ancient world epics, the actors of *300* were filmed in a single studio using minimal sets and were inserted into a digital epic environment through extensive postproduction work. In contrast to earlier historical epics, which depended on exotic location shooting and/or elaborate studio sets, *300*'s sense of spectacle was essentially created after the cameras were unplugged. The film was marketed at a younger audience than the epics which preceded it and grossed $456 million internationally.[78]

The revival of the historical epic in the late 1990s was unmistakable, as was its self-conscious engagement with the epics of Hollywood's past. However, it would be misleading to suggest that the new epic cycle dominated Hollywood production as it had done during the roadshow era. Of the films mentioned, only *Titanic* and *The Passion of the Christ* grossed more than $500 million internationally. As a whole, the historical epic was overshadowed by more popular science-fiction, superhero, animated, and fantasy films, even though some releases in these cycles displayed the influence of the historical epic. The most notable of example of the genre's creative stimulus can be seen in the *Lord of the Rings* trilogy (2001-2003), which in turn exerted considerable influence over subsequent historical epics.[79] It is also worth

[76] Michael Cieply, "That Film's Real Message? It Could Be: 'Buy a Ticket,'" *New York Times*, March 5, 2007.
[77] Thompson, "Philip Never Saw Babylon," n.58.
[78] "300," Box Office Mojo. Accessed December 11, 2011, http://boxofficemojo.com/ movies/ ?id=300.htm.
[79] Russell, *Past Glories*, 212–13; Thompson, "Philip Never Saw Babylon," 53.

noting that with the exception of *The Passion of the Christ*, the historical epics of the 2000s were consistently more successful internationally than in North America. *Alexander, King Arthur,* and *Kingdom of Heaven* would have been financial disasters were it not for their performances in overseas markets, where each of them earned more than 75 percent of their total box office gross.[80] If the historical epic had once been favored by American audiences despite its non-American subject matter, this no longer seemed to be the case in the twenty-first century.

The huge success of *Titanic* notwithstanding, historical cinema lost its position at the center of Hollywood's production strategies after the collapse of the epic in the late 1960s. Nevertheless, the varied representations of the past in the years which followed proved to be both commercially significant and sensitive to broader cultural developments. Historical issues were frequently addressed in the major films of the New Hollywood period, and a renewed emphasis on America's own history arguably allowed films to reflect the contemporary political atmosphere with greater clarity. The restoration of American subject matter as a means to speak about the present also reinvigorated the western. At a time when the war film genre was rarely used to depict America's ongoing military engagements in Southeast Asia in a direct manner, westerns of the early 1970s allowed anti-war statements to be displaced onto depictions of America's brutal Indian Wars. Even after American troops withdrew, direct representations of Vietnam remained problematic, and the highest profile war films of the era preferred to depict the conflict in psychological rather than political terms. The ebb and flow of opinion regarding war was also reflected by films depicting World War II: in the early 1970s the conflict permitted measured criticism of American military culture, while from the late 1990s it was used to restore the war film genre to its pre-Vietnam moral directness. War films after the roadshow era also underlined the turn away from international history. Whereas *The Longest Day* and *Tora! Tora! Tora!* strove for inclusivity, later American war films focused entirely on the American experience of conflict. Spielberg's *Schindler's List* is an exception, but *Saving Private Ryan's* exclusion of British and Commonwealth soldiers typifies the approach. Conversely, the new epic cycle marked a return to European and Holy Land history. These new films were comparable to their roadshow predecessors in their emphasis on spectacle and their engagement with the narratives and iconography of the ancient world, but their ideological emphases departed from prior conventions. The twenty-first century epics were less Christian (with the obvious exception of *The Passion of the Christ*) and less concerned with constructing

[80] Based on statistics from Box Office Mojo. Accessed December 11, 2011, http://boxofficemojo.com.

straightforward parallels with the present. Their political rhetoric, which was almost always given its most elevated expression in speeches delivered on the battlefield, tended to reveal politically vague, often individualist ambitions rather than aspirations for national or religious self-expression. The 'moral intensity' which Durgnat once identified with the roadshow epics was barely in evidence.

At the beginning of the twentieth-century, then, Hollywood film companies no longer depend on the historical film to stabilize fragmenting markets or to burnish the image of the film industry. The commercial and cultural force of the historical film has dimmed but has by no means been extinguished, and the genre remains a significant and prestigious production category.

6

Spectacle, technology, and aesthetics

The spectacle of history

As I have suggested, the historical film depends on the accumulation and display of visual information for its effective evocation of the past. As Michele Pierson puts it, historical cinema is to some extent 'a production designer's cinema' which constructs and authenticates representations of the past through detailed and often allusive visual design.[1] But in addition to generating a sense of the past, the display of visual information constitutes a second key aspect of historical cinema: the creation of spectacle. The term 'spectacle' can be used to describe the visual aspect of almost any activity, but in the context of cinema it typically refers to the staging of momentous events on a large scale. Often enhanced by technology, this form of spectacle has typically been associated with exaggerated size and heightened action, creating episodes which deliberately contrast and even overwhelm the non-spectacular scenes surrounding them. Spectacular scenes of this type are often highlighted by promotional and advertising materials, thus increasing their privileged and exceptional status within the narratives which contain them. The connections between historical filmmaking and spectacle have always been strong, and in many prominent historical films the production of spectacle is explicitly motivated by the plot. In both the 1934 and 1963 *Cleopatra* films, for example, the political and romantic power of the Egyptian Queen is shown to derive from her talent for stage-managing her own spectacular events: grand processions, titillating entertainments, eye-catching entrances. In many depictions of ancient Rome, too, conspicuously spectacular and usually violent events are performed in

[1] Michele Pierson, "A Production Designer's Cinema: Historical Authenticity in Popular Films Set in the Past" in Geoff King (ed.), *Spectacle and the Real* (Bristol: Intellect, 2005), 145–55.

large theatrical spaces to entertain the massed Roman public, who in some ways stand in for the contemporary spectator. Tellingly, Hall and Neale have shown that the terms 'epic' and 'spectacle' were used in conjunction to describe large-scale historical productions during the silent period and to differentiate these productions from more routine cinema releases.[2] The association was maintained in the decades which followed. A 1935 review of *The Crusades* described the film as DeMille's 'latest spectacle,' whereas the colonial Indian drama *Kim* (1950) was dismissed as 'quite a spectacle, but not much else.'[3] During the era of the roadshow epics, historical cinema and spectacle were bound even more closely. A *New York Times* review of *El Cid* (1961) proposed that:

> If the worth of a big historical movie were measured solely by its wealth of spectacle, by the castles and crowds and battles in it, and by the amount of noise it makes... *El Cid* would easily command the title of the worthiest historical movie ever made.[4]

A production value and a formal trope tied to a certain type of historical cinema, then, spectacle has been a productive area for investigation among critics of the genre.

Some critics have interpreted the spectacular nature of so many prominent historical films as ostentatious assertions of the cinema's power and significance. According to Maria Wyke, the representation of ancient Rome in the cinema has functioned 'not only as a mechanism for the display or interrogation of national identities' but also 'as a mechanism for the display of cinema itself – its technical capacities and its cultural value.'[5] So often at the forefront of Hollywood's global operations, historical films might thus be regarded as ambassadors for the medium, a spectacular showcase for its potential both in terms of cultural status and technological accomplishment. These ideas are echoed in an earlier essay by Michael Wood. Examining the epics of the roadshow era, he argues that their foregrounding of spectacle 'ought to have made the epics a kind of celebration of pure cinema, an expression of the cinema as a self-advertisement, a demonstration of what the medium could do'. But in contrast to Wyke, he identifies their display of power not with cinema as a whole but as the flamboyant last hurrah of Hollywood's waning production apparatus: 'by a slight and characteristic Hollywood slip, the part was taken somehow for the whole, and the epics

[2] Hall and Neale, 5.
[3] Andre Sennwald, "The Screen," *New York Times*, August 22, 1935; "Kim," *Variety*, December 6, 1950.
[4] Bosley Crowther, "Screen: Spectacle of *El Cid* Opens," *New York Times*, December 15, 1961.
[5] Wyke, 32.

became demonstrations of what a *studio* could do, they were the last grand flings of those factories of illusion.'[6] A third interpretation has been made by Alan Nadel, who argues that the spectacular widescreen images of *The Ten Commandments* (1956) 'manifested visually the rhetoric of American foreign policy during the cold war' and 'celebrated technological supremacy as the mandate for a theological and political vision.' This topical overlapping between political and cultural ideology 'helps explain why the Biblical epic was the particularly privileged product of the American movie industry in the 1950s.'[7] Although Nadel's arguments correspond with DeMille's stated intentions regarding the film, he perhaps overstates the ability of popular culture to be determined by foreign policy discourses in such specific ways.[8] At the same time, it is hard to deny the cultural power which historical epics such as *The Ten Commandments* expressed as they were consumed by audiences around the world, particularly as the film industries of Communist nations struggled to match them. As Melani McAlister has argued, the 'extrafilmic discourse' of such epics, with its emphasis on money, manpower, and momentousness, suggested that Hollywood and by extension America 'was unique in its ability to command the resources and the organization required to stage an epic film.'[9]

The most detailed analysis of spectacle in historical cinema has been made by Vivian Sobchack. Sobchack initially affirms the notion that spectacle, particularly in relation to the epics of the roadshow era, can be understood simply as an exercise in formal showmanship:

> At first, the purpose of all this hyperformalism seems significant only as a perverse and inflated display of autoerotic spectacle – that is, as cinema tumescent: institutionally full of itself, swollen with its own generative power to mobilize the vast amounts of labor and money necessary to diddle its technology to an extended and expanded orgasm of images, sounds and profits.[10]

But rather than simply identifying the prevalence of visual excess in historical cinema, Sobchack proceeds to examine what she refers to as the 'history effects' created by historical spectacle and in particular its 'narrative construction of *general historical eventfulness*.'[11] For Sobchack,

[6] Michael Wood, *America in the Movies, or, 'Santa Maria. It Had Slipped My Mind'* (London: Secker & Warburg, 1975), 169.

[7] Nadel, "God's Law," 416.

[8] For more on DeMille's interpretations of the film, see Chapter 2.

[9] McAlister, 60.

[10] Sobchack, "Surge and Splendor," 282.

[11] Ibid., 286.

the spectacular form and 'representational excess' of the historical epic is motivated principally by the need to find an appropriate visual expression for the gravity and momentousness signified by historical narratives. She suggests that:

> The genre *formally repeats* the surge, splendor and extravagance, the human labor and capital cost entailed by its narrative's *historical content* in both its *production process* and its *modes of representation*. Through these means, the genre *allegorically* and *carnally* inscribes on the model spectator a sense and meaning of being in time and participating in human events in a manner and at a magnitude that is *intelligible as excess* to lived-body subjects in a historically specific *consumer* culture. (author's italics)[12]

In this way, spectacle in historical cinema is less a process of historical reconstruction or a display of technological or cultural prowess, and more an attempt to create a sense of awe in the spectator and thus to evoke a feeling of 'being in' the past. According to Sobchack, 'the Hollywood historical epic... constructs a "field of historicity" by mimicking the subjective sense we have of temporal excess and giving it objective and visible form.'[13] It is for this reason that spectacular historical cinema tends not to be specifically concerned with historical authenticity: such films primarily represent 'the construction of history' rather than the specific details of past events.[14] The spectacular events which characterize many Hollywood historical films are thus not merely empty fulfillments of genre conventions or exhibitions for lavish, technologically advanced production values. Instead, the creation of spectacle is one of the ways in which films construct a sense of the past.

Spectacular tropes

The process of pinning down textual cohesion in the historical cinema genre is, as I suggested in the first chapter of this book, problematic and in the long run self-defeating. Nevertheless, it is possible to identify certain recurring tropes in the genre related to the production of spectacle. Perhaps the clearest form of spectacle in historical film is the procession: ceremonial, choreographed movements of people, objects, and vehicles which usually occur before an exultant crowd. As Sobchack has suggested, the capacity of historical films to create the sense of being 'swept along' by social events is often translated

[12] Ibid., 287.
[13] Ibid., 294.
[14] Ibid., 297.

into 'massive surges of movement.'[15] Processions often occupy screen time in excess of their narrative significance and function instead as platforms for the exhibition of elaborate, spectacular imagery. Several of the most lavishly realized processions in historical cinema are featured in *Cleopatra* (1963), where the trope is associated with the entrances of the Egyptian Queen on matters of state. Her arrival in Rome is particularly notable. As Caesar, Mark Anthony, and the Roman crowd wait, Cleopatra orchestrates a succession of visual events—costumed dancers, musicians on horseback, performing animals—which are eventually capped by her own arrival, carried by dozens of bare-chested men on an enormous, sphinx-shaped palanquin. In formal terms, the sequence emphasizes seriality, excess, and escalation as each spectacle is immediately succeeded by another, even more extravagant event, arriving at its climax with the long-deferred appearance of Cleopatra herself. By contrast, the editing and cinematography of the scene is restrained: static long-shots taken at ground level provide a point of view similar to the assembled crowd (the pattern is eventually broken by two high-angle shots used for Cleopatra's arrival) and long takes are preferred to rapid editing. Cinematic technique thus becomes a means to display elaborate production design, which is the locus of spectacle throughout the sequence. The decision to reflect the visual viewpoint of the crowd rather than that of Cleopatra is also significant. Although Cleopatra's anticipated reunion with Julius Caesar ought to be dramatically significant, the decision to focus on the responses of the crowd rather than the emotions of the film's heroine further emphasizes the centrality of design in the procession. This choice also highlights the significant role played by diegetic audiences in many spectacular processions: a spectacle is incomplete without spectators to respond to it.

The crowd also plays a heightened role in the climax of *The Sign of the Cross* (1932), in which a series of brutal entertainments are played out in the arena for the amusement of Emperor Nero and the Roman public. Scenes of gladiatorial combat are followed by images of humans being assaulted by elephants, tigers, and bulls, scenes of bound and naked women being brutalized by crocodiles and gorillas, and dwarves in blackface fighting Amazonian women. The escalating spectacle reaches its grisly climax as a group of hymn-singing Christians face the lions in the arena. The serialized spectacle is consistently intercut with images of the crowd. Wide shots emphasize the size of the arena and of the audience, tracking shots individualize faces within the mass, and close-ups depict emotional responses, showing the public to be alternately horrified, amused, and entranced by the action, or in some cases absorbed in their own affairs. The unusual emphasis

[15] Ibid., 294.

FIGURE 6.1 *Spectacle and spectator in* The Sign of the Cross *(1932)*

given to the crowd in these scenes points to the film's awareness of its own spectacle and its anticipated impact on the second audience watching in the cinema. But in addition to simply observing the action in the arena, the spectators are made part of the spectacle and the performance itself, a shift made clearest when the face of an enthused female viewer dissolves into the head of a growling tiger.

The spectacular procession also plays a major role in *Around the World in 80 Days* (1956), a historical travelogue adapted from Jules Verne's fantastical novel. As Phileas Fogg and his companions traverse the globe, the procession is used as a visual motif to represent the exotic foreign cultures they encounter. In the streets of Bombay they witness a parade of Indians celebrating a Hindu festival, in Hong Kong they see a performance of Chinese dancing dragons, in Thailand they pass the procession of the Thai royal barge, and in America they witness a Native American pow-wow. The camera lingers each time, its oblong format suited to the lateral movement of the procession, while the native culture is performed for the tourist spectators. It is possible to interpret imperialist overtones in this representation of exotic spectacle. Mary Louise Pratt identifies a tendency in Western travel writing which she describes as the 'monarch-of-all-I-survey': the sweeping, panoramic description of an exotic and alien landscape narrated from a fixed vantage point, typically a promontory of some kind. This kind of narrated gaze

attempts to both aestheticize and find meaning in the landscapes it surveys, announcing their discovery and in the process creating a 'relation of mastery predicated between the seer and the seen.'[16] In its ostentatious representation of foreign landscapes and cultures, *Around the World in 80 Days* does something similar, staging spectacular processions of exotic spectacle for Western spectators, although in contrast to the rapturous crowds in *Cleopatra* and *The Sign of the Cross* they maintain a cool distance from the spectacle. Like these films, however, the spectacular processions of *Around the World in 80 Days* are serial, excessive, and to some extent escalating. The effect is to overwhelm the audience, creating visual events on a scale which dwarfs the human perspective and emphasizes the greater significance of spectacular architecture and objects.

As James Russell has suggested, another axiomatic trope of epic spectacle involves positioning an individual within spectacular landscapes or massive crowds.[17] *The Ten Commandments* (1956) features several scenes of this type, and the trope serves to assert the heroism of Moses and his status as a man apart from the people he leads. As Steve Cohan observes, compositions throughout the film emphasize Moses' height in relation to other characters in the film.[18] As he closes the Red Sea and submerges the Egyptian chariots, Moses appears in the center of a long shot, arms and staff raised, standing on top of a rock. He is surrounded on all sides by a dense crowd and the roaring tide, but his elevated position and physical stature in the frame separates him from the masses, emphasizing his role as the lone orchestrator of the spectacular event. The composition is repeated in a later spectacular sequence as Moses brings the Ten Commandments down from Mount Sinai. He is encircled by hundreds of extras once again, but rather than being overwhelmed by the vast crowd, Moses controls their attention from another elevated position before throwing the stone tablets at the golden calf. In contrast, much of the spectacle featured in *Lawrence of Arabia* (1962) involves panoramic shots of the film's hero not among a crowd but against vast, empty backdrops of desert and sky. Extreme long shots of Lawrence as he first arrives in Arabia and as he crosses the Nefud Desert serve to diminish his physical presence almost to the point where he becomes indistinguishable from the landscape. Even when he is filmed in medium shot, the bareness of the landscape around him is emphasized and his dusty military uniform and Arab robes offer little tonal contrast with his environment. The images isolating Moses among crowds are composed in ways which

[16] Mary Louise Pratt, *Imperial Eyes: Travel Writing and Transculturation* (London: Routledge, 1992), 201–5.
[17] Russell, *Past Glories*, 32.
[18] Cohan, 158.

emphasize his individuality and illustrate his heroism and power, but images of Lawrence isolated in the desert imply that the spectacular environment has overwhelmed and overpowered him. Whereas Moses' stature is emphasized during the spectacular set-pieces in *The Ten Commandments*, the spectacular scenes in *Lawrence of Arabia* have the opposite effect on its protagonist, indicating the fragility of his leadership.

A third example of spectacle in historical cinema can be found in what Cohan terms 'conspicuous destruction': the spectacular obliteration of architecture and physical objects in scenes which typically form the climactic point of a film.[19] The tradition of constructing elaborate movie sets before filming their controlled destruction has a long history in epic historical cinema and, like much else, it can be traced back to the Italian ancient world epics of the 1910s. Rome is burned to the ground in *Quo Vadis?* (1913) while *The Last Days of Pompeii* (1913) reaches its unavoidable conclusion with the violent eruption of Mount Vesuvius and the destruction of the city below it. In Hollywood the 'disaster film' genre was probably associated with historical cinema before science fiction. Spectacular destruction was the focal point of historical disaster films such as *San Francisco* (1936), depicting the 1906 earthquake, and *In Old Chicago* (1938), which depicted the 1871 fire. Later the same decade, the burning of Atlanta in *Gone with the Wind* (1939) provided the film's most spectacular set-piece and descriptions of its production played a significant role in contemporary promotional materials.[20] Scenes of destruction became even more prominent in the epics of the roadshow era. This is largely due to the increasing emphasis on spectacle as a production value in epic cinema of the period, but as Cohan suggests, such images may also have resonated with Cold War anxieties over nuclear destruction.[21] In *Samson and Delilah* (1949) the narrative concludes with Samson tearing down the Temple of Dagon, a feat of strength which leaves the building as rubble and seems to crush all those in it. The destruction and loss of life ought to be horrifying, but as the film's long-anticipated and heavily promoted climax, as well as the just punishment for Samson's pagan tormentors, the scene is presented as a source of pleasure for the audience. Deleuze suggests that the sequence provokes 'Olympian laughter'—presumably a combination of the sublime and the ridiculous—'which takes hold of the spectator.'[22] The film's brief coda underlines the uplifting tone of destruction as the mourning Miriam declares that Samson's 'strength will never die.' In *Quo Vadis* (1951) the spectacular burning of Rome is presented in rather more somber terms.

[19] Ibid., 129.
[20] See, for example, the printed souvenir program which has been reproduced for sale with recent home media editions of the film.
[21] Cohan, 129.
[22] Deleuze, 149. See also Babington and Evans, *Biblical Epics*, 11.

But although the fire is shown to provoke terror among the populace, the spectacle also provides gratification for Nero, who much like the audience is able to observe the destruction from a safe distance.

Referring to the *Quo Vadis* narrative, André Bazin describes the audience response to spectacular destruction as 'the Nero complex': 'the pleasure experienced at the sight of urban destruction.'[23] As Bazin indicates, the act of enjoying depictions of death and destruction is ethically ambiguous. It is worth noting, however, that in many scenes of spectacular destruction the audience is invited to respond to the destruction of physical objects rather than to dramatized loss of life. The ability of destruction to excite rather than appal may thus be related to the strategy of investing meaning and value in spectacular objects rather than in mere humans. In an essay about science fiction disaster films, Susan Sontag suggests that 'a greater range of ethical values is embodied in the décor of these films than in the people. Things, rather than helpless humans, are the locus of values because we experience them, rather than people, as sources of power.'[24] This observation can be applied to the excessive, extended, digitally enhanced destruction which dominates the latter half of *Titanic* (1997) and provided the principal element in its marketing. The tragic, human dimensions of the disaster are mitigated first by its inevitability (as with Pompeii and Dagon, it is impossible to conceive a different end for the ship) and secondly by the aesthetic and technological prowess of the spectacle put on screen. Even in *Pearl Harbor* (2001), the extended bombing of the harbor functions much more as a showcase for vivid, technologically advanced spectacle than as a depiction of human suffering.

The three tropes of spectacle I have outlined share an interest in depicting events on a larger-than-human scale. In processions, images of individuals in landscapes or crowds, and scenes of destruction, the emphasis tends to be placed on excessive objects and vistas or, in the case of Cleopatra and Moses, on people rendered excessive through composition or by association with spectacular objects. Instead, the role designated for humans as spectacular events unfold is to be a spectator: to be amazed and overwhelmed, but also overpowered and physically diminished. Whether participating in the crowd on screen or watching in the audience off-screen, the spectator is kept at a distance from the spectacle itself. As Geoff King has argued, the 'pleasures' offered by spectacle 'include a sense of being taken beyond the scale of everyday life to something suggesting grandeur, an awe, or a sense of the

[23] André Bazin, "On *Why We Fight:* History, Documentation and the Newsreel" in Bert Cardullo (ed.), *Bazin at Work: Major Essays and Reviews from the Forties and Fifties*, trans. Alain Piette and Bert Cardullo (New York: Routledge, 1997), 188.
[24] Susan Sontag, "The Imagination of Disaster" in Gilbert Adair (ed.), *Movies* (London: Penguin, 1999), 176.

sublime.'[25] To return to Sobchack's arguments, it is perhaps this assertion of spectacle which transcends everyday life and gives 'objective and visible form' to the feeling of being in the past.

History and technology

The creation of spectacle in historical cinema is closely related to the development of film technology, and for many decades the genre has been closely identified with innovations in production and exhibition techniques. Experiments with color, widescreen, and even sound frequently occurred in historical films during the 1920s. The pre-eminent color processes used during this period were devised by the Technicolor Corporation. The early 'two-color' Technicolor process was trialled in a full-length film in 1922, but its practical limitations and prohibitive cost led to it being used more commonly to create short sequences in otherwise black-and-white films. DeMille's *The Ten Commandments* (1923), for example, used Technicolor to enhance the spectacle of some of its set-piece sequences, including parts of the exodus and the parting of the Red Sea. Color inserts were subsequently used in several of the biggest historical films of the decade, including *Ben-Hur* (1925), *The Phantom of the Opera* (1925), *The Big Parade* (1925), and *King of Kings* (1927), which used Technicolor to depict the resurrection of Christ. As Scott Higgins suggests, color technologies of this type were thus initially used in a 'demonstrational mode' before entering an 'assertive mode' once they had proven popular with audiences.[26] Two-color Technicolor was used throughout in the Douglas Fairbanks swashbuckler *The Black Pirate*, released by United Artists in 1926, and again in MGM's *The Viking* (1928), which introduced an improved, dye-transfer version of the process. *The Viking* also featured a fully synchronized (but dialogue-free) soundtrack and musical score, a process which was first heard in Warner Bros.'s historical romance *Don Juan* (1926).

In addition to innovations in color, spectacle in historical cinema was also achieved through tentative experiments enlarging the dimensions of the cinema screen. In 1926 Paramount unveiled the Magnascope format in the historical maritime adventure *Old Ironsides*. The process allowed images to be created on a screen far larger than standard formats, but as with early uses of Technicolor the widescreen enlargement was used only for special spectacle sequences (including the climactic battle sequence) which were

[25] Geoff King, "Spectacle, Narrative and the Spectacular Hollywood Blockbuster" in Julian Stringer (ed.), *Movie Blockbusters* (London: Routledge, 2003), 118.
[26] Scott Higgins, *Harnessing the Technicolor Rainbow: Color Design in the 1930s* (Austin: University of Texas Press, 2007), 209.

revealed by receding curtains at the edges of the screen.[27] In 1930 Fox experimented with a process designed to create images of similar proportions using 70mm film. Known as Fox Grandeur, the studio attempted to establish a market for the process with *The Big Trail* (1930), a western depicting westward immigration on the Oregon Trail.[28] Both of these enlarged screen films proved unprofitable, however, and the cost of converting cinemas to the new specifications plus the financial impact of the Great Depression stalled further development.

The historical film nevertheless continued to be linked to technological innovation in the decades which followed. Most notably, the improved 'three-color' Technicolor process had its feature film debut in the Victorian-era drama *Becky Sharp* (1935). The new process was strongly associated with historical spectacle in subsequent films, including *The Garden of Allah* (1936), *The Adventures of Robin Hood* (1938), and, most profitably, *Gone with the Wind*. During the 1950s historical cinema drew on technology even more heavily to achieve spectacular effects and create distinctive viewing experiences for roadshow exhibition. As David Eldridge suggests, the 'technological advances and gimmicks, so characteristic of 1950s cinema, were launched with one foot firmly in the past – heralded by history.'[29] 20th Century Fox's CinemaScope process recommenced the enlarged-screen experiments of the 1920s using anamorphic lenses to create a widescreen image using traditional 35mm film. The process also broke new ground in its use of stereo soundtracks for mainstream film production and contributed to the ascendance of Eastmancolor's new 'monopack' system over the more technically restrictive Technicolor process.[30] Benefitting from lower installation costs than competing widescreen technologies, CinemaScope premiered in 1953 with the Christian/Roman Epic *The Robe*. The film opens with a procession of Roman soldiers and slaves carrying gifts, their horizontal movement emphasizing what Roland Barthes calls the 'stretched-out frontality' of the CinemaScope format, and continues in a marketplace where slaves are being auctioned.[31] In this sequence, spectacle is created primarily by filling the extended dimensions of the frame with an abundance of visual detail. Long- and medium-long shots of the principal characters are composed with little depth, but with background performers in elaborate costumes lined

[27] John Belton, *Widescreen Cinema* (Cambridge: Harvard University Press, 1992), 36–7.
[28] Ibid., 48.
[29] Eldridge, *Hollywood's History Films*, 57.
[30] David Bordwell, Janet Staiger, and Kristin Thompson, *The Classical Hollywood Cinema: Film Style and Mode of Production to 1960* (London: Routledge, 1988), 357.
[31] Roland Barthes, "On CinemaScope," trans. Jonathan Rosenbaum, *Jouvert: A Journal of Postcolonial Studies* 3/3 (1999). Accessed February 26, 2012, http://english.chass.ncsu.edu/jouvert/v3i3/ barth.htm.

FIGURE 6.2 *Lateral CinemaScope compositions in* The Robe *(1953)*

up right to the edges of the image. These highly lateral compositions tend to draw attention away from the dramatic content of the scene, particularly when conventional shot/reverse shot editing structure is eliminated, and they occasionally require the viewer to scan the frame for narratively significant information. The aesthetic strategies of early widescreen films thus emphasized detail-based spectacle over spatial coherence and dramatic engagement, demonstrating the aesthetic priorities of much historical cinema from the period.

Between the release of *The Robe* and the end of the roadshow era, historical cinema became inseparable from widescreen processes designed to showcase ever more spectacular images. In 1954 a total of 35 films were released in CinemaScope; 21 of them were historical films.[32] Various competing widescreen formats were promoted in the following years, most notably Todd-AO, which returned to the 70mm film technology previously seen in Fox Grandeur. Featuring six-track stereo sound, the process was capable of exhibiting widescreen images at resolutions superior to CinemaScope. Todd-AO was developed initially outside the Hollywood studio system and debuted in the historical musical *Oklahoma!* (1955), before reaching even larger audiences in roadshow epics including *Around the World in 80 Days* and *Cleopatra*. The success of these productions encouraged Hollywood studios to invest in their own 70mm widescreen processes. MGM launched a format called MGM Camera 65 with the historical melodrama *Raintree County* (1957) and bought it to a much wider audience in *Ben-Hur* (1959). The format later became the basis for the Super Panavision 70 and Ultra Panavision 70 processes, which were used on several high-profile historical films during the 1960s including *Lawrence of Arabia* and *Mutiny on the Bounty* (1962). The Cinerama process, which created a wide, curved image by joining footage

[32] Eldridge, *Hollywood's History Films*, 58.

recorded by three cameras, was initially used for non-fiction travelogues, but in the early 1960s it was employed for two narrative productions: *The Wonderful World of the Brothers Grimm* (1962), a literary biopic, and the historical western *How the West Was Won* (1963). The latter film followed a family through several generations as they migrated westward, participating in the Civil War and the construction of the Union Pacific railroad. An epilogue featuring spectacular aerial images of San Francisco's modern road network asserts the geographic extent and technological accomplishment of America's westward expansion. Over time, the techniques for widescreen composition also acquired a greater flexibility and nuance, benefitting from deeper focus and thus a clearer separation of visual planes, a greater variation in shot distance, and more assertive editing. In *Ben-Hur*, for example, the procession of the Roman governor to Jerusalem achieves its visual impact not simply from a density of detail but through the alternation and contrast of extreme long-shots which reveal the spectacular mass of marching soldiers, and sparser, closer shots of Judah Ben-Hur and his sister observing from a rooftop.

The epics of the roadshow era were marketed not simply for their widescreen spectacle but also in terms of their ability to create viewing experiences which engulfed their spectators. The Cinerama, CinemaScope, and Todd-AO formats were designed to be exhibited on screens that were not only wide but deeply curved, creating an immersive 'wrap-around' effect. Advertising for early widescreen films emphasized this new dimension, likening the effect to three-dimensional processes, and suggesting that the phenomenon allowed audiences to participate in screen spectacle, either by their immersion in the image or the entry of the spectacle into the space occupied by the audience.[33] One press advert stated, 'through the magic of CinemaScope, you become part of the miracle of *The Robe* – you share in each moment of wondrous drama – as the imperial might of Rome crashes against the word of God!'[34] Similarly, the Todd-AO experience in *Oklahoma!* was described in press adverts as 'ecstatic in its realism... supreme in its audience emotional involvement and participation... you live the action... you're part of it.'[35] This discourse of participation was not limited to Hollywood's promotional copywriters. In a short essay on CinemaScope from 1954, Roland Barthes speculated about how the Odessa Steps sequence from *Battleship Potemkin* (1925) might have appeared were it filmed using the new technology:

[33] Angela Ndalianis, *Neo-Baroque Aesthetics and Contemporary Entertainment* (Cambridge: MIT Press, 2005), 151.
[34] Quoted in Eldridge, *Hollywood's History Films*, 66.
[35] Advertisement, *Variety*, October 12, 1955, 20.

No longer stationed at the end of a telescope but supported by the same air, the same crowd: this ideal Potemkin, where you could finally join hands with the insurgents, share the same light, and experience the tragic Odessa Steps in their fullest force, this is what is now possible; the balcony of History is ready.[36]

As David Eldridge has suggested, the promotion of films as active viewing experiences can be related to the transformation of American recreation habits in the 1950s and to the popularity of 'Living History' museums.[37] However, they were also presented in terms of their ability to transform the relationship between spectator and screen. More than simply creating a spectacle for the passive consumption of the audience, immersive historical films of the era were discussed in terms of their ability to allow viewers to travel back in time and witness the past from the widescreen 'balcony of history.' As I have suggested, the designated human role in spectacular scenes is that of the passive, awed spectator. The discourse created by widescreen films in the 1950s and 1960s, however, suggested that this sense of awe could actually bring the spectator closer to the historical spectacle itself.

Digitizing the past

Since the 1990s, the relationship between historical cinema and technologies of spectacle has been dominated by the development of CGI. Indeed, it seems reasonable to propose that CGI technologies have broadened the imaginative possibilities of the genre. The first major historical film to be decisively shaped by CGI was *Forrest Gump* (1994). Among other things, the film used digital processing to insert its hero into documentary footage from the past, allowing him to interact with historical figures such as John F. Kennedy, Lyndon Johnson, and the first African American students enrolled at the University of Alabama. The process of integrating documentary and dramatized material in historical films is nothing new; war films such as *Sands of Iwo Jima* (1949) interpolated newsreel images for its battle scenes and *Mission to Moscow* (1943) edited footage of actors into documentary images of a Soviet military parade. The invention of encounters between a fictional character and multiple historical figures also has precedents in the genre, forming the basis of films such as *Little Big Man* (1970) and *Zelig* (1983). But the superior realism of the digital processes used in *Forrest Gump* as well as the effective rewriting of archival material to suit the film's fictional narrative

[36] Barthes, "On CinemaScope."
[37] Eldridge, *Hollywood's History Films*, 65–6.

is more unusual. As Robert Burgoyne has argued, in specific reference to a scene where Gump is grafted on to archival newsreel for a fictional conversation with President Kennedy,

> This sequence no longer originates from a fixed moment in history, no longer carries… the archival trace of the moment of its shooting: it rather carries a double temporality, conveying its separate origins – Kennedy from the past of 1962, Hanks as Gump from the past of 1994 – as well as the resulting single morphed present.[38]

It seems likely that a modern, media-literate audience would immediately understand that scenes such as these are fictional constructs, particularly when viewed in the context of the film's whimsical style and Gump's somewhat unreliable status as a narrator. However, the apparent potential of CGI to dissolve the authority of archival images might be regarded as problematic. As Stephen Prince has put it, 'digital imagery possesses a flexibility that frees it from the indexicality of photography's relationship with its referent.'[39]

The use of digital effects in *Forrest Gump* remains relatively unusual, however, and during the 1990s the technology was soon established as a means to achieve more conventional forms of spectacle. According to Kirsten Moana Thompson, digital effects in historical cinema tend to be associated with 'spectacular action (both individual and crowd based), spectacular architecture, and spectacular detail.'[40] At times, these elements can be seen in unison, particularly in moments when historical films self-consciously reveal the spectacular capabilities of digital technology. In *Titanic*, for example, the spectacularly large, immaculately detailed ship is the principal site for spectacle in the film. Its fantastic dimensions are established in several wide shots at the start of the film, but the spectacle is unveiled in full by an extended aerial camera movement which travels from the ship's prow to its stern, integrating actors on physical sets with digitally animated models. The shot begins with Jack in medium shot and pulls backwards and upwards into a bird's-eye view of the ship, the camera fluidly passing between two smoking chimneys as it reveals an object far larger than initial appearances indicated. As the camera rises, the spectator is constantly required to recalibrate his/her sense of the ship's dimensions, the rapid transformations of scale grounded by the decreasing size of the human figures visible on the deck. As with

[38] Robert Burgoyne, "Memory, History and Digital Imagery in Contemporary Film" in Paul Grainge (ed.), *Memory and Popular Film* (Manchester: Manchester University Press, 2003), 228.

[39] Stephen Prince, "True Lies: Perceptual Realism, Digital Images and Film Theory," *Film Quarterly*, 49/3 (1996): 30.

[40] Thompson, "Philip Never Saw Babylon," 46.

many older historical films, the scene features an excess and an escalation of spectacular imagery, but the airborne mobility of the camera and seamless integration of live action and animation mark the scene as a product of digital technology. A similar spectacle of digitized revelation can be seen in *Gladiator* (2000) in the use of the Colosseum in Rome, a composite set combining physical and digital elements. In its first appearance the camera begins at the base and tilts up to the highest tiers—perhaps imitating the craning of a human neck—implying that the construction is too large to be contained by a static image. As with *Titanic*, the scale of the architecture is illustrated by minute human figures visible within the walls, and also by a flock of birds who rise up the facade in time with the camera. A subsequent scene provides a view inside the Colosseum as the gladiators enter and prepare to fight. The camera tracks in a full circle around them, replicating their visual perspective, revealing the physical extent and the visual density of the arena in three-dimensional space. Seen from without and within, the digital architecture is overwhelming both in its gigantic scale and its ornate detail. This combination of vastness and intricacy can be observed in moments from both *Gladiator* and *Titanic* and it would seem to be characteristic of CGI spectacle in general. Amelia Arenas has drawn attention to digitally composited panoramic views in *Gladiator* in which the 'level of detail is so exhaustive as to be optically impossible,' creating an effect which is 'more hallucinatory than realistic.'[41] As Kevin Mack has suggested, this sense of artificiality may be due to lighting: images such as these are given an unnatural luminance due to the abnormal evenness with which light is distributed, creating an effect which is impossible in conventional cinematography.[42]

An additional trope of spectacle in the digital age involves proliferation. As Thompson has put it, spectacle in contemporary historical cinema can be created through the 'exponential multiplication of heroic bodies into a mass or crowd.'[43] Massive crowd scenes in films such as *Gladiator* and battle scenes in *Alexander* (2004) and *300* (2006) were made possible by crowd replication software, which allows thousands of autonomous, three-dimensional digital characters to be animated and integrated with live-action footage.[44] Of course, spectacularly large crowds and armies have been common in high-budget historical cinema since the 1910s, but the ability to create them inside a computer rather than by organizing human extras has made the effect more achievable in practical terms and more spectacular in terms of potential scale. A second example of digital proliferation can be seen in the acceleration of a

[41] Arenas, 4.
[42] Prince, "True Lies," 30. The same effect can also be observed in many computer animated films and video games.
[43] Thompson, "Philip Never Saw Babylon," 48.
[44] Ibid., 49.

FIGURE 6.3 *Digital proliferation of arrows in* 300 *(2006)*

FIGURE 6.4 *Live-action arrows in* Braveheart *(1995)*

popular visual trope from recent ancient world films: battle images where the sky fills with arrows. In *Troy*, Trojan archers fire at the invading Greek army and a low-angle shot depicts the trajectory of hundreds of arrows against a blue sky.[45] The effect is repeated and intensified in the climactic battle of *King Arthur*, and in *Alexander* the arrows of the enormous Persian armies are rendered in an extreme long shot as a dense swarm. In *300* the significance of the arrows image is emphasized and prefigured by dialogue in which a Persian officer boasts that 'our arrows will blot out the sun.' The arrows sequence itself fulfills this promise and easily overwhelms analogous scenes in the older films, providing a visual representation not only of the Persian army's superior manpower but also of the potential of digital technology to push at the boundaries of visual excess. Ironically, the popularity of the arrows image can probably be traced to *Braveheart* (1995), a film whose

[45]A version of this shot can also be seen in the Chinese/Hong Kong film *Hero* (2002).

dependence on live-action spectacle aligns it with an older generation of historical cinema. Unassisted by digital animation, the arrows fired by English archers are fewer in number and more wayward in their trajectories, but they travel with a heaviness lacking the weightless CGI creations of more recent films. The contrast between the arrows of *Braveheart* and *300* might be said to encapsulate the wider impact of digital technologies on historical cinema and their attendant substitution of the physical world, however fictionalized, for virtualized imagery.

Digitally enhanced spectacle in historical films has also taken less overt forms, most notably in the use of 'digital intermediate' technology to alter the visual surface of films in postproduction and in particular to manipulate color values. Many of the earliest experiments with the technology were made in historical cinema. A digital intermediate process was used briefly to add a red-colored dress to the predominantly black-and-white images of *Schindler's List* (1994), and more extensively in *Pleasantville* (1998) to illustrate the gradual intrusion of color into a monochrome 1950s American suburbia. As Richard Misek has put it, the digital displacement of black-and-white imagery is used as a fairly overt metaphor for 'America's transition from Cold War Authoritarianism to postmodern social pluralism.'[46] The first feature production to use digital intermediate color manipulation throughout was *O Brother, Where Art Thou?* (2000). The film recreates the American South of the Great Depression using a desaturated color palette which recalls the chemical degradation of old photos and, according to Misek, 'hypostatize[s] the fading of our cultural memory.'[47] In both cases, the digital manipulation of color is related to pastiche: color, or the absence of it, is a means to recreate the past by imitating its representations in other media. Since the early 2000s, digital intermediate techniques have been widely used in mainstream cinema in a variety of genres. The digital postproduction aesthetic created in *300* is a particularly extreme example, showcasing a distinctive sepia palette punctuated by heavy yellows and reds which emulate the watercolors of the comic from which the film was adapted.[48] Digital postproduction technologies illustrate the fact that the overall 'look' of a film and many of its most spectacular elements has little connection to conventional photography. Moreover, the visual excess associated with historical representation is increasingly a function of computer software rather than the work of the production designer on set. Michael Wood has suggested that the historical films of the roadshow era achieved 'the reverse of mimesis' in their 'complete

[46] Richard Misek, Chromatic Cinema: A History of Screen Cinema (Oxford: Wiley-Blackwell, 2010), 162.
[47] Ibid., 163.
[48] Thompson, "Philip Never Saw Babylon," 55.

replacement of life by a life-size simulacrum.'[49] By contrast, the digital production design of contemporary historical cinema presents mimesis of a different sort: the physical world not simply replaced, but tuned up, scaled up, and multiplied by computer algorithms.

Spectacle in historical film has been achieved through various means over time—production design, exhibition technologies, digital postproduction processes—and it has tended to create visual events which are excessive and overwhelming in both their detail and scale. Imagery of this nature has by no means been confined to the historical film, and yet the genre seems to have been a privileged site for spectacular events and the technological innovations associated with their screen representation. As Sobchack has suggested, the connection between history and spectacle may derive from the need to find a visual correlative for the momentous tone conventionally adopted by many historical narratives. According to this argument, spectacular form emerges as a consequence of a certain type of storytelling. At the same time, an argument can also be made that the form adopted by historical films in fact precedes the demands made by their content. According to John Belton, the pre-eminence of historical epics during the 1950s and 1960s can be attributed to the need for subject matter which was suited to the specific formal demands of fashionable, widescreen exhibition processes. The 'shift to historical spectacle,' he argues, 'functioned to naturalize pictorial spectacle.'[50] More broadly, Eldridge has suggested that historical epics feature spectacular events because their narratives were thought able to 'contain' them effectively, 'providing a rationale for excessive display' and allowing visual excess to be presented 'in an appropriate narrative context.'[51] In other words, the past provides a fitting narrative context for spectacular events which might appear implausible or inappropriate if they occurred in other genres. Historical films, in this sense, are spectacular because history is able to legitimize spectacle, and the prestige commonly assigned to the genre thus functions to excuse visual excess. The question of historical cinema's seemingly elevated cultural status is the subject of the following chapter.

[49] Michael Wood, 170.
[50] Belton, 194.
[51] Eldridge, *Hollywood's History Films*, 59.

7

Prestige, education, and cultural value

Historical cinema and public relations

In *The Last Tycoon*, F. Scott Fitzgerald's closely observed satire on the 1930s Hollywood studio system, the young Hollywood mogul Monroe Stahr (modeled on MGM producer Irving Thalberg) surprises his lunch guests by announcing a high-budget 'quality picture' which he predicts will fail at the box office. He explains:

> It's time we made a picture that'll lose some money. Write it off as good will – this'll bring in new customers… We have a certain duty to the public as Pat Brady says at Academy dinners. It's a good thing for the production schedule to slip in a picture that'll lose money.[1]

Film production in America has often been regarded as a relentless pursuit of financial returns, but as with any successful industry the profit motive of the Hollywood studios has also been balanced by the need for good public relations. As Ruth Vasey has suggested, 'Hollywood has always had to tread a fine line between the short-term profits associated with sensational material and the long-term industrial stability promised by "responsible" entertainments.'[2] To this end, historical filmmaking has frequently been charged with an ambassadorial role: showcasing the medium's prowess, engaging with audiences not traditionally attracted to cinema, and providing evidence for the cultural potential of the film industry as a whole. This role has certainly been highlighted by the annual Academy Awards ceremony, perhaps

[1] F. Scott. Fitzgerald, *The Last Tycoon* (New York: Scribner's, 1993), 48.
[2] Ruth Vasey, *The World According to Hollywood, 1918–1939* (Exeter: Exeter University Press, 1997), 29.

the most conspicuous event in Hollywood's ongoing effort to uphold a public image combining glamor with artistic sophistication. In 84 ceremonies between 1929 and 2012, films set in the past have received the Best Picture Award on no fewer than 47 occasions.[3] The record for most awards is shared by *Titanic* (1997), *Ben-Hur* (1959), and the non-historical *Lord of the Rings: The Return of the King* (2003). If the Academy Awards have sought to regulate and promote Hollywood's cultural legitimacy by showcasing what the film industry regards as its greatest cultural achievements, the historical film has always been absolutely central to this effort. However, as I will argue in this chapter, the prestigious status attributed to the genre within the film industry has not always been accepted outside it, and the cultural value of historical cinema has been a matter of constant debate.

The need to burnish the film industry's public image was particularly acute during the 1920s and 1930s as Hollywood's expansion was constrained by moral concern over its adverse effect on audiences. From 1922, the public relations of the film industry were handled by the Motion Picture Producers and Distributors of America (MPPDA), headed by former politician Will Hays. Hays, the MPPDA, and the Production Code Administration (the division of the MPPDA charged with censorship) are generally remembered for their constrictive regulation of Hollywood filmmaking. But in addition to discouraging certain kinds of filmmaking, they were also involved in promoting the kind of films they thought would counter the industry's taint of dissipation with the impression of moral and cultural respectability. From the outset, Hays was heavily invested in the cultural status of the historical film for these purposes. In 1926 he lobbied President Coolidge for public funds to arrange for the 'preservation for posterity of worthy historical film subjects.' In the same year, a communication from his office proposed that 'patriotic and historical pictures' were shown in 'the steerage of transatlantic vessels to immigrants' in order to 'give the future Americans their first lesson in American citizenship.'[4] As calls for government regulation of the cinema increased during the early 1930s, Hays became particularly concerned with attracting educated, middle-class patrons to cinemas in order to give them a 'positive investment' in the film industry's survival.[5] Studios were encouraged to cater for filmgoers of a higher social status, a market which could apparently be lured by a combination of lavishly staged historical films, biopics, and adaptations of 'classic' literature. In 1938 *Variety* linked a raft of films based on the history of American businesses to Hays'

[3] For a complete list see the AMPAS website, accessed March 28, 2012, www.oscars.org/ awards/ academyawards/legacy/best-pictures.html.

[4] "Historical Film Subjects Suggested for Government Vaults," *New York Times*, September 12, 1926.

[5] Vasey, 29.

lobbying, stating, 'Hays has always been of the belief that the harnessing of the world-wide and powerful sway of American made celluloid product to useful purposes would more firmly entrench the picture industry with present patrons.'[6] Historical films, biopics and literary adaptations thus served a dual public relations purpose: they allowed the film industry to broaden its cultural influence and demographic reach by appealing to the professional middle classes and, as Thomas Doherty has suggested, they were promoted as evidence that Hollywood had undergone a moral reformation.[7]

Hays' endorsement of historical cinema in the 1930s coincided with a prominent cycle of 'prestige films,' a production trend rated by Tino Balio as the most commercially significant of the decade. According to Balio, the term 'prestige film' was in general use in the trade press during the 1930s and typically described 'a big-budget special based on a presold property... and tailored for top stars.'[8] A 1936 *Motion Picture Herald* report listed the principal source materials as nineteenth-century European novels, Shakespeare, prize-winning contemporary plays and novels, and biographies of historical figures. Emphasizing the cultural role played by the cycle and their conflation of artistic legitimacy and popular appeal, the report stated that such source material had been 'acclaimed by the classes and bought by the masses.'[9] The majority of the examples cited are historical films, including MGM's *David Copperfield* (1935), Warner's *The Life of Emile Zola* (1937), and Selznick's *Gone with the Wind* (1939), but contemporary dramas such as *Grand Hotel* (1932) were also identified with the term. Films with such a broad range of subject matter cannot be unified textually; instead, Balio suggests that the prestige film is defined by its 'production values and promotion treatment,' both of which were characterized by extravagance and a sense of cultural significance.[10] In this way the prestige film cycle was premised on the association of high culture with high production and exhibition standards: the more expensive the film looked the greater its claim to cultural legitimacy. As Chris Cagle has suggested, the social function of the prestige film was twofold: for the public such films promised 'the possibility of high-culture experience' and to the studios such films bestowed a sense of 'cultural elevation' on their business practices.[11] But although such films were intended to flatter the cultural aspirations of the filmgoing public, their aura of prestige was primarily the

[6] "Historical Pix to Up B.O," *Variety*, April 20, 1938, 7.

[7] Thomas Doherty, *Pre-Code Hollywood: Sex, Immorality and Insurrection in American Cinema, 1930–1934* (New York: Columbia University Press, 1999), 333.

[8] Balio, *Grand Design*, 179.

[9] "Producers Aim Classics at 36,000 Audience," *Motion Picture Herald*, August 15, 1936, 13–14.

[10] Balio, *Grand Design*, 179.

[11] Chris Cagle, "Two Modes of Prestige Film," *Screen*, 43/3 (2007): 303.

product of film industry discourses rather than audience reception.[12] To this extent, historical cinema in the 1930s belonged to a top-down approach to the production of prestige which depended on the favorable response of the public but which did not necessarily take their interests into account.

The prestige film's potential for cultural elevation was not always accepted by contemporary film critics. As Chris Robé has shown, historical cinema generated significant debates within intellectual film culture during the 1930s. Left-wing critics in America endeavored to maintain a distinction between what they regarded as 'legitimate' historical films, such as Eisenstein's *Battleship Potemkin* (1925) and Jean Renoir's *La Marseillaise* (1937), and the historical 'costume drama' which was by and large linked to Hollywood. The latter was found wanting due to its romanticization of the past and its 'stupe-fying obsessions with the details of *mise en scène*,' which was thought to inhibit 'the ability to develop nuanced themes and sociohistorical contexts.'[13] An alternate point of view was presented by novelist Philip Lindsay in the British film journal *Cinema Quarterly* in 1932. Seeking to defend the genre, Lindsay outlined their value for reinforcing conservative models of historical progress:

> We have been pushed too close to the shoddy, vulgar, and brutal things of today; we are tormented by memories of the last war, frightened at the menace of another war; we have gone to the film for relaxation, for inspiration, for pleasure, and we have returned shocked and a little ashamed of our civilization. In the future, however, we will be shown the great achievements of man in the past; we will see the heroic deeds and splendid women, and thus we will be taught that our civilization is not a crude, sudden growth – not a 'system' as the Communists, in defiance of history, will call it – but that down the centuries man has been striving forward, building, creating... This is what costume films can make us realize.[14]

Emphasizing the class dimensions of these arguments, Lindsay added: 'I am not speaking of the cultured audience who know these things... we must not forget that the great film public is often entirely uneducated.'[15] In a rebuttal printed in the next issue of the journal, Thomas Simms argued that 'historical films will not contribute the slightest inspiration to the people of to-day... Let

[12] Ibid., 293.

[13] Chris Robé, "Taking Hollywood Back: The Historical Costume Drama, the Biopic, and Popular Front US Film Criticism," *Cinema Journal* 48/2 (2009): 72.

[14] Quoted in Jeffrey Richards, *The Age of the Dream Palace: Cinema and Society in 1930s Britain* (London: I. B. Tauris, 2010), 257–8.

[15] Ibid., 258.

us have films which keep our world before us.'[16] Whereas the film industry discourse stressed the cultural elevation of the masses, then, many critics saw historical films as a kind of palliative, to both positive and negative ends.

The ambivalence towards historical cinema in intellectual culture was by no means limited to the 1930s, and similar responses may be found in critical and academic discussions of Anglo-American 'heritage cinema' during the 1980s and 1990s.[17] Films such as *A Room with a View* (1985) and *Howards End* (1992) appealed to large crossover audiences and received numerous prestigious awards, but they were frequently reviled within intellectual culture. Pam Cook summarizes the principal objections raised in response to them as:

A distrust of decoration and display, which is perceived as obfuscating a more genuinely authentic approach to history; a fear of being 'swallowed up' by nostalgia and a concomitant desire for critical distance and irony; a view of history as necessarily offering lessons for the present; and a sense that history should somehow remain uncontaminated by commodification.[18]

Such concerns mirror those voiced several decades before with remarkable precision. Criticism of heritage cinema has also drawn attention to its problematic conflation of prestige and populism, in particular its tendency to draw material from high cultural texts and forms while appealing to a mass audience. Claire Monk has noted the ironic tension between 'the low status of the heritage films within film and popular culture' and 'the elitist affirmation with high/literary culture which the anti-heritage critics claim to find in them.'[19] This ambiguity points towards the connection between heritage and other historical films and the concept of the 'middlebrow' in art more generally. Like the prestigious historical film, middlebrow culture has often been discussed in terms of its employment of high and low cultural codes. According to Pierre Bourdieu, the middlebrow negotiates between the associability of low culture and the prestige of high culture by combining 'two normally exclusive characteristics, immediate accessibility and the outward signs of cultural legitimacy.'[20] Similarly, Joan Shelley Rubin

[16] Ibid.

[17] In particular, see Andrew Higson, "Re-presenting the Past: Nostalgia and Pastiche in the Heritage Film" in Lester Friedman (ed.), *British Cinema and Thatcherism: Fires Were Started* (Minneapolis: University of Minnesota Press, 1993), 109–29.

[18] Cook, *Fashioning the Nation,* 69.

[19] Claire Monk, "The British 'Heritage Film' and Its Critics," *Critical Survey,* 7/2 (1995): 117.

[20] Pierre Bourdieu, *Distinction: A Social Critique of the Judgment of Taste*, trans. Richard Nice (Cambridge: Harvard University Press, 1984), 323.

has described a tension in middlebrow culture's tendency to be at once democratic and 'reverential to cultural authority.'[21] A paradigmatic manifestation of middlebrow culture, perhaps, the popular/prestigious historical film has enjoyed a conflicted cultural status over time. Films of this type have played a valuable public relations role for the Hollywood studios and have mediated between high art and popular audiences, but they have frequently been rejected by figures within intellectual culture due to suspicions about their superficial representation of historical processes and their mollifying effect on audiences.

Censoring history

The cultural status attributed to historical cinema has often been understood both as a riposte to censorship and as a means to bypass it. Thomas Elsaesser has described the prestigious biopics of the 1930s as 'a strategic response to censorship' which exchanged 'moral violence for gratuitous violence,' and J. E. Smyth has suggested that 'history was often protection against censorship and a means to make controversial films.'[22] Nevertheless, historical films have often fallen victim to institutional censorship and legal suppression. During the 1930s and 1940s in particular, the tension between filmmakers and the Production Code Administration (PCA) frequently reached the shores of the historical film genre. Although the impact of censorship was greater in other popular genres, the conflict between the censor and historical cinema sheds light on the practical limits of the genre's cultural status.

Released in 1940, Warner's *Dr. Ehrlich's Magic Bullet* depicted the career of German scientist Paul Ehrlich, who was widely known for his treatment of syphilis. Despite the prestige of the biopic form and the relative familiarity of the subject matter, the basic facts of the film's narrative stood in clear contravention of the MPPDA's Production Code, which stated that 'sex hygiene and venereal disease are not subjects for motion pictures.'[23] As a result, the screenplay for *Dr. Ehrlich's Magic Bullet* was revised to minimize specific references to the disease and to ensure that syphilitic patients were not shown to be 'too realistically horrifying or shocking.'[24] In the opening scene of the completed film, Ehrlich treats a melancholy young man for an unnamed 'contagious disease' which appears to affect his skin, and informs him that 'marriage is out of the question.' Even though syphilis

[21] Cagle, 303.
[22] Elsaesser, 22; Smyth, 20.
[23] Quoted in Doherty, 363.
[24] Quoted in Custen, 140.

and its treatment played a major role in the movie, filmmakers were obliged to depict the condition in a highly oblique manner. The 1941 Anglo-American coproduction *That Hamilton Woman* (1941) received a similar treatment from the PCA due to its depiction of an 'adulterous relationship' between Lord Nelson and Emma Hamilton 'as a romance rather than a sin.'[25] According to the Code, while adultery could be depicted on screen, it should not be shown to be 'attractive or alluring.'[26] The screenplay was amended on the request of the PCA, most notably to include prologue and epilogue scenes which framed the romance by showing Emma drunk, destitute, and rather less than alluring on the streets of Calais.[27] The clearest statement of the PCA's stance on historical cinema was perhaps made in a report on *The Egyptian* (1954), which argued that the 'ancient degeneracies and depravities' depicted in the film 'would be extremely offensive, despite the fact that they may possibly be authentic and historically accurate.'[28] Historical settings were thus unable to provide immunity from censorship on their own, and as Custen notes, 'historically accurate facts had to be bent to conform to the Code's public notion of how history should be told.'[29] At the same time, it seems likely that historical settings did lead to greater leniency in the representation of material which the PCA deemed controversial. In dramas with contemporary settings, such as RKO's *Of Human Bondage* (1934) and United Artists' *Dead End* (1937), references to sexually transmitted diseases were cut entirely, and the 'degeneracies' which were thought to characterize ancient civilizations would surely have been inconceivable in modern settings.[30]

In a smaller number of cases, censorship of historical cinema has occurred due to political and personal sensitivities surrounding events from the recent past. In 1934 the MGM film *Rasputin and the Empress* (1932) became the subject of a libel case in the English courts due to its implication that Princess Irina Youssoupoff, a white Russian exiled in London and the wife of one of Rasputin's murderers, had been seduced by the 'Mad Monk.' MGM eventually paid damages of more than $700,000 and the offending subplot was excised completely from the film.[31] The case established a legal precedent for historical films as forms of slander and, according to Natalie Zemon Davis, led to the widespread adoption of the disclaimer 'any similarity to actual persons, living or dead, is purely coincidental'—even in films where

[25]Quoted in David Eldridge, "Hollywood Censors History," *49th Parallel,* 20 (2006): 4.

[26]Quoted in Doherty, 353.

[27]Eldridge, "Hollywood Censors History," 5.

[28]Quoted in Ibid., 11.

[29]Custen, 141.

[30]Gregory D. Black, *Hollywood Censored: Morality Codes, Catholics, and the Movies* (Cambridge: Cambridge University Press, 1994), 297, 299.

[31]Mark A. Vieira, *Irving Thalberg: Boy Wonder to Producer Prince* (Berkeley: University of California Press, 2010), 197.

this was manifestly not the case.[32] During the same period, the topicality of gangster films such as *The Public Enemy* (1931) and *Scarface* (1932) also proved problematic and films were transformed by censors long before they reached the public. The PCA's concerns stemmed in part from the apparent glamorization of criminal lifestyles, but they also reflected political anxieties about the government's response to organized crime. Correspondence warned producers at Warner Bros. of 'the grave danger of portraying on the screen actual contemporary happenings' if they concerned the failure of political or legal systems in dealing with crime.[33] According to Smyth, filmmakers were thus obliged to play down the historical dimensions of the gangster cycle. Early screenplay drafts indicate that *Scarface* 'began as a rigorously historical film' which documented the rise of Al Capone, but under PCA pressure writers subsequently adopted elements of fiction to disguise its factual basis.[34] In the completed film, a text prologue bluntly instructs the audience in the correct meaning of the narrative: *Scarface* is 'an indictment of gang rule in America and of the callous indifference of the government to this constantly increasing menace to our safety and liberty.' But if the disclaimers used in the wake of *Rasputin and the Empress* attempted to distance the narratives of historical films from actual events, the *Scarface* prologue serves to emphasize the reality of the world depicted on screen. In this engagement with history, the prologue undoes the elements of fiction worked into the screenplay and appears to contravene the wishes of the PCA.

Political concern over the impact of Hollywood's historical cinema was also felt in the international market, particularly Britain. The UK and its overseas territories made up Hollywood's largest export market for much of the twentieth century, and although Hollywood companies were under no obligation to cooperate with the dictates of British censors, it was often expedient to do so. As the British Government struggled to maintain the prestige of Imperial rule in the face of internal and external conflict, historical representations of the British Empire in Hollywood films began to generate anxiety. In 1930 the British Board of Film Censors instituted a ban on films depicting 'the degradation of white men in Far Eastern and native surroundings.'[35] The dictates regarding films imported to Britain's colonies were even stricter; the government of Trinidad sought to ban films which implied any criticism of British institutions or social customs, and the 1930 film *The Green Goddess*, which depicted a sinister raja seeking revenge on British travelers, was kept

[32] Davis, 457.
[33] Quoted in Smyth, 80.
[34] Smyth, 79.
[35] Quoted in Vasey, 149.

away from British territories in Asia. As Vasey has argued, impediments such as these inevitably made an impact on Hollywood's representation of Empire, binding American film producers to 'tacit, if not active, compliance with British notions of global white supremacy.'[36] Perhaps ironically, representations of Empire which actually maintained the impression of British supremacy also proved problematic, particularly as resistance to British colonial rule gathered momentum. The release of the British-made imperial drama *The Drum* (1938) provoked violent unrest among Indian nationalists following its release in Bombay.[37] The following year, the British colonial administration blocked the distribution of RKO's *Gunga Din* within many Indian provinces, fearing that its pro-Empire stance would generate further popular agitation.[38] Historical films have perhaps faced fewer censorship restrictions than many other filmmaking genres, but local and foreign censors nevertheless kept Hollywood's representations of the past in check during the 1930s and early 1940s. Prestigious historical settings did not exempt films from the dictates of the Production Code, and depictions of the recent past—in America, Europe, or in Britain's overseas territories—were fraught with political sensitivities which often worked against their engagement with the past.

Cultural sensitivities

As the British response to Hollywood's 1930s Empire cycle indicates, there is a long history of British discomfort at American representations of its past. According to C. A. Lejeune, writing in 1922, 'the American mind cannot fully embrace the spirit of the past and an American talent cannot reproduce it.. By contrast, she went on, the British

> grow up... with some ideal for which "the past" is a label – something which brings to us serene pleasure, a little pathos, a dash of mystery, and an escape from life; something almost worshipful, with the dignity that comes of age.[39]

Three years later the *Daily Mail* took offense at the anachronistic furniture featured in the Tudor-era Mary Pickford film *Dorothy Haddon of Vernon Hall* (1924), declaring, 'the case against the foreign film is, in fact... that it is

[36] Vasey, 151.
[37] Chowdhry, 57.
[38] Ibid., 180–1.
[39] C.A. Lejeune, "The Week on Screen: Out of the Past," *Manchester Guardian*, July 1, 1922, 9.

an attack on the English soul.'[40] Of course, Britain was not the only nation during this period to express concern about Hollywood's carefree and disconcertingly popular approach to its national history. In 1923 an attaché of the French Ministry of Public Education addressed the International Congress of Picture Producers in New York to urge Hollywood studios to cease adaptations of French historical novels, declaring that it was 'almost impossible for a foreigner to get the true significance of historical facts of a nation.'[41] The appropriation and representation of national history was also debated at the 1926 International Kinematograph Congress in Paris. A proposal preventing historical events from being filmed outside 'the country in which they took place' was ultimately rejected in favor of a resolution requiring accuracy in historical films more generally.[42] These anxieties can be seen in the context of a broader concern regarding Hollywood's expansion into the European film markets during the 1920s, but the fact that arguments coalesced around the issue of historical cinema serves to highlight the national sensitivities which have been associated with the genre.

British sensitivities came to the surface once again in the period following World War II as representations of the allies' wartime experiences began to offer conflicting messages. The 1945 Warner Bros. film *Objective Burma!* became a particularly significant flashpoint. Based on the Allied Campaign in Burma and filmed very shortly after its completion, *Objective Burma!* was subjected to sustained criticism in the British media due to its focus on American troops at the expense of British and Indian soldiers. The film's opening narration made passing reference to General Wingate, who led British operations in the region, and the epilogue text included a dedication to 'the men of the American, British, Chinese and Indian armies,' but for many British viewers the film gave the impression of an American-led military victory. As an editorial in *The Times* put it, the film 'leaves the audience to draw the conclusion that the Burma campaign was fought exclusively by American troops.'[43] In fact, *Objective Burma!* had become controversial several months before it reached Britain. In a letter to a military newspaper an American veteran of the campaign noted that Americans 'were in the minority' in Burma and described the film as 'meretricious' and 'a travesty of truth.'[44] As Ian *Jarvie* has shown, subsequent accounts have tended to exaggerate the press campaign against *Objective Burma!* Nevertheless, the *Evening Standard*, the *Sunday Express*, and the *Daily Mirror* all called for the film to

[40] Quoted in "Balm for the English Soul," *Washington Post*, May 2, 1925, 6.

[41] "Gives Answer to Film Critic," *Los Angeles Times*, June 9, 1923, II8.

[42] "The Delicate Question of Nationality," *Manchester Guardian*, October 1, 1926, 11.

[43] "Films and the Allies," *The Times*, September 25, 1945.

[44] Quoted in I. C. Jarvie, "Fanning the Flames: Anti-American Reaction to *Objective Burma!*" *Historical Journal of Film Radio and Television* 1/2 (1981): 123.

be withdrawn following its release in London.[45] Perhaps most forcefully, a *Daily Mirror* editorial cartoon featured a stereotypical Hollywood mogul sitting on the graves of British soldiers, which were marked 'Britain's Sacrifice for World Freedom.'[46] In the face of such bad press and amid rising anti-American feeling against Hollywood war films generally, Warner Bros. withdrew the film from British cinemas just one week into its release.[47] However, as Chapman and Cull have argued, the British response seems excessive in hindsight: American units were in fact active in Burma, and 'far from suggesting that the US Army won the war in Burma the film focuses on a single patrol with limited tactical objectives.'[48] To a large extent, perhaps, these negative responses can be attributed to the manner in which the film contradicted Britain's preferred historical narrative for World War II. Instead of showing Britain 'standing alone' against the Axis powers, the nation's role is supplanted by America.

Fifty years later, the re-emergence of the Hollywood World War II combat film indicated that British sensitivities around the conflict were very much alive. Many commentators noted the exclusion of British, Commonwealth, and French forces from the D-Day landings depicted in *Saving Private Ryan* (1998), although the film was very successful in the UK, while *Pearl Harbor* (2000) drew stronger criticism for inserting its American protagonist into the Battle of Britain. According to the *Guardian* reviewer, 'if you thought that the war in the Pacific would be one World War II story which didn't need to take time out to patronise the Brits, you were wrong.'[49] However, the strongest complaints were directed at *U-571* (2000), which depicted the capture of an Enigma code machine from a German U-boat in 1942. The narrative has its basis in the Allied capture of the Enigma machine, but the British naval officers involved in the incident were replaced by fictional American characters. More to the point, the historical operation had occurred seven months before America joined the war.[50] The irony of the film's tag line 'Nine ordinary men are about to change history,' was perhaps unintended.[51] The controversy quickly reached Britain's highest office. Five days after its release, Tony Blair gave his support to a statement (made in the House of Commons by Brian Jenkins MP) describing the film as 'an affront to the memory of the British sailors who lost their lives in this action.'[52] Britain's Culture Secretary Chris Smith offered to 'raise the issue in Hollywood,' adding,

[45] Ibid., 126.

[46] Ibid., 135.

[47] Ibid., 125.

[48] Chapman and Cull, 59.

[49] Quoted in Trevor B. McCrisken and Andrew Pepper, *American History and Contemporary Hollywood Film* (Edinburgh: Edinburgh University Press, 2005), 106.

[50] Ibid., 105.

[51] This tag line can be read on the case of the 2001 Region 2 DVD edition of the film.

[52] *Hansard HC Deb*, June 7, 2000, vol. 351, col. 283.

I think one of the things we need to make clear to Hollywood is, yes you're in the entertainment business but people see your movies, they're going to come away thinking that's information not just entertainment. You've got to make it clear where the dividing lines between these things lie.[53]

To a certain extent the producers of *U-571* were able to respond to the criticisms made in Britain, and like many historical films the epilogue text provided space for the film to recalibrate its relationship to the past. Following a dedication to all Allied sailors involved in the Battle of the Atlantic, the text states:

May 9, 1941. Enigma machine and coding documents captured from U-110 by HMS Bulldog and HMS Aubretia of the 3rd Escort Group, Royal Navy.

October 30, 1942. Short weather cipher captured from U-559 by HMS Petard of the Royal Navy.

June 4, 1944. Enigma machine and coding documents captured from U-505 by US Navy Task Force 22.3.

In its closing moments, then, the film's events are contradicted by an alternate time line in which the centrality of the British Navy is emphasized and perhaps contrasted with the lesser role played by US forces. The advent of home media also gave the film's producers the opportunity to address some of the issues raised in the film's reception. The UK DVD edition, released in January 2001, includes an interview with the Royal Navy Lieutenant Balme, who led the capture of the real Enigma machine in 1941. Like the epilogue text, Balme narrates a version of events significantly at odds with those presented in the film. *U-571* was not withdrawn from release, but it is perhaps unique among historical films in the extent to which it acknowledges its own departure from past events. Historical films evidently have the capacity to provoke ill feeling among certain audiences if they are perceived to engage with the past in a way which infringes on accepted national historical narratives. The examples cited here concern Britain and the dynamics of the Anglo-American relationship, but audiences and governments in many other nations have been similarly affronted by representations in Hollywood historical films. However, not all nations succeeded in having their complaints answered directly by American studios.

[53] "U-Boat Film an 'Affront', says Blair," *BBC News*, last modified June 7, 2000, http://news. bbc. co.uk/2/hi/uk_news/781858.stm.

History in the classroom

At first sight, the consistent association of historical cinema with education appears to confirm the genre's privileged cultural status. However, the classroom has proven to be another battleground in which the value of the historical film has been contested. In cinema's early years the educational prospects for films of this type seemed positive. In 1914 an article in the *Washington Post* stated:

> What educators regard as the most valuable post graduate course in history ever presented is being offered to the public night after night in the form of moving pictures... Anyone who has ever seen one of these films will readily agree that the impression they leave is far more vivid and lasting than that derived from any amount of historical reading.[54]

The following year, while promoting his film *The Birth of a Nation* (1915), D. W. Griffith asked readers to imagine a library of the future in which films had taken the place of books:

> Suppose you wish to 'read up' on a certain episode in Napoleon's life. Instead of consulting all the authorities, wading laboriously through a host of books... you will merely seat yourself at a properly adjusted window, in a scientifically prepared room, press the button and actually see what happened. There will be no opinions expressed. You will merely be present at the making of history. All the work of writing, revising, collating and reproducing will have been carefully attended to, by a corps of recognized experts, and you will have received a vivid and complete expression.[55]

The notion that historical films 'express no opinions' seems extraordinary, particularly in connection with a film as brutally flawed as *The Birth of a Nation*, but Griffith's remarks point to an optimistic faith in in the elevating potential of the genre and its ability to make the past accessible to audiences more at home with images than words.

During the 1930s, as the Hollywood studios endeavored to raise the cultural profile of the industry, it became expedient to extend the promotion of historical cinema into American classrooms. To some extent these efforts can also be linked to a broader movement of 'film education' intended to

[54] "How the Moving Pictures are Making the Past Live Again," *Washington Post*, March 15, 1914, M6.
[55] Quoted in Harry M. Geduld (ed.), *Focus on D. W. Griffith* (London: Prentice Hall, 1972), 35.

refine the tastes of young audiences.[56] In 1935 Paramount marketed Cecil B. DeMille's *The Crusades* by sponsoring college scholarships for high school students who produced the best art work inspired by the 'historical era of the medieval crusades.' Competitors were advised to see the film 'twice if you can.'[57] However, the most common strategy used to sell films of this type in schools involved the production of tie-in educational material which could be distributed nationally to classrooms. Promotional materials for *A Midsummer Night's Dream* (1935) reported that Warner Bros. had produced half a million study guides and teachers' manuals in association with the MPPDA and offered them to schools priced at a dollar for 30.[58] In addition to study guides, historical films themselves were prepared for classroom use. DeMille's *The Plainsman* (1936) was distributed to schools in an abridged, 16mm version re-titled 'The Valor of the Plains' and accompanied by a study guide. According to Paramount it was 'the first educational film to be produced by a major studio for distribution to schools.'[59] The apparent success of the film led Paramount to abridge other historical films from their archives: *Maid of Salem* (1936) was re-edited as two separate classroom films, the historical musical *High, Wide and Handsome* (1937) was transformed into a history of oil-pipelines, and *Wells Fargo* (1937) was used as the basis for a 'history of communication in the United States.' For the latter two projects Paramount reportedly received assistance from the University of Chicago.[60] The process of educational abridgment was taken even further by a company named Pictorial Events Films, who worked with Warner Bros. to transform historical films into classroom slideshows. According to promotional materials advertising their adaptation of *A Dispatch from Reuters* (1940), the classroom kit contained a prewritten historical lecture with 50 stills from the film to illustrate and accompany it.[61] Materials produced for use in schools remained part of the promotional process during the roadshow era – MGM advertised their school guide for *Ben-Hur* (1959) as 'one of the most complete pamphlets of its kind ever produced.'[62] As James Russell suggests, extra-textual resources of this type not only acted as advertising but were intended to determine 'the context in which these films were supposed to be experienced.'[63]

[56] Janet Staiger, "The Revenge of the Film Education Movement: Cult Movies and Fan Interpretive Behaviours," *Reception: Texts, Readers, Audiences History* 1 (2008): 47–9.
[57] "The Cinema Sponsors Drive for Scholarships in High School," *Washington Post*, August 4, 1935, 3.
[58] *A Midsummer Night's Dream* Pressbook, Pressbook Collection. BFI National Library, London.
[59] Quoted in Wagner, 222.
[60] Robert Joseph, "A Jester in Hollywood," *New York Times*, October 29, 1939.
[61] Custen, 13–14.
[62] Quoted in Russell, *Past Glories*, 65.
[63] Ibid., 66.

As these examples indicate, the use of historical cinema in schools during this period was led by the promotional activities of the Hollywood studios, who were eager to expand their audience and to refine the public image of the industry as a whole. By contrast, the use of historical cinema in higher education has generally been associated with innovative teaching practices rather than the publicity initiatives of the film industry. In 1934 a British MP from the Board of Education echoed Griffith's vision of a bookless library by predicting that 'every university will have, as an essential part of the equipment of its historical faculty, a film studio.'[64] As it transpired, historical films did not enter university curricula on a systematic basis until the early 1970s, and the emphasis was very much on the study rather than the production of films in the genre. In 1974 Sheldon Harris, a professor at the California State University Northbridge History Department, was twice featured in the *Los Angeles Times* when he announced a course titled 'Hollywood in American History.'[65] Harris's course involved the study of films such as *The Birth of a Nation*, *The Grapes of Wrath* (1940), and *Bonnie and Clyde* (1967) in relation to the eras which they depicted, as well as to the contemporary cultures in which they were produced. However, alternate practices also emerged during the same period. Writing in 1976, Arthur Marwick examined the 'integration of film into the mainstream of historical study' at several universities in Britain and America.[66] In contrast to the methods endorsed by Harris, however, Marwick argued against the study of films on their own terms as representations of historical events, stating that films are 'most certainly unsuited to complex historical analysis.' Instead, the university courses in his survey tended to approach films as aesthetic artifacts reflecting the cultures which produced them.[67] A more recent survey, published by the newsletter of the American Historical Association, indicated that screening and analyzing films as symptoms of historical processes rather than works of history in their own right had become widespread among history educators at American universities.[68]

As new technologies simplified the exhibition of films in classrooms, historical films have continued to play a significant role in history education. In the process, a body of academic work specifically engaging with the

[64] "Films to Teach History," *Manchester Guardian*, April 17, 1934, 8.

[65] Donne Scheibe, "Class Will Use Movies to Help Dramatize History," *Los Angeles Times*, August 25, 1974, B1; William Trombley, "Movies Give Students Window to the Past," *Los Angeles Times*, October 8, 1974, C1.

[66] Arthur Marwick, "Film in University Teaching" in Paul Smith (ed.), *The Historian and Film* (Cambridge: Cambridge University Press, 1979), 143.

[67] Ibid., 153.

[68] Kathryn Helgesen Fuller, "Lessons from the Screen: Film and Video in the Classroom," *Perspectives*, last modified January 24, 2008, http://www.historians.org/ perspectives/ issues/1999/9904/9904FIL3.CFM.

educational uses of historical cinema has emerged. In a book entitled *Teaching History on Film*, Alan S. Marcus et al. recommend education in what they call 'historical film literacy': the use of historical films not simply as a means to illustrate past events, but to impart 'skills and dispositions that empower students to look at movies set in the past critically as historical documents.'[69] At the same time, the use of historical cinema in the classroom has remained closely linked to the promotional activities of Hollywood studios. In 1997 DreamWorks studios partnered the educational company Lifetime Learning Systems to produce a study guide for *Amistad*. Entitled 'Amistad: A Lasting Legacy', the guide was distributed to teachers in 20,000 American colleges and high schools.[70] As a promotional strategy this was hardly unusual, but the guide nevertheless generated significant controversy (largely outside the educational environment in which it was intended to be used) due to its apparent blending of the historical record with the film's dramatic constructions. Attention was drawn to an exercise in which students were asked to study a 'composite' character created for the film rather than one of the real African American figures involved in the incident, and to the fact that quotations attributed to John Quincy Adams derived from *Amistad*'s screenplay rather than his own writings or speeches. The guide was described as a 'distortion' by radio pundit Michael Medved and became the subject of a *New York Times* op-ed piece by Columbia University historian Eric Foner.[71] Foner argued that the study guide 'erases the distinction between fact and fabrication' and took particular offense to its implication that historians had previously neglected or misrepresented slavery in America.[72] Foner's article was titled 'Hollywood Invades the Classroom,' an indication of the hostility perceived by some in Hollywood's promotion of historical films in schools.

Criticisms of the *Amistad* guide were also made in two essays from a special supplement on *Amistad* in *The History Teacher*, the journal of the Society for History Education. Taking a different tack, schoolteacher Ronald F. Briley found that the guide overemphasized the present-day parallels of events depicted in the film at the expense of its representation of the past. Whereas other educators have promoted the analysis of films in terms of their contemporary resonances, Briley suggests that the emphasis in the classroom should be on historical films as history: 'the film's primary use,' he argues, should be as 'a vehicle for initiating student investigation and study

[69] Alan S. Marcus, Scott Alan Metzger, Richard J. Paxton, and Jeremy D. Stoddard, *Teaching History with Film: Strategies for Secondary Social Studies* (New York: Routledge, 2010), 6.
[70] John Horn, "Critics deride 'Amistad' study guide for use in classroom," *Daily Gazette* (Schenectady), January 4, 1998.
[71] Ibid.
[72] Eric Foner, "Hollywood Invades the Classroom," *New York Times*, December 20, 1997.

of the slave trade and slavery and their legacy for contemporary America.'[73] The British release of *Amistad* was accompanied by a completely different study guide prepared by Film Education, an educational charity which is not engaged directly by individual production companies. Perhaps due in part to the negative responses in America, the British guide is remarkably forthright about the limitations of the film as a work of history, stating: 'It is important to remember that films do not mirror reality. They re-create reality by presenting images. They are not history lessons.'[74] Other exercises actually foreground *Amistad*'s departures from the historical record, inviting students to compare and contrast excerpts from John Quincy Adam's original speeches with equivalent passages from the screenplay. Instead of asking students to study a fictional character, as the American guide had done, the British guide asks, 'Why do you think the screenwriter created this character?' More unusually still, perhaps, the guide contextualizes *Amistad* within modern historiography by suggesting that all forms of historical representation have the potential to be biased, misleading, and symptomatic of the present as well as the past: 'history presents a reconstruction of the past. The view of the past that emerges will depend on the selection and interpretation of sources and upon the beliefs and values of the historian'. Whereas the American study guide was criticized for its blending of fact and fiction, then, the British guide was careful to outline *Amistad*'s constructedness, and by extension the constructedness inherent to all representations of the past.

Hollywood historical films have long been associated with school teaching and to a lesser degree with university education, and to some extent this points to their privileged status in relation to other popular genres. This cultural status has certainly been the aspiration of film industry marketing departments, who have consistently used study guides and abridgments to promote historical films in classrooms, thereby attracting new audiences and establishing a scholarly context for their products. The issue of historical cinema's educational usefulness has nevertheless been hotly contested. The film industry discourse has attempted to position historical films in terms of their ability to narrate the past, but many educators and critics, both in universities and schools have favored approaches which position films as symptoms of the cultures which produced them and have been skeptical of material which takes them at face value.

The sense of prestige, moral elevation, and educational value which has been attached to historical films has, by and large, been generated within

[73] Ronald F. Briley, "The Study Guide *Amistad: A Lasting Legacy,*" *The History Teacher* 31/3 (1998): 393.

[74] "Amistad Study Guide," Film Education, accessed April 18, 2012, http://www.filmeducation.org/pdf/film/Amistad.pdf.

the film industry itself. The Academy Awards ceremony, Will Hays' advocacy work in the 1930s, and the production of educational study guides point to an ongoing public relations campaign to promote historical cinema as the pinnacle of the American film industry's seriousness and worth. However, responses to historical cinema outside this industrial context have been more complex. Historical films, even those garlanded at the Academy Awards, have not always been accepted on the same terms by film critics. In contrast to intellectual approaches to film within intellectual culture, the elevation of historical cinema reflects a traditional, middlebrow approach to art where significance and value derives from the subject matter rather than from independent aesthetic criteria. Historical films have also stirred controversy if they are perceived to disrupt nationalist narratives, and their place in the classroom has been a matter of dispute. And as the occasional impact of censorship demonstrates, the sense of privilege and exceptionalism enjoyed by historical films has been limited even within the film industry. Far from being secure, then, the cultural status of historical cinema has been the site of a constant struggle between film industry discourses and wider contexts of reception.

Conclusion: The role of the historian

In this book I have approached historical films in terms of the engagements they make with the past. By way of a conclusion, I will refine this focus slightly to examine the ways in which historical films have engaged with history as a profession and with historians as individuals. In this way I hope to reinforce some of the more general points I have made about the nature and the function of the historical film's relationship with history. As far as representation is concerned, historical films have tended to be hostile or at best indifferent to working historians. The academic historian is supercilious and arrogant in the frame story of *Little Big Man* (1970), experiencing a mid-life crisis as his historical research is adapted for the screen in *Sweet Liberty* (1986), and rudely interrupted by a lance through the chest in *Monty Python and the Holy Grail* (1975). As Dana Polan has noted, 'history professors are judged against a world of active doing and found wanting.'[1] Even Professor Indiana Jones, by far the most glamorous and heroic scholar yet to be depicted in a Hollywood film, comes into his own only when he changes his tweed jacket for leather and puts his unconventional brand of archaeology into practice. Within the context of film production, however, academic historians are frequently involved in 'active doing' in one way or another: as technical advisors, as critics providing scholarly evaluations, and as elements in the promotional discourses created as historical films are bought to the marketplace.

In the early years of American filmmaking, any necessary historical research was conducted on an *ad hoc* basis. Actress Dorothy Gish, who worked with D. W. Griffith at Biograph studios from the early 1910s, claimed that 'we used to do our own research. We went down to the public library and looked up what we wanted.'[2] According to Bordwell, Staiger, and Thompson the first dedicated historical research staff emerged during mid-1910 in the form of

[1] Dana Polan, "The Professors of History" in Vivian Sobchack (ed.), *The Persistence of History: Cinema, Television and the Modern Event* (London: Routledge, 1996), 249.
[2] Quoted in Kevin Brownlow, *The Parade's Gone By...* (Berkeley: University of California Press, 1996), 243.

'technical experts' who specialized in archaeology. By the end the decade experts of this type were beginning to lead in-house research departments and to curate studio-wide libraries of research materials.[3] However, David Eldridge has pointed to the limitations of what he calls the 'institutionalised research culture' which existed during the studio era.[4] Their primarily purpose, he argues, was to assemble visual reference materials for the production design team and to highlight inaccuracies or anachronisms in screenplays and mises en scène. The work of studio research departments was thus 'reactive and service orientated, rather than pro-active and critical,' and researchers were not expected to assess the relative validity of sources or to interpret the information they gathered.[5] As such, the role tended to be free of the rigors associated with history as practiced in an academic context. Tellingly, a 1953 career guide (uncovered by Eldridge) indicated that the best training for those wishing to enter a studio research department would be librarianship rather than higher education.[6]

Although studio research departments took responsibility for historical inquiries on a day-to-day basis during the 1930s, academic historians were nevertheless drawn to the industry. In 1935 an article in the Los Angeles Times wryly commented on the elevation of academic advisors in the production (and the promotion) of MGM's Romeo and Juliet (1936):

> Whereas one good slightly used technical advisor, or at best two, used to suffice for even the most epic of epics, they now import a whole advisory board, whiskers and all, to sit in on script and set during production of anything that savors remotely of the classical... Not only has [Irving Thalberg] bought out Prof. William Strunk of Cornell to check up on the Bard, but also Prof. John Tucker Murray to check up on Prof. Strunk. Or vice versa. Or both. [7]

As Hollywood studios competed to assert the cultural value of expensive prestige films, the benefits provided by the association of prominent academics became clear. For this reason, suspicions persist that academic historians have been exploited by Hollywood filmmakers as a means to add legitimacy to their work and to act as a kind of intellectual insurance policy against external criticism. In her celebrated anthropological study Hollywood, the Dream Factory, originally published in 1950, Hortense Powdermaker

[3] Bordwell, Staiger and Thompson, 147.
[4] Eldridge, Hollywood's History Films, 138.
[5] Ibid., 131–8.
[6] Ibid., 131.
[7] Philip K. Scheuer, "Hollywood Imports College Professors as Film Experts," Los Angeles Times, August 4, 1935, A1.

observed that 'the position of the "expert" who is called in for temporary consultation on a picture is frequently like that of the artist. He is usually paid a high fee, and then very little or no attention is paid to his opinion.'[8] It has also been argued that the use of historians for limited periods, usually after work on the film has begun, allows them little opportunity to make meaningful contributions and confines their role to the affirmation of decisions which have already been made. As Eldridge has suggested, the role of technical advisor has tended to prioritize 'description and confirmation of visual details' and not the 'argument or interpretation' which is associated with academic history.[9]

A broader insight into the experiences of academics working as advisors for historical films is provided in their own written accounts of the process. Powdermaker's interpretation of the expert's role was disputed by P.M. Pasinetti, a professor of Italian at University of California, Los Angeles, who was hired to advise the production of *Julius Caesar* (1953). Writing in the *Quarterly of Film, Radio and Television*, Pasinetti dismisses as 'fiction' the suggestion that producers hire experts so they can feel 'protected' and to give their films the 'stamp of specialised approval,' and claims that the advisor is, 'in however, minor, indirect and peripheral a way,' intimately involved in the production of the film at hand.[10] In a similarly tentative vein, he continued:

> Of course it would be fatal for, say, a historian to think that a historical film is the place to apply the most delicate results of his scholarship; but it would be wrong for him to think that, as an expert, he will be confronted by uniformed people waiting to be enlightened by him. [11]

More recently, Howard Jones (University of Alabama) recounted his visit to the set of *Amistad* (1997) for the newsletter of the American Historical Association in glowing terms. Although he was yet to see the completed film, Jones noted with approval the director's constant interactions with historian Arthur Abraham (Virginia State University) and suggested that Spielberg 'wanted historians around to add authenticity to the production.'[12] Indeed, eleven scholars are thanked in the film's credits in addition to its five researchers.[13] Robin Lane Fox, Oxford historian and advisor to *Alexander*

[8] Hortense Powdermaker, *Hollywood, the Dream Factory* (London: Secker & Warburg, 1951), 27.
[9] Eldridge, *Hollywood's History Films*, 135.
[10] P.M. Pasinetti, "Julius Caesar: The Role of the Technical Advisor," *The Quarterly of Film, Radio and Television*, 8/2 (1953): 132.
[11] Ibid., 132.
[12] Howard Jones, "A Historian Goes to Hollywood: The Spielberg Touch," *Perspectives*, December 1997, http://www.historians.org/perspectives/issues/1997/ 9712/9712FIL.CFM.
[13] Julie Roy Jeffrey, "*Amistad* (1997): Steven Spielberg's 'True Story'," *Historical Journal of Film, Radio and Television*, 21/1 (2001): 81.

THE PRODUCERS WISH TO THANK THE FOLLOWING:
DR. LERONE BENNETT, PROFESSOR HENRY LOUIS GATES, JR.,
PROFESSOR JOHN HOPE FRANKLIN, PROFESSOR GLENDA DICKERSON,
PROFESSOR HOWARD JONES, PROFESSOR ELEANOR TRAYLOR,
DR. LESTER P. MONTS, PROFESSOR DOMINIQUE SPORTICHE,
PROFESSOR REBECCA SCOTT, PROFESSOR JOSEPH E. HARRIS,
PROFESSOR EDWARD REYNOLDS,
LESLEE FELDMAN - DREAMWORKS CASTING

THE CITY AND PEOPLE OF NEWPORT, RHODE ISLAND
PRESERVATION SOCIETY OF NEWPORT COUNTY
THE NEWPORT CHAMBER OF COMMERCE

THE MYSTIC SEAPORT MUSEUM -
HOME OF THE AMISTAD AMERICA PROJECT
THE LEGACY OF THE AMISTAD INCIDENT
LIVES ON THROUGH THE WORK OF AMISTAD AMERICA,
NOW BUILDING A REPLICA OF THE SCHOONER AMISTAD AT
MYSTIC SEAPORT IN MYSTIC, CONNECTICUT

FIGURE 7.1 *Roll call of historians credited in* Amistad *(1997)*

(2004), was remarkably positive about both the film and the extent of his contribution to it in an interview for *Archaeology* magazine. Praising the film's 'density of historical allusion, and reference' he asserted (correctly, I think) that no previous historical advisor had ever had a 'such a role in a film.'[14] The author John Matthews described his experiences as on-set historical advisor for *King Arthur* (2004) in a medievalist academic journal, but was more cautious about his practical influence on set, writing, 'I found that I could look at every aspect of production and comment on them. I also found that my comments were not only listened to, but in many cases acted on.'[15] The fact that these articles and interviews were published in specialized film and historical journals makes it difficult to dismiss them as the products of studio publicity departments.

These broadly positive testimonies are balanced by accounts which suggest less favorable working conditions for academic historians. Two prominent historians hired by John Wayne to advise him for *The Alamo* (1960) reportedly left the project 'in disgust at the historical liberties being taken' and asked for their names to be removed from the credits.[16] In more recent years, several historical advisors have been contacted by journalists apparently

[14] "Riding with Alexander," Archaeology, September 14, 2004, www.archaeology.org/ online/ interviews/fox.html. Lane Fox was also the author of the 'making of' book published to tie in with the film: *The Making of Alexander: The Official Guide to the Epic Alexander Film* (R & L: Oxford, 2004).

[15] John Matthews, "A Knightly Endeavor: The Making of Jerry Bruckheimer's *King Arthur*," *Arthuriana*, 14/3 (2004): 114.

[16] Frank Thompson, "Getting it Right: The Alamo on Film" in James M. Welsh and Peter Lev (eds), *The Literature/Film Reader: Issues of Adaptation* (Lanham: Scarecrow Press, 2007), 299.

eager to stir-up scandal and to debunk the historical value of films prior to their actual release. Jack Green, curator of the Naval Historical Center and advisor for *Pearl Harbor* (2001), appeared to distance himself from the production by emphasizing his powerlessness, saying, 'It's their movie, it's not mine, I was purely an advisor... They could take my advice or not, and that's the way it was.'[17] Anthropologist Richard Hansen, who served as an advisor on Mel Gibson's *Apocalypto* (2006), was quoted expressing his disappointment at the way the film depicted the Mayas as 'bloodthirsty savages' while downplaying their cultural achievements.[18] The *Financial Times* reported that the historical advisor for *Gladiator* (2000) was 'appalled by Hollywood methods,' adding, 'one message from the production office said: "Kathy, we need to get a piece of evidence which proves that women gladiators had sharpened razor blades attached to their nipples. Could you have it by lunchtime?"'[19] The advisor in question was Kathleen M. Coleman, a Classics professor at Harvard. She later gave her own assessment of the historical advisor's role, and although she tactfully makes no mention of her own experiences with *Gladiator* her frustrations with Hollywood's approach to history in general are evident. She argues that historians should be used throughout the pre-production and production processes, and not simply on a piecemeal basis to legitimize artistic decisions retroactively. 'The consultant's advice,' she avers, should not be treated 'like a buffet supper from which one guest might select five dishes and someone else three entirely different confections.'[20] Coleman was also critical of the notion that the 'hiring of a consultant is in itself sufficient to give a film a veneer of respectability,' describing the use of academic personnel in such a way as 'unethical.'[21]

Over the past ten years a small number of Hollywood films have called on historians not simply to provide advice during the production stage but to contribute scholarly evaluations of films after their completion. In particular, these evaluations have been presented as part of the range of supplementary materials which commonly accompany 'special edition' home media packages. Oliver Stone's *Alexander* (2004) may be viewed with a commentary track featuring Oliver Stone and Robin Lane Fox, and it is possible to watch *The Passion of the Christ* (2004) accompanied by Mel Gibson and no fewer than three Catholic theologian commentators. A

[17] Bob Strauss, "Reelism: 'Pearl Harbor' Accuracy Questioned," *Seattle Post-Intelligencer*, May 22, 2001, E4.
[18] Robert W. Welkos, "In 'Apocalypto,' fact and fiction play hide and seek," *Los Angeles Times*, December 9, 2006.
[19] David Winner, "A Blow to the Temples," *Financial Times,* January 28, 2005.
[20] Kathleen M. Coleman, "The Pedant Goes to Hollywood: The Role of the Academic Consultant" in Marvin M. Winkler (ed.), Gladiator: Film and History (London: Blackwell, 2004), 47.
[21] Ibid., 48.

small but growing number of historical film DVDs also feature supplemental documentaries in which historians directly address issues of historical representation, sometimes in association with the film's creative personnel. For example, the *300* (2006) special edition DVD features a documentary entitled 'The 300: Fact or Fiction', a name which might initially raise eyebrows given the film's highly stylized depiction of the Spartan war with Persia. However, the documentary examines the film not in terms of its historical fidelity but as part of a tradition of creative representation. As Victor Davis Hanson (California State University, Fresno) affirms, 'the film adaptation is consistent with a long line of interpretation of the battle of Thermopylae, whether it is novelists in the nineteenth century, vase painters in the fourth century or Herodotus in the fifth century. Hanson is joined by author Bettany Hughes, and in separate interviews they endorse many of the creative decisions taken by the filmmakers which had been ridiculed elsewhere. Hanson argues that the decision to dress the Spartan soldiers in leather underpants rather than armor is a means to convey their physical skill, and that the presence of an attack rhinoceros among the Persian troops relates to the Greek perception of Persians as foreign, savage, and incomprehensible. He also points out that 'much of the dialogue is from Herodotus.' Hughes argues that the decision to portray Persian soldiers as supernatural and demonic is a reflection of Spartan beliefs about their enemy, and that the depiction as Ephialtes as a deformed hunchback might be thought to reflect his unfavorable characterization by Greek historians. The academic evaluation provided by the documentary thus legitimizes the filmmakers' creative interpretation of the past by contextualizing it within a longer tradition of representation.

Kingdom of Heaven (2005), another film which generated controversy due to its depiction of the past, also draws on the evaluation of academic historians for its 'Definitive Edition' DVD. Among others, Hamid Dabashi (Columbia University) and Nancy Caciola (University of California, San Diego) are interviewed for a documentary entitled 'Creative Accuracy: the Scholars Speak.'[22] Much more than the *300* documentary, these historians do raise criticisms of the film, particularly its treatment of religion and the idea that the central character, Ballian, would believe that all religions should be treated equally. As Caciola puts it, 'the scriptwriters have taken some sort of artistic license here.' But on the whole their testimony is positive. Dabashi accounts for anachronisms present in the text by describing the film as being 'located between history and contemporary issues' and 'a work of art that reflects

[22] Dabashi was in fact among the harshest academic critics of *300*, which was released two years later. See "The '300' Stroke," *Al-Ahram*, last modified August 2, 2007, http://weekly.ahram.org.eg/2007/856/cu1.htm.

the particular anxieties of the artist in 2005.' In fact, the strongest criticisms in the documentary are made by the film's screenwriter, William Monahan, who complains about studio pressure to humanize the characters by giving them contemporary ideas and attitudes. This is followed by a comment from Caciola in which she notes the dramatic need to create sympathetic characters and states that as a medieval historian she is unlikely to be fond of the medieval people she studies were she able to meet them. To a surprising extent, perhaps, the historians featured in these supplementary documentaries are eager to approach the historical films not in terms of their accuracy or authenticity, but as creative representations of the past inflected by the contemporary culture which produced them. It is worth pointing out, however, that the DVD materials mentioned here represent a highly controlled and potentially selective use of the evaluations made by historians. The production teams responsible for assembling the DVD packages have ultimate control over which scholars are selected to speak and the way in which their interviews are edited. It might also be noted that the historians speaking on the commentary tracks mentioned above only do so while accompanied by the directors of the respective films. On the other hand, it seems remarkable that these evaluative documentaries and commentaries exist at all. *Alexander*, *300,* and *Kingdom of Heaven* were (more or less) popular films produced and promoted in accordance with the conventions of a well-established filmmaking cycle and the appraisal and approval of academic historians seem "largely" incidental to their commercial success or failure.

Academic historians have never been absolutely central to the production of historical films, but the ways in which they have been used and the experiences they have recorded provide a valuable insight into the relationship between films and history. Arguments have been made about historians functioning as a kind of promotional window-dressing intended to emphasize engagements with the past, or as a means to deflect criticisms regarding fidelity. In the cycle of ancient world epics from the early 2000s in particular, the showcasing of high-profile historians seems to have been a fashionable and even necessary means to legitimize historical content. It is also possible that the use of historians on a temporary, selective basis reduces the value and impact of their advice. At the same time, there can be little doubt that the work of academic historians has had a direct impact on the content of historical films over the years, either directly in the form of guidance solicited from advisors, or indirectly through the consultation of published research. What historians have been unable to do, however, is to act as gatekeepers for the representation of history or to insert themselves forcibly into the creative filmmaking process. Something along these lines was proposed in a 1937 report from the British Film Institute, which recommended that 'a competent

historian should be called in for consultation before production' to confirm whether historical films were 'likely to be reasonably accurate.'[23] But to give historians this degree of editorial control in film production or to require their approval of individual films prior to their release would surely amount to a form of censorship. To repeat historian Robert Rosenstone's views on the matter,

> Film is out of the control of historians. Film shows we do not own the past. Film creates a historical world with which books cannot compete, at least in terms of popularity. Film is a disturbing symbol of an increasingly postliterate world.[24]

Or, as the filmmaker John Sayles has put it, 'if historical accuracy were the thing people went to the movies for, historians would be the vice presidents of studios.'[25]

Throughout this book I have sought to determine the various ways in which films have engaged with the past, to survey their development over time, and to establish the ways in which these engagements have shaped practices of film promotion and reception. As I have shown, the historical film has been absolutely central to the business operations of the American film industry over the past hundred years, attracting a large proportion of its investments and generating a correspondingly large proportion of its revenues. Over decades of technological innovation, industrial restructuring and the revision of Hollywood's relationship with its audience, the popularity of the historical film has been constant. In addition, historical films have frequently reflected broader cultural and historical trends, offering both intentional and unintentional commentaries on the cultures which produced them. I have also suggested that the process of constructing a relationship with history may form the basis for a fruitful definition of a historical film genre. Approached in this way, the historical film emerges as a genre of immense and sprawling proportions, but this conceptual breadth serves to underline the sheer number and the variety of films which have in some way constructed a relationship with history. For much of its life, the historical film has also been associated with debates concerning the suitability of the film medium as a vehicle for historical narrative, and the cultural value of the genre more generally. However, questions about the authenticity, accuracy, and artistic seemliness of historical films tend to be less productive than questions about how and why they have engaged with the past and the ways in which the

[23] "Travesties of History," *Manchester Guardian*, May 6, 1937, 13.
[24] Rosenstone, *Visions*, 46.
[25] Quoted in Carnes, *Past Imperfect*, 22.

filmgoing public has responded to them. The manner of these engagements and responses has developed rapidly over time and will no doubt continue to do so, adding new dimensions to the relationship between the past and the popular understanding of it. In this respect, the historical film continues to be a fascinating area for study.

Annotated guide to further reading

These ten monographs and five edited collections include some of the most useful and accessible scholarship recently published on Hollywood historical cinema.

Monographs

Robert Burgoyne, *Film Nation: Hollywood Looks at US History* (Minneapolis: University of Minnesota Press, 1997).
Burgoyne's valuable book examines representations of American history produced in Hollywood in the 1980s and 1990s from a theoretical viewpoint, arguing that his selection of historical films creates a 'counter-narrative of nation.' Case-study chapters address films including *Glory* (1989), *JFK* (1991), and *Forrest Gump* (1994). A second edition was published in 2010, adding new essays which apply his original thesis to more recent films including *The New World* and *Gangs of New York*.

Robert Burgoyne, *The Hollywood Historical Film* (Oxford: Blackwell, 2008).
Burgoyne's second book on Hollywood historical filmmaking benefits from a broader perspective on the subject which also addresses non-American history, although the focus remains on relatively recent productions. Introductory chapters identify and survey a range of historical film 'subtypes' which are then illustrated by a series of well-argued case studies based on individual films. The chapters on *Saving Private Ryan* (war film) and *JFK* ('metahistorical film') are particularly useful.

George F. Custen, *Bio/Pics: How Hollywood Constructed Public History* (New Brunswick: Rutgers University Press, 1992).
Although this book covers a relatively short period (1927–60) it remains the definitive work on the Hollywood biopic. Custen's broad definition of the genre and detailed archival research leads into a politically astute

discussion regarding the construction of 'public history' in Hollywood films. His arguments are deepened by his extensive and wide-ranging survey of biopic production in which fruitful connections are established between well-known Oscar-winning films and comparatively obscure productions.

David Eldridge, *Hollywood's History Films* (London, I. B. Tauris, 2006).
The title is slightly misleading as this is a book about the historical film in the 1950s. Nevertheless, Eldridge engages with such a broad range of important conceptual issues that this hardly seems a limitation. Rather than the case-study approach favored by the majority of writers on the subject, Eldridge aims to be comprehensive and draws on extensive archival research to trace patterns across an enormous range of films. The chapters on 'Thrill History,' regarding the role of spectacle and technology in history films, and 'Researching History,' which examines the role of the historical advisor, are especially valuable.

Marnie Hughes-Warrington, *History Goes to the Movies: Studying History on Film* (Abingdon: Routledge, 2007).
Hughes-Warrington's book surveys much of the most interesting work on historical cinema while also breaking new ground, producing a thoughtful and original consideration on the relationship between film and history. Unlike most historians who have written on the subject, she draws on film studies as well contemporary critical theory and scholarship from her own field. The chapter 'Selling History,' which examines promotional discourses generated by historical films, is particularly useful.

Robert A. Rosenstone, *Visions of the Past: The Challenge of Film to Our Idea of History* (Cambridge: Harvard University Press, 1995).
Rosenstone's seminal book has done much to promote serious study of films as works of historical representation and provides a useful theoretical model for doing so. A collection of thematically connected essays, the strongest chapters make a cogent case for the reappraisal of film as a form of history. In contrast to the majority of the books on this list, he draws on examples from cinema cultures around the world and not simply from Hollywood.

Robert A. Rosenstone, *History on Film/Film on History* (Harlow: Pearson Educational, 2006).
Rosenstone's follow up to *Visions of the Past* collects his subsequent contributions to the subject, most of which are published elsewhere. Among others, chapters addressing the films *October, Glory* and the historical cinema of Oliver Stone augment and expand his original arguments.

James Russell, *The Historical Epic and Contemporary Hollywood: From Dances with Wolves to Gladiator* (London: Continuum, 2007).
Russell examines the re-emergence of the Hollywood historical epic in the 1990s and 2000s, making a strong case for the new epic cycle's basis in the historical epics of the 1950s and 1960s. The bulk of the book consists of chapter-long case studies of key films (most notably *Gladiator* and *The Passion of the Christ*) which skillfully combine cultural context, production history, critical reception, and textual analysis.

J. E. Smyth, *Reconstructing American Historical Cinema: From Cimarron to Citizen Kane* (Lexington: University Press of Kentucky, 2006).
A bold reappraisal of conventional assumptions about the relationship between cinema and history which draws on a formidable volume of original research. Smyth focuses on American history in Hollywood films produced between 1931 and 1942 and makes a convincing case for the significance of gangster films, westerns, and showbusiness biopics to public history. Chapters addressing *Young Mr Lincoln* (1939) and *Citizen Kane* (1941) are particularly insightful.

Maria Wyke, *Projecting the Past: Ancient Rome, Cinema and History* (London: Routledge, 1997).
This is the most valuable of several interesting books by classics scholars examining the representation of the ancient world in cinema. Addressing Hollywood and, to a lesser extent, Italian cinema, the main section of the book is divided into case studies of the screen images of Spartacus, Cleopatra, Nero, and Pompeii. While this structure emphasizes the history of the ancient world rather than the history of cinema, the scholarship is excellent throughout and the chapter addressing fluctuating representations of Cleopatra during the twentieth century is particularly insightful. The introductory chapter also includes a substantial and accessible survey of theoretical approaches to historical film.

Edited collections

Robert Burgoyne (ed.), *The Epic Film in World Culture* (London: Routledge, 2011).
As its title suggests, Burgoyne's collection departs from Hollywood-centric approaches to the form by considering the international dimensions of epic cinema. American cinema is by some measure the best represented, however, although several essays broaden discussions of the epic beyond the roadshow era and the 2000s. Useful research addresses the role of CGI

in contemporary epic filmmaking and the epic qualities of recent Chinese martial arts cinema.

Marnie Hughes-Warrington (ed.), *The History on Film Reader* (London: Routledge, 2009).
A superb collection containing some of the best and most important writing on historical cinema to date. Chapters include Natalie Zemon Davis' ground-breaking essay 'Film and the Challenge of Authenticity,' Roland Barthes' celebrated analysis of Roman hairstyles in Hollywood films, and Jean-Louis Comolli's insightful 'Historical Fiction: A Body Too Much.' The book also contains well-chosen extracts from important monographs by Pierre Sorlin, Marcia Landy, and Philip Rosen.

Peter C. Rollins (ed.), *The Columbia Companion to American History on Film: How the Movies Have Portrayed the American Past* (New York: Columbia University Press, 2003).
Rollins assembles an impressive squadron of academic historians in this comprehensive survey of American historical representation in American film (and to a lesser extent television). The book is organized by topic, and chapters address screen depictions of major American wars, leaders, and social movements. More useful, perhaps, are the sections on less familiar areas of historical representation, including 'Robber Barons, Media Moguls, and Power Elites,' 'Public High Schools,' 'Suburbia,'and 'The American Fighting Man.'

Robert A. Rosenstone (ed.), *Revisioning History: Filmmakers and the Construction of a New Past* (Princeton: Princeton University Press, 1995).
A lively collection of original essays which serve to illustrate the diversity of contemporary academic research into historical cinema. The collection covers a broad range of historical periods and national cinemas, and highlights include chapters on the films *Hiroshima mon amour* (1959), *Walker* (1987), and *Hitler: A Film from Germany* (1997).

J. E. Smyth (ed.), *Hollywood and the American Historical Film* (London: Palgrave, 2011).
An impressively unconventional survey of the field which emphasizes case studies of individual films and bridges the gap between historical and film scholarship. Significantly, Smyth expands traditional conceptions of what might constitute historical cinema by including essays on films such as *Some Like It Hot* (written by David Eldridge) (1959) and *The Man Who Shot Liberty Valance* (1962).

Bibliography

AFI Film Catalog, CD-ROM edition (Chadwyck-Healey Inc., 1999).

Altman, Rick, *Film/Genre* (London: BFI, 1999).

Arenas, Amelia, "Popcorn and Circus: *Gladiator* and the Spectacle of Virtue," *Arion: A Journal of Humanities and the Classics,* 9/1 (2001): 1–12.

Babington, Bruce and Peter William Evans, *Blue Skies and Silver Linings: Aspects of the Hollywood Musical* (Manchester: Manchester University Press, 1985).

—*Biblical Epics: Scared Narrative in the Hollywood Cinema* (Manchester: Manchester University Press, 1993).

Balio, Tino, *United Artists: The Company that Changed the Film Industry* (Madison: University of Wisconsin Press, 1987).

—*Grand Design: Hollywood as a Modern Business Enterprise, 1930–39* (New York: Scribner's, 1993).

Barefoot, Guy, *Gaslight Melodrama: From Victorian London to 1940s Hollywood* (London: Continuum, 2001).

Barra, Michael, "The Incredible Shrinking Epic," *American Film,* 14/5 (1989): 40–5.

Barthes, Roland, *The Rustle of Language*, trans. Richard Howard (Berkeley: University of California Press, 1989).

—*Mythologies*, trans. Annette Lavers (London: Vintage, 1993).

—"On CinemaScope," trans. Jonathan Rosenbaum, *Jouvert: A Journal of Postcolonial Studies,* 3/3 (1999).

Basinger, Jeanine, *The World War II Combat Film: Anatomy of a Genre* (Middletown: Wesleyan University Press, updated edn, 2003).

Baudrillard, Jean, "Apocalypse Now," in Gilbert Adair (ed.), *Movies* (London: Penguin, 1999), 265–7.

Bazin, André, "On *Why We Fight:* History, Documentation and the Newsreel," in Bert Cardullo (ed.), *Bazin at Work: Major Essays and Reviews from the Forties and Fifties*, trans. Alain Piette and Bert Cardullo (New York: Routledge, 1997), 187–192.

Belton, John, *Widescreen Cinema* (Cambridge: Harvard University Press, 1992).

Benjamin, Walter, *Illuminations*, trans. Harry Zohn (New York: Schocken Books, 1968).

Bennett, Todd, "The Celluloid War: State and Studio in Anglo-American Propaganda Film-Making, 1939–1941," *The International History Review,* 24/1 (2002): 64–102.

Bernstein, Irving, *Hollywood at the Crossroads: An Economic Study of the Motion Picture Industry* (Los Angeles: Hollywood Association of Film Labor, 1957).

Biskind, Peter, *Easy Riders, Raging Bulls: How the Sex-Drugs-and Rock 'n' Roll Generation Changed Hollywood* (London: Bloomsbury, 1999).

Black, Gregory D., *Hollywood Censored: Morality Codes, Catholics, and the Movies* (Cambridge: Cambridge University Press, 1994).

Block, Alex Ben (ed.), *George Lucas's Blockbusting* (New York: George Lucas Books, 2010).

Booker, Keith M., *From Box Office to Ballot Box: The American Political Film* (Westport: Greenwood Press, 2007).

Bordwell, David, Janet Staiger, and Kristin Thompson, *The Classical Hollywood Cinema: Film Style and Mode of Production to 1960* (London: Routledge, 1988).

Bourdieu, Pierre, *Distinction: A Social Critique of the Judgment of Taste*, trans. Richard Nice (Cambridge: Harvard University Press, 1984).

Bowser, Eileen, *The Transformation of Cinema, 1907–1915* (New York: Charles Scribner's Sons, 1990).

Briley, Ronald F., "The Study Guide *Amistad: A Lasting Legacy*," *The History Teacher,* 31/3 (1998): 390–4.

Britton, Andrew, "Hollywood in Vietnam," *Movie,* 27–28 (1980-81): 2–23.

Browne, Nick (ed.), *Refiguring American Film Genres: Theory and History* (Berkeley: University of California Press, 1998).

Brownlow, Kevin, *The Parade's Gone By...* (Berkeley: University of California Press, 1996).

Burgoyne, Robert, *Film Nation: Hollywood Looks at US History* (Minneapolis: University of Minnesota Press, 1997).

—"Memory, History and Digital Imagery in Contemporary Film," in Paul Grainge (ed.), *Memory and Popular Film* (Manchester: Manchester University Press, 2003), 220–36.

—*The Hollywood Historical Film* (Oxford: Blackwell, 2008).

Burris, Gregory A., "Barbarians at the Box Office: *300* and *Signs* as Huntingtonian Narratives," *Quarterly Review of Film and Video,* 28/2 (2011): 101–19.

Cagle, Chris, "Two Modes of Prestige Film," *Screen,* 43/3 (2007): 291–311.

Carnes, Mark C. (ed.), *Past Imperfect: History According to the Movies* (New York: Henry Holt, 1995).

—"Shooting Down the Past: Historians vs. Hollywood," *Cineaste,* 29/2 (2004): 45–9.

Carter, Tim, *Oklahoma! The Making of an American Musical* (New Haven: Yale University, 2007).

Chapman, James, *Past and Present: National Identity and the British Historical Film* (London: I. B. Tauris, 2005).

Chapman, James and Nicholas Cull, *Projecting Empire: Imperialism and Popular Cinema* (London, I. B. Tauris, 2009).

Chowdhry, Prem, *Colonial India and the Making of Empire Cinema: Image Ideology and Identity* (Manchester: Manchester University Press, 2000).

Cohan, Steve, *Screening the Male: Exploring Masculinities in Hollywood Cinema* (Bloomington: Indiana University Press, 1998).

Coleman, Kathleen M., "The Pedant Goes to Hollywood: The Role of the Academic Consultant," in Marvin M. Winkler (ed.), Gladiator: *Film and History* (London: Blackwell, 2004), 45–52.

Cook, David A., *Lost Illusions: American Cinema in the Shadow of Watergate and Vietnam, 1970–79* (New York: Charles Scribner's Sons, 2000).

Cook, Pam, *Fashioning the Nation: Costume and Identity in British Cinema* (London: BFI, 1997).

Crafton, Donald, *The Talkies: America's Transition to Sound 1926–1931* (New York: Charles Scribner's Sons, 1998).

Crowdus, Gary, "History, Dramatic License, and Larger Historical Truths: An Interview with Oliver Stone," *Cineaste,* 22/4 (1997): 38–42.

Custen, George F., *Bio/Pics: How Hollywood Constructed Public History* (New Brunswick: Rutgers University Press, 1992).

Cyrino, Monica, "*Gladiator* and Contemporary American Society" in Marvin M. Winkler (ed.), *Gladiator: Film and History* (London: Blackwell, 2004), 124–48.

—*Big Screen Rome* (Oxford: Blackwell, 2005).

Davis, Natalie Zemon, "'Any Resemblance to Persons Living or Dead': Film and the Challenge of Authenticity," *Yale Review,* 76 (1987): 457–482.

De Groot, Jerome, *Consuming History: Historians and Heritage in Contemporary Popular Culture* (London: Taylor & Francis, 2008).

Deleuze, Gilles, *Cinema 1: The Movement Image,* trans. Hugh Tomlinson and Barbara Habberjam (Minneapolis: University of Minnesota Press, 1986).

Derrida, Jacques, "The Law of Genre," trans. Avital Ronell, *Critical Inquiry,* 7/1 (1980): 55–81.

Dick, Bernard F., *The Star Spangled Screen: The American World War II Film* (Lexington: University Press of Kentucky, 1996).

Doherty, Thomas, *Pre-Code Hollywood: Sex, Immorality and Insurrection in American Cinema, 1930–1934* (New York: Columbia University Press, 1999).

Draper, Ellen, "Untrammelled by Historical Fact: *That Hamilton Woman* and Melodrama's Aversion to History," *Wide Angle,* 14/1 (1991): 56–63.

Durgnat, Raymond, "Epic," *Films and Filming,* 10/3 (1963): 9–12.

Eldridge, David, "Hollywood Censors History," *49th Parallel,* 20 (2006): 2–14.

—*Hollywood's History Films* (London, I. B. Tauris, 2006).

Elsaesser, Thomas, "Film History as Social History: The Dieterle/Warner Brothers Bio-Pic," *Wide Angle,* 8/2 (1986): 15–32.

Fitzgerald, F. Scott, *The Last Tycoon* (New York: Scribner's, 1993).

Fradley, Martin, "Oliver Stone," in Yvonne Tasker (ed.), *Fifty Contemporary Filmmakers* (London: Routledge, 2002), 328–337.

Fraser, George MacDonald, *The Hollywood History of the World: From One Million Years B.C. to Apocalypse Now* (New York: William Morrow, 1988).

Geduld, Harry M. (ed.), *Focus on D.W. Griffith* (London: Prentice Hall, 1972).

Glancy, Mark H. (ed.), "The Eddie Mannix Ledger," *Historical Journal of Film, Radio and Television,* 12/2 (1992), microfiche supplement.

—*When Hollywood Loved Britain: The Hollywood 'British' Film (1939–45)* (Manchester: University of Manchester Press, 1999).

—(ed.), "The William Schaefer Ledger," *Historical Journal of Film, Radio and Television,* 15/1 (1995), microfiche supplement.

Gledhill, Christine, "History of Genre Criticism" in Pam Cook (ed.), *The Cinema Book* (London: BFI, 1999), 252–64.

Grindon, Leger, *Shadows on the Past: Studies in the Historical Fiction Film* (Philadelphia: Temple University Press, 1994).

Guynn, William, *Writing History in Film* (London: Routledge, 2006).

Hall, Sheldon and Steve Neale, *Epics, Spectacles, and Blockbusters: A Hollywood History* (Detroit: Wayne State University Press, 2010).

Hamburg, Eric (ed.) *Nixon: An Oliver Stone Film* (London: Bloomsbury, 1996).

Harper, Sue, "Bonnie Prince Charlie Revisited: British Costume Film in the 1950s," in Robert Murphy (ed.), *The British Cinema Book* (London: BFI, 2002), 276–85.

Herlihy, David, "Am I a Camera? Other Reflections on Films and History," *American Historical Review,* 93/5 (1988): 1186–92.

Higgins, Scott, *Harnessing the Technicolor Rainbow: Color Design in the 1930s* (Austin: University of Texas Press, 2007).

Higson, Andrew, "Re-presenting the Past: Nostalgia and Pastiche in the Heritage Film," in Lester Friedman (ed.), *British Cinema and Thatcherism: Fires Were Started* (Minneapolis: University of Minnesota Press, 1993), 109–29.

Hoff, Joan, "Nixon," *American Historical Review,* 111/4 (1996): 1173.

Hozic, Aida, *Hollyworld: Space, Power and Fantasy in the American Economy* (Ithaca: Cornell University Press, 2001).

Hughes-Warrington, Marnie, *History Goes to the Movies: Studying History on Film* (Abingdon: Routledge, 2007).

Jackson, Russell, *Shakespeare's Films in the Making: Vision, Production and Reception* (Cambridge: Cambridge University Press, 2007).

Jarvie, I. C., "Fanning the Flames: Anti-American Reaction to *Objective Burma*," *Historical Journal of Film Radio and Television,* 1/2 (1981): 117–34.

Jeffords, Susan, *Hard Bodies: Hollywood Masculinity in the Reagan Era* (New Brunswick: Rutgers University Press, 1994).

Jeffrey, Julie Roy, "*Amistad* (1997): Steven Spielberg's 'True Story'," *Historical Journal of Film, Radio and Television,* 21/1 (2001): 77–96.

Jewell, Richard (ed.), "The C. J. Tevlin Ledger," *Historical Journal of Film, Radio and Television,* 14/1 (1994), microfiche supplement.

Jowett, Garth S., "The Concept of History in American Produced Films: An Analysis of the Films Made in the Period 1950–1961," *Journal of Popular Culture,* 3/4 (1970): 799–813.

Kanfer, Stefan, *Somebody: The Reckless Life and Remarkable Career of Marlon Brando* (New York: Vintage, 2009).

King, Geoff, "Spectacle, Narrative and the Spectacular Hollywood Blockbuster," in Julian Stringer (ed.), *Movie Blockbusters* (London: Routledge, 2003), 114–27.

Klein, Christina, *Cold War Orientalism: Asia in the Middlebrow Imagination, 1945–61* (Berkeley: University of California Press, 2003).

Koppes, Clayton R. and Gregory D. Black, *Hollywood Goes to War: How Politics, Profits and Propaganda Shaped World War II Movies* (London: Collier Macmillan, 1987).

—"Regulating the Screen: The Office of War Information and the Production Code Administration," in Thomas Schatz, *Boom and Bust: The American Cinema in the 1940s* (New York: Scribner's, 1999), 262–84.

Koszarski, Richard, *An Evening's Entertainment: The Age of the Silent Feature Picture, 1915–1928* (New York: Charles Scribner's Sons, 1990).

Krämer, Peter, *The New Hollywood: From Bonnie and Clyde to Star Wars* (London: Wallflower, 2005).

Landau, Diana (ed.), *Gladiator: The Making of the Ridley Scott Epic* (London: Boxtree, 2000).

Landy, Marcia, *British Genres: Cinema and Society, 1930–1960* (Princeton: Princeton University Press, 1991).

Lane Fox, Robin, *The Making of Alexander: The Official Guide to the Epic Alexander Film* (Oxford, R & L: 2004).

Langford, Barry, *Film Genre: Hollywood and Beyond* (Edinburgh: Edinburgh University Press, 2005).

Lev, Peter, *American Films of the 70s: Conflicting Visions* (Austin: University of Texas Press, 2000).

Lindley, Arthur, "Once, Present, and Future Kings: *Kingdom of Heaven* and the Multitemporality of Medieval Film," in Lynn T. Ramey and Tison Pugh (eds), *Race, Class, and Gender in 'Medieval' Cinema* (New York: Palgrave Macmillan, 2007), 15–29.

Louvish, Simon, *Cecil B. DeMille and the Golden Calf* (London: Faber and Faber, 2007).

Lupack, Alan, "Review," *Arthuriana*, 14/3 (2004): 123–5.

Maltby, Richard, *Hollywood Cinema* (London: Blackwell, 2nd edn, 2003).

—"Mapping New Cinema Histories," in Maltby, Daniel Biltereyst, and Philippe Meers (eds), *Explorations in New Cinema History: Approaches and Case Studies* (Oxford: Wiley-Blackwell, 2011), 3–40.

Manland, Charles, "Movies and American Culture in the Annus Mirabilis" in Ina Rae Hark (ed.), *American Cinema of the 1930s: Themes and Variations* (New Brunswick: Rutgers University Press, 2007), 227–52.

Marcus, Alan S., Scott Alan Metzger, Richard J. Paxton, and Jeremy D. Stoddard, *Teaching History with Film: Strategies for Secondary Social Studies* (New York: Routledge, 2010).

Mart, Michelle, "The 'Christianization' of Israel and Jews in 1950s America," *Religion and American Culture*, 14/1 (2004): 109–46.

Marwick, Arthur, "Film in University Teaching," in Paul Smith (ed.), *The Historian and Film* (Cambridge: Cambridge University Press, 1979), 142–56.

Matthews, John, "A Knightly Endeavor: The Making of Jerry Bruckheimer's *King Arthur*," *Arthuriana*, 14/3 (2004): 112–15.

McAlister, Melani, *Epic Encounters: Culture, Media and US Interests in the Middle East since 1945* (Berkeley: University of California Press, updated edn, 2005).

McCrisken, Trevor B. and Andrew Pepper, *American History and Contemporary Hollywood Film* (Edinburgh: Edinburgh University Press, 2005).

Misek, Richard, *Chromatic Cinema: A History of Screen Cinema* (Oxford: Wiley-Blackwell, 2010).

Mittel, Jason, "A Cultural Approach to Television Genre Theory," *Cinema Journal*, 40/3 (2001): 3–24.

Monk, Claire, "The British 'Heritage Film' and Its Critics," *Critical Survey*, 7/2 (1995): 116–24.

Munslow, Alun, *The Routledge Companion to Historical Studies* (London: Routledge, 2005).

Musser, Charles, *Before the Nickelodeon: Edwin S. Porter and the Edison Manufacturing Company* (Berkeley: University of California Press, 1991).

Nadel, Alan, "God's Law and the Wide Screen: *The Ten Commandments* as Cold War Epic," *PMLA,* 103/3 (1993): 415–30.

—*Containment Culture: American Narrative, Postmodernism and the Atomic Age* (Durham: Duke University Press, 1995).

Ndalianis, Angela, *Neo-Baroque Aesthetics and Contemporary Entertainment* (Cambridge: MIT Press, 2005).

Neale, Steve, "Aspects of Ideology and Narrative Form in the American War Film," *Screen,* 32/1 (1991): 35–57.

—*Genre and Contemporary Hollywood* (London: Routledge, 2000).

Noerdlinger, Henry S., *Moses and Egypt: The Documentation to the Motion Picture* The Ten Commandments (Los Angeles: University of Southern California Press, 1956).

Pasinetti, P. M., "*Julius Caesar:* The Role of the Technical Advisor," *The Quarterly of Film, Radio and Television,* 8/2 (1953): 131–8.

Pettigrew, Terence, *Trevor Howard: A Personal Biography* (London: Peter Owen, 2001).

Pierson, Michele, "A Production Designer's Cinema: Historical Authenticity in Popular Films Set in the Past," in Geoff King (ed.), *Spectacle and the Real* (Bristol: Intellect, 2005), 145–55.

Polan, Dana, "The Professors of History," in Vivian Sobchack (ed.), *The Persistence of History: Cinema, Television and the Modern Event* (London: Routledge, 1996), 235–56.

Powdermaker, Hortense, *Hollywood, the Dream Factory* (London: Secker & Warburg, 1951).

Pratt, Mary Louise, *Imperial Eyes: Travel Writing and Transculturation* (London: Routledge, 1992).

Prince, Stephen, "True Lies: Perceptual Realism, Digital Images and Film Theory," *Film Quarterly,* 49/3 (1996): 27–37.

—(ed.), *Screening Violence* (New Brunswick: Rutgers University Press, 2000).

Pye, Douglas, "Ulzana's Raid," *Movie,* 27–8 (1980–1): 78–84.

Richards, Jeffrey, *Visions of Yesterday* (London: Routledge & Kegan Paul, 1973).

—*The Age of the Dream Palace: Cinema and Society in 1930s Britain* (London: I. B. Tauris, 2010).

Robé, Chris, "Taking Hollywood Back: The Historical Costume Drama, the Biopic, and Popular Front US Film Criticism," *Cinema Journal,* 48/2 (2009): 70–87.

Roddick, Nick, *A New Deal in Entertainment: Warner Bros. in the 1930s* (London: BFI, 1983).

Rollins, Peter C. (ed.), *The Columbia Companion to American History on Film: How the Movies Have Portrayed the American Past* (New York: Columbia University Press, 2003).

Roquemore, Joseph, *History Goes to the Movies: A Viewers Guide to the Best (and Some of the Worst) Historical Films Ever Made* (New York: Random House, 1999).

Rosen, Philip, *Change Mummified: Cinema, Historicity, Theory* (Minneapolis: University of Minnesota Press, 2001).

Rosenstone, Robert A., "*JFK:* Historical Fact/Historical Film," *American Historical Review,* 97/2 (1992): 506–11.

—*Visions of the Past: The Challenge of Film to Our Idea of History* (Cambridge: Harvard University Press, 1995).

—*History on Film/Film on History* (Harlow: Pearson Educational, 2006).

Rosenzweig, Roy and David Thelen, *The Presence of the Past: Popular Uses of History in American Life* (New York: Columbia University Press, 1998).

Russell, James, *Past Glories: The Historical Epic in Contemporary Hollywood* (PhD thesis, University of East Anglia, 2005).

—*The Historical Epic and Contemporary Hollywood: From* Dances with Wolves *to* Gladiator (London: Continuum, 2007).

Sanello, Frank, *Reel v. Real: How Hollywood Turns Fact into Fiction* (Lanham: Taylor Trade, 2003).

Schatz, Thomas, *Hollywood Genres: Formulas, Filmmaking, and the Studio System* (Philadelphia: Temple University Press, 1981).

—"The New Hollywood," in Jim Collins, Hilary Radner, and Ava Preacher Collins (eds), *Film Theory Goes to the Movies* (New York: Routledge, 1993), 8–36.

—*The Genius of the System: Hollywood Filmmaking in the Studio Era* (London: Faber and Faber, 1998).

—"The Western," in Wes D. Gehring, *Handbook of American Film Genres* (Westport: Greenwood Press, 1988).

Schlesinger Jr., Arthur M., "On JFK and Nixon," in Robert Brent Toplin (ed.), *Oliver Stone's USA* (Lawrence: University of Kansas Press, 2000).

Shaw, Tony, *Hollywood's Cold War* (Edinburgh: Edinburgh University Press, 2007).

Slotkin, Richard, *Gunfighter Nation: The Myth of the Frontier in Twentieth-Century America* (Norman: University of Oklahoma Press, 1992).

Smith, Jeff, "Are You Now or Have You Ever Been a Christian? The Strange History of *The Robe* as Political Allegory," in Frank Krutnik, Steve Neale, Brian Neve, and Peter Stanfield (eds), *'Un-American' Hollywood: Politics and Film in the Blacklist Era* (New Brunswick: Rutgers University Press, 2007), 19–38.

Smith, Jeffrey P., "'A Good Business Proposition': Dalton Trumbo, *Spartacus*, and the End of the Blacklist," *Velvet Light Trap,* 23 (1989): 75–100.

Smyth, J. E., "Surge and Splendor: A Phenomenology of the Hollywood Historical Epic," in Barry Keith Grant (ed.), *Film Genre Reader II* (Austin: University of Texas Press, 1995), 296–323.

—*Reconstructing American Historical Cinema: From Cimarron to Citizen Kane* (Lexington: University Press of Kentucky, 2006).

Sobchack, Vivian, "The Insistent Fringe: Moving Images and Historical Consciousness," *History and Theory: Studies in the Philosophy of History,* 36/4 (1997): 4–20.

Sontag, Susan "The Imagination of Disaster," in Gilbert Adair (ed.), *Movies* (London: Penguin, 1999), 171–85.

Sorlin, Pierre, *The Film in History: Restaging the Past* (Totowa: Barnes and Noble, 1980).

Staiger, Janet, "Securing the Fictional Narrative of a Tale of the Historical Real: *The Return of* Martin Guerre," in Jane Gaines (ed.), *Classical Narrative Cinema: The Paradigm Wars* (Durham: Duke University Press, 1992), 107–27.

—"The Revenge of the Film Education Movement: Cult Movies and Fan Interpretive Behaviours," *Reception: Texts, Readers, Audiences History,* 1 (2008): 43–69.

Sterritt, David, "*Fargo* in Context: The Middle of Nowhere?" in William Luhr
 (ed.), *The Cohen Brother's Fargo* (Cambridge: Cambridge University Press,
 2004) 10–32.
Stokes, Melvyn, *D. W. Griffith's* The Birth of a Nation: *A History of 'The Most
 Controversial Motion Picture of All Time'* (Oxford: Oxford University Press,
 2007).
Stone, Oliver and Zachary Sklar, *JFK: The Book of the Film* (New York: Applause
 Books, 1992).
Stringer, Julian, "'The China Had Never Been Used!' On the Patina of Perfect
 Images in *Titanic*," in Kevin S. Sandler and Gaylyn Studlar (eds), *Titanic:
 Anatomy of a Blockbuster* (New Brunswick: Rutgers University Press, 1999),
 205–19.
Stubbs, Jonathan, "Hollywood's Middle Ages: The Script Development of
 Knights of the Round Table and *Ivanhoe*, 1935–53," *Exemplaria: A Journal of
 Theory in Medieval and Renaissance Studies*, 21/4 (2009): 399–418.
—"The Runaway Bribe? American Film Production in Britain and the Eady Levy,"
 Journal of British Cinema and Television, 6/1 (2009): 1–20.
Studlar, Gaylyn, *This Mad Masquerade: Stardom and Masculinity in the Jazz Age*
 (New York, Columbia University Press, 1996).
Sturken, Marita, "Reenactment, Fantasy and the Paranoia of History: Oliver
 Stone's Docudramas," *History and Theory: Studies in the Philosophy of
 History*, 3/4 (1997): 64–79.
Susman, Warren I., "Film and History: Artifact and Experience," *Film and History*,
 15/2 (1985): 26–39.
Taves, Brian, *The Romance of Adventure: The Genre of Historical Adventure
 Movies* (Jackson: University Press of Mississippi, 1993).
Thomas, Deborah, "Grease," *Movie*, 27–8 (1980–1): 94–8.
Thompson, Frank, "Getting it Right: The Alamo on Film," in James M. Welsh and
 Peter Lev (eds), *The Literature/Film Reader: Issues of Adaptation* (Lanham:
 Scarecrow Press, 2007), 297–306.
Thompson, Kirsten Moana, "'Philip Never Saw Babylon': 360-Degree Vision and
 the Historical Epic in the Digital Era," in Robert Burgoyne (ed.), *The Epic Film
 in World Culture* (London: Routledge, 2011), 39–62.
Thompson, Kristin and David Bordwell, *Film History: An Introduction* (New York:
 McGraw Hill, 1994).
Toplin, Robert Brent, *Reel History: In Defense of Hollywood* (Lawrence:
 University of Kansas Press, 2002).
Tudor, Andrew, *Theories of Film* (London: Secker & Warburg, 1975).
Uricchio, William and Roberta E. Pearson, *Reframing Culture: The Case of the
 Vitagraph Quality Films* (Princeton: Princeton University Press, 1993).
Vankin, Jonathan and John Whalen, *Based on a True Story: Fact and Fantasy in
 100 Favorite Movies* (Chicago: Chicago Review Press, 2005).
Vasey, Ruth, *The World According to Hollywood, 1918–1939* (Exeter: Exeter
 University Press, 1997).
Vieira, Mark A., *Irving Thalberg: Boy Wonder to Producer Prince* (Berkeley:
 University of California Press, 2010).
Wagner, Phil, "Passing through Nightmares: Cecil B. DeMille's *The Plainsman*
 and Epic Discourse in New Deal America," in Robert Burgoyne (ed.), *The Epic
 Film in World Culture* (London: Routledge, 2011), 207–34.

Walker, Alexander, *Elizabeth: The Life of Elizabeth Taylor* (London: Grove Press, 2001).

Ward, Allen M., "History, Ancient and Modern in *The Fall of the Roman Empire*," in Martin M. Winkler (ed.), *The Fall of the Roman Empire: Film and History* (London: Blackwell, 2009), 51–88.

White, Hayden, *Tropics of Discourse: Essays in Cultural Criticism* (Baltimore: Johns Hopkins University Press, 1978).

—"Historiography and Historiophoty," *American Historical Review*, 93/5 (1988): 1193–9.

—*Figural Realism: Studies in the Mimesis Effect* (Baltimore: Johns Hopkins University Press, 1998).

—"Film and History: Questions to Filmmakers and Historians," *Cineaste,* 29/2 (2004): 66–7.

Wood, Michael, *America in the Movies, or, 'Santa Maria. It Had Slipped My Mind'* (London: Secker & Warburg, 1975).

Wood, Robin, *Hollywood from Vietnam to Reagan* (New York: Columbia University Press, 1986).

Wyke, Maria, *Projecting the Past: Ancient Rome, Cinema and History* (London: Routledge, 1997).

Xavier, Ismail, "Historical Allegory," in Toby Miller and Robert Stam (eds), *A Companion to Film Theory* (Oxford: Blackwell, 1999), 333–62.

Filmography

300 (2006) dir. Zack Snyder
The Adventures of Quentin Durward (1955) dir. Richard Thorpe
The Adventures of Robin Hood (1938) dir. Michael Curtiz
The Alamo (1960) dir. John Wayne
Alexander (2004) dir. Oliver Stone
Alexander Hamilton (1931) dir. John G. Adolfi
Alexander's Rag Time Band (1938) dir. Henry King
All the President's Men (1976) dir. Alan Pakula
American Gangster (2007) dir. Ridley Scott
American Graffiti (1973) dir. George Lucas
Amistad (1997) dir. Steven Spielberg
Animal House (1978) dir. John Landis
Antony and Cleopatra (1908) Vitagraph Company
Apocalypse Now (1979) dir. Francis Ford Coppola
Apocalypto (2006) dir. Mel Gibson
Apollo 13 (1995) dir. Ron Howard
Around the World in 80 Days (1956) dir. Michael Anderson
Back to the Future (1985) dir. Robert Zemeckis
Barabbas (1962) dir. Richard Fleischer
Battleship Potemkin (1925) dir. Sergei Eisenstein
Becket (1964) dir. Peter Glenville
Becky Sharp (1935) dir. Rouben Mamoulian
Ben-Hur: A Tale of the Christ (1925) dir. Fred Niblo
Ben-Hur (1959) dir. William Wyler
The Bible (1966) dir. John Huston
The Big Fisherman (1959) dir. Frank Borzage
The Big Parade (1925) dir. King Vidor
The Big Trail (1930) dir. Raoul Walsh
The Birth of a Nation (1915) dir. D.W. Griffiths
Black Hawk Down (2001) dir. Ridley Scott
The Black Pirate (1926) dir. Albert Parker
The Black Shield of Falworth (1954) dir. Rudolph Maté
Blackbeard the Pirate (1952) dir. Raoul Walsh
Bonnie and Clyde (1967) dir. Arthur Penn
Born on the 4th of July (1989) dir. Oliver Stone
Braveheart (1995) dir. Mel Gibson
The Bridge on the River Kwai (1957) dir. David Lean
The Buccaneer (1938) dir. Cecil B. DeMille
Buffalo Bill and the Indians, or Sitting Bull's History Lesson (1976) dir. Robert
 Altman

Cabaret (1971) dir. Bob Fosse
Cabiria (1914) dir. Giovanni Pastrone
Camelot (1967) dir. Joshua Logan
Captain Blood (1935) dir. Michael Curtiz
Cardinal Richelieu (1935) dir. Rowland V. Lee
The Charge of the Light Brigade (1936) dir. Michael Curtiz
The Charge of the Light Brigade (1968) dir. Tony Richardson
Chinatown (1974) dir. Roman Polanski
Cimarron (1931) dir. Wesley Ruggles
Cimarron (1960) dir. Anthony Mann
Citizen Kane (1941) dir. Orson Welles
Cleopatra (1917) dir. J. Gordon Edwards
Cleopatra (1934) dir. Cecil B. DeMille
Cleopatra (1963) dir. Joseph Mankiewicz
Coming Home (1978) dir. Hal Ashby
The Covered Wagon (1923) dir. James Cruze
The Crimson Pirate (1952) dir. Robert Siodmak
The Crusades (1935) dir. Cecil B. DeMille
The Damned United (2009) dir. Tom Hooper
Dances with Wolves (1990) dir. Kevin Costner
David and Bathsheba (1951) dir. Henry King
David Copperfield (1935) dir. George Cukor
Dead End (1937) dir. William Wyler
The Deer Hunter (1978) dir. Michael Cimino
Demetrius and the Gladiators (1954) dir. Delmer Daves
The Diary of Ann Frank (1959) dir. George Stevens
The Dirty Dozen (1967) dir. Robert Aldrich
A Dispatch from Reuters (1940) dir. William Dieterle
Disraeli (1929) dir. Alfred E. Green
Doctor Dolittle (1967) dir. Richard Fleischer
Doctor Zhivago (1965) dir. David Lean
Dog Day Afternoon (1975) dir. Sidney Lumet
Don Juan (1926) dir. Alan Crosland
Dorothy Haddon of Vernon Hall (1924) dir. Marshall Neilan
The Drum (1938) dir. Zoltan Korda
The Egyptian (1954) dir. Michael Curtiz
Dr Ehrlich's Magic Bullet (1940) dir. William Dieterle
El Cid (1961) dir. Anthony Mann
Empire of the Sun (1987) dir. Steven Spielberg
Enemy at the Gates (2001) dir. Jean-Jacques Annaud
The English Patient (1996) dir. Anthony Minghella
Execution of Czolgosz with Panorama of Auburn Prison (1901) Edison Company
The Execution of Mary Queen of Scots (1895) Edison Company
Exodus (1960) dir. Otto Preminger
The Fall of the Roman Empire (1964) dir. Anthony Mann
Fargo (1996) dir. Joel Coen
Fiddler on the Roof (1971) dir. Norman Jewison
Flags of Our Fathers (2006) dir. Clint Eastwood
Forrest Gump (1994) dir. Robert Zemeckis

The Four Horsemen of the Apocalypse (1921) dir. Rex Ingram
The Four Horsemen of the Apocalypse (1962) dir. Vincente Minnelli
Frost/Nixon (2008) dir. Ron Howard
Gandhi (1982) dir. Richard Attenborough
The Garden of Allah (1936) dir. Richard Boleslawski
Gladiator (2000) dir. Ridley Scott
Glory (1989) dir. Edward Zwick
The Godfather (1972) dir. Francis Ford Coppola
The Godfather Part II (1974) dir. Francis Ford Coppola
Gone with the Wind (1939) dir. Victor Fleming
Go Tell the Spartans (1978) dir. Ted Post
The Grapes of Wrath (1940) dir. John Ford
Grease (1978) dir. Randal Kleiser
The Great Escape (1963) dir. John Sturges
The Greatest Story Ever Told (1965) dir. George Stevens
The Great Ziegfeld (1936) dir. Robert Z. Leonard
The Green Berets (1968) dir. John Wayne
The Green Goddess (1930) dir. Alfred E. Green
Guadalcanal Diary (1943) dir. Lewis Seiler
Gunga Din (1939) dir. George Stevens
The Guns of Navarone (1961) dir. J. Lee Thompson
Heaven's Gate (1980) dir. Michael Cimino
Hello, Dolly! (1969) dir. Gene Kelly
Hercules/Le fatiche di Ercole (1958) dir. Pietro Francisci
Hercules Unchained/Ercole e la regina Lidia (1959) dir. Pietro Francisci
Hero (2002) dir. Zhang Yimou
High, Wide and Handsome (1937) dir. Rouben Mamoulian
Hotel Rwanda (2004) dir. Terry George
Howards End (1992) dir. James Ivory
How the West was Won (1963) dirs. John Ford, Henry Hathaway, & George
 Marshall
Indiana Jones and the Last Crusade (1989) dir. Steven Spielberg
In Old Chicago (1938) dir. Henry King
In the Name of the Father (1993) dir. Jim Sheridan
Intolerance (1916) dir. D.W. Griffith
The Invention of Lying (2009) dirs. Ricky Gervais & Matthew Robinson
The Iron Horse (1924) dir. John Ford
Ivanhoe (1952) dir. Richard Thorpe
I Want to Live! (1958) dir. Robert Wise
JFK (1991) dir. Oliver Stone
Joan of Arc (1895) Edison Company
Joan the Woman (1916) dir. Cecil B. DeMille
Juarez (1939) dir. William Dieterle
Judgment at Nuremberg (1961) dir. Stanley Kramer
Judith of Bethulia (1914) dir. D.W. Griffith
Julius Caesar (1953) dir. Joseph L. Mankiewicz
Kim (1950) dir. Victor Saville
The King and I (1956) dir. Walter Lang
King Arthur (2004) dir. Antoine Furqua

Kingdom of Heaven (2005) dir. Ridley Scott
King of Kings (1927) dir. Cecil B. DeMille
King of Kings (1961) dir. Nicholas Ray
King Richard and the Crusaders (1954) dir. David Butler
Knights of the Round Table (1953) dir. Richard Thorpe
Land and Freedom (1995) dir. Ken Loach
Land of the Pharaohs (1955) dir. Howard Hawks
The Last Days of Pompeii (1913) dir. Mario Caserini
The Last Days of Pompeii (1935) dirs. Ernest B. Schoedsack & Merian C. Cooper
The Last Emperor (1987) dir. Bernardo Bertolucci
The Last King of Scotland (2006) dir. Kevin McDonald
The Last Picture Show (1971) dir. Peter Bogdanovich
Lawrence of Arabia (1962) dir. David Lean
Les Misérables (1909) Vitagraph Company
Letters from Iwo Jima (2006) dir. Clint Eastwood
The Life of Emile Zola (1937) dir. William Dieterle
The Life of George Washington (1909) Vitagraph Company
The Life of Moses (1909) Vitagraph Company
The Life of Napoleon (1909) Vitagraph Company
Little Big Man (1970) dir. Arthur Penn
Little Caesar (1931) dir. Mervyn LeRoy
Little Women (1933) dir. George Cukor
The Lives of a Bengal Lancer (1935) dir. Henry Hathaway
Lloyds of London (1936) dir. Henry King
The Longest Day (1962) dirs. Ken Annakin, Andrew Marton & Bernhard Wicki
Madame Du Barry (1917) dir. J. Gordon Edwards
Maid of Salem (1936) dir. Frank Lloyd
Malcolm X (1992) dir. Spike Lee
A Man Called Horse (1970) dir. Elliot Silverstein
A Man for All Seasons (1966) dir. Fred Zinnemann
Marie Antoinette (1938) dir. W.S. Van Dyke
*Mary Poppins (*1964) dir. Robert Stevenson
MASH (1970) dir. Robert Altman
Men with Wings (1938) dir. William Wellman
A Midsummer Night's Dream (1935) dirs. Max Reinhardt & William Dieterle
Milk (2008) dir. Gus Van Sant
Missing (1982) dir. Costa-Gavras
Mission to Moscow (1943) dir. Michael Curtiz
Mohammad, Messenger of God (1976) dir. Moustapha Akkad
Monty Python and the Holy Grail (1975) dirs. Terry Gilliam & Terry Jones
Mutiny on the Bounty (1935) dir. Frank Lloyd
Mutiny on the Bounty (1962) dir. Lewis Milestone
My Fair Lady (1964) dir. George Cukor
Nixon (1995) dir. Oliver Stone
Objective Burma! (1945) dir. Raoul Walsh
O Brother, Where Art Thou? (2000) dir. Joel Cohen
October (1928) dir. Sergei Eisenstein
Of Human Bondage (1934) dir. John Cromwell
Oklahoma! (1955) dir. Fred Zinnemann

Old Ironsides (1926) dir. James Cruze
A Passage to India (1984) dir. David Lean
The Passion of the Christ (2004) dir. Mel Gibson
Paths of Glory (1957) dir. Stanley Kubrick
Patton (1970) dir. Franklin J. Schaffner
Pearl Harbor (2001) dir. Michael Bay
The People vs. Larry Flynt (1996) dir. Milos Forman
Peter Pan (1953) dirs. Clyde Geronimi, Wilfred Jackson, & Hamilton Luske
The Phantom of the Opera (1925) dir. Rupert Julian
Pirates of the Caribbean (2003) dir. Gore Verbinski
The Plainsman (1936) dir. Cecil B. DeMille
Platoon (1986) dir. Oliver Stone
Pleasantville (1998) dir. Gary Ross
Pork Chop Hill (1959) dir. Lewis Milestone
The Prince of Egypt (1998) dirs. Brenda Chapman & Steve Hickner
Prince Valiant (1954) dir. Henry Hathaway
The Private Life of Henry VIII (1933) dir. Alexander Korda
The Private Lives of Elizabeth and Essex (1939) dir. Michael Curtiz
The Public Enemy (1931) dir. William Wellman
The Queen (2006) dir. Stephen Frears
Quiz Show (1994) dir. Robert Redford
Quo Vadis? (1913) dir. Enrico Guazzoni
Quo Vadis (1951) dir. Mervyn LeRoy
Raiders of the Lost Ark (1981) dir. Steven Spielberg
Rasputin and the Empress (1932) dir. Richard Boleslavsk
Reds (1981) dir. Warren Beatty
Rescue of Capt. John Smith by Pocahontas (1895) Edison Company
The Return of Martin Guerre (1982) dir. Daniel Vigne
The Robe (1953) dir. Henry Koster
Robin Hood (1922) dir. Allan Dwan
Robin Hood: Prince of Thieves (1991) dir. Kevin Reynolds
A Room with a View (1985) dir. James Ivory
Rulers of the Sea (1939) dir. Frank Lloyd
Salome (1918) dir. J. Gordon Edwards
Salome (1954) dir. William Dieterle
Samson and Delilah (1949) dir. Cecil B. DeMille
Sands of Iwo Jima (1949) dir. Allan Dwan
San Francisco (1936) dir. W.S. Van Dyke
Saving Private Ryan (1998) dir. Steven Spielberg
Scarface (1932) dir. Howard Hawks
The Scarlet Empress (1934) dir. Josef von Sternberg
Schindler's List (1993) dir. Steven Spielberg
The Sea Hawk (1940) dir. Michael Curtiz
Sergeant York (1941) dir. Howard Hawks
Serpico (1973) dir. Sidney Lumet
The Sign of the Cross (1932) dir. Cecil B. DeMille
Singin' in the Rain (1952) dirs. Gene Kelly & Stanley Donen
Sins of Jezebel (1953) dir. Reginald Le Borg
The Social Network (2010) dir. David Fincher

Somebody Up There Likes Me (1956) dir. Robert Wise
Soldier Blue (1970) dir. Ralph Nelson
Solomon and Sheba (1959) dir. King Vidor
The Sound of Music (1965) dir. Robert Wise
South Pacific (1958) dir. Joshua Logan
Spartacus (1960) dir. Stanley Kubrick
Spawn of the North (1938) dir. Henry Hathaway
The Story of Alexander Graham Bell (1939) dir. Irving Cummings
The Story of Louis Pasteur (1936) dir. William Dieterle
Sweet Liberty (1986) dir. Alan Alda
That Hamilton Woman/Lady Hamilton (1941) dir. Alexander Korda
The Ten Commandments (1923) dir. Cecil B. DeMille
The Ten Commandments (1956) dir. Cecil B. DeMille
The Thief of Baghdad (1924) dir. Raoul Walsh
The Thin Red Line (1998) dir. Terence Malick
Thirteen Days (2001) dir. Roger Donaldson
Thirty Seconds over Tokyo (1944) dir. Mervyn LeRoy
Titanic (1997) dir. James Cameron
Tora! Tora! Tora! (1970) dir. Richard Fleischer
Troy (2004) dir. Roland Emmerich
U-571 (2000) dir. Jonathan Mostow
Union Pacific (1939) dir. Cecil B. DeMille
United 93 (2006) dir. Paul Greengrass
The Viking (1928) dir. Roy William Neill
Voltaire (1933) dir. John G. Adolfi
W (2008) dir. Oliver Stone
Walker (1987) dir. Alex Cox
Waterloo (1970) dir. Sergei Bondarchuk
Wells Fargo (1937) dir. Frank Lloyd
Western Union (1941) dir. Fritz Lang
We Were Soldiers (2002) dir. Randall Wallace
Windtalkers (2002) dir. John Woo
The Wonderful World of the Brothers Grimm (1962) dir. Henry Levin & George
 Pal
World Trade Center (2006) dir. Oliver Stone
Yankee Doodle Dandy (1942) dir. Michael Curtiz
Yellow Jack (1938) dir. George B. Seitz
Young Mr Lincoln (1939) dir. John Ford
Zelig (1983) dir. Woody Allen

Index